Breakfast with Lucian

Breakfast with Lucian

A Portrait of the Artist

Geordie Greig

JONATHAN CAPE

LONDON

First published in Great Britain in 2013 by Jonathan Cape
Random House, 20 Vauxhall Bridge Road, London SW1V 2SA

www.vintage-books.co.uk

Addresses for companies within The Random House Group Limited can be found at: www.randomhouse.co.uk/offices.htm

The Random House Group Limited Reg. No. 954009

A CIP catalogue record for this book is available from the British Library

ISBN 9780224096850

The Random House Group Limited supports The Forest Stewardship Council (FSC®), the leading international forest certification organisation. Our books carrying the FSC label are printed on FSC® certified paper. FSC is the only forest certification scheme endorsed by the leading environmental organisations, including Greenpeace. Our paper procurement policy can be found at: www.randomhouse.co.uk/environment

Designed and typeset in Centaur by Peter Ward

Printed and bound in Italy by Graphicom Srl

What matter? Out of cavern comes a voice,
And all it knows is that one word 'Rejoice!'
Conduct and work grow coarse, and coarse the soul,
What matter? Those that Rocky Face holds dear,
Lovers of horses and of women, shall,
From marble of a broken sepulchre,
Or dark betwixt the polecat and the owl,
Or any rich, dark nothing disinter
The workman, noble and saint, and all things run
On that unfashionable gyre again.

'The Gyres', W. B. Yeats

'Dull not to.'

H. L. C. Greig (1925–2012)

For Kathryn, Jasper, Monica and Octavia

Contents

Preface

In the mid 1990s Lucian Freud stopped publication of his authorised biography. Even though he had cooperated with the writer he paid him off with a substantial sum. When Lucian read the manuscript he was appalled that so many intimate details would enter the public domain. The idea that the book would be published in his lifetime was abandoned.

When I was a news reporter on the *Sunday Times* in the late 1980s, another writer told me that East End gangsters had come round to his house, at Freud's request, and threatened him with unpleasant consequences if he did not stop researching a biography. That book withered too.

This book avoided his obstructions. We met for breakfast regularly over the last ten years of his life, and during our many conversations Lucian gradually opened up. Eventually he was happy for me to record what we said. We had an understanding that it was fine for me to publish what he told me in different magazines and newspapers. The resulting book, started after Lucian's death, is a personal perspective on his life and work by someone who followed his career for thirty-five years but only gained his confidence and trust in his last decade.

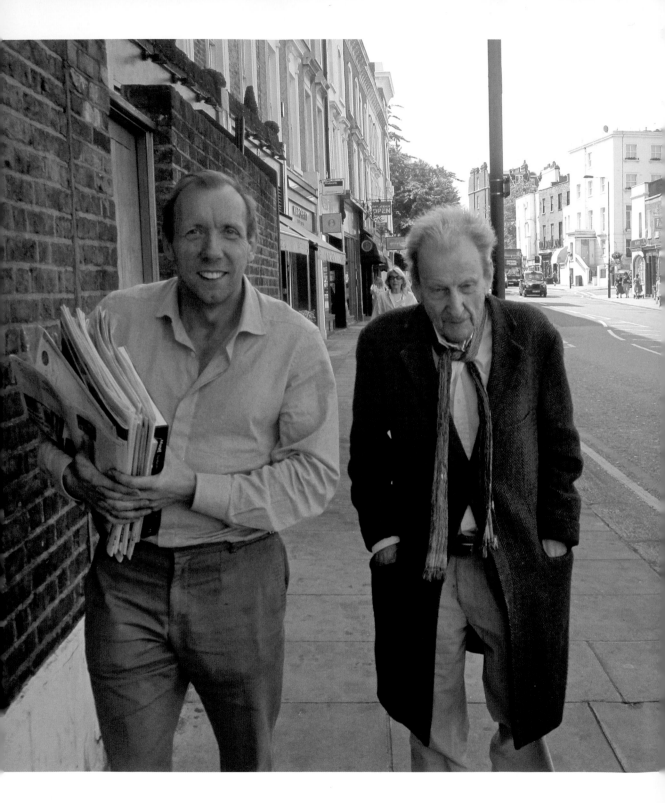

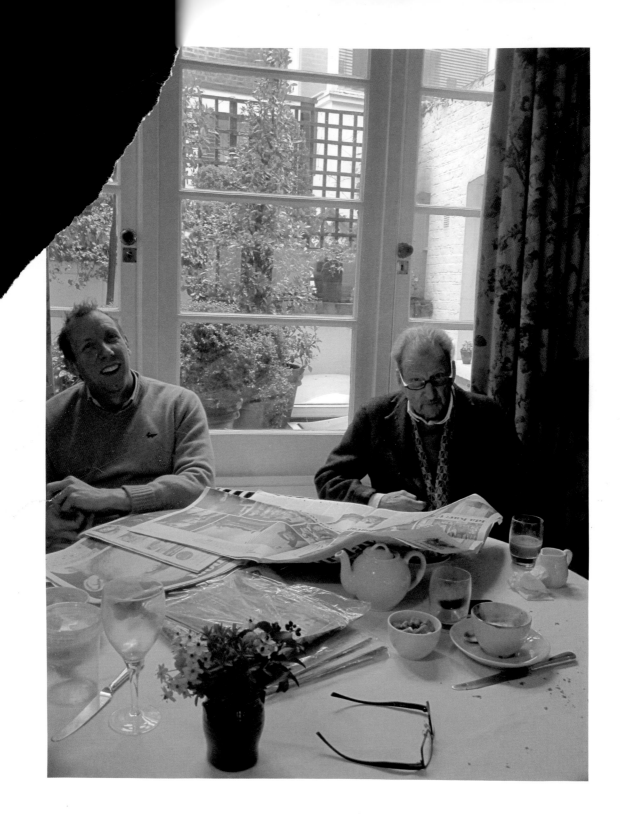

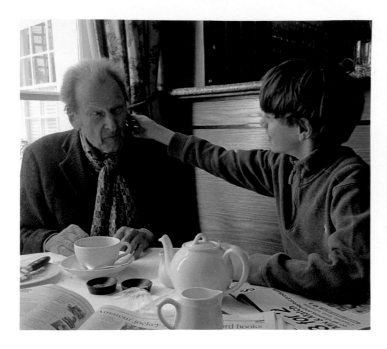

In conversation with Jasper Greig, September 2010

Lucian's doodle of a horse, his only i-Pad drawing, November 2010

and the other on an iPhone. He was enchanting with the children, amused when Jasper told him he had nice knees – 'One of the finest parts of me' – and laughed when Jasper told him he thought that the initials 'OM' after Lucian's name stood for Old Man, not Order of Merit. Lucian would mock-drum on the table with a spoon or his clenched fist, pretend to take cherries out of the children's ears, sing ditties or recite poems by Walter de la Mare or Rudyard Kipling. He was always delighted to talk and tease, and their interaction was often very moving.

In that quiet space, Lucian's conversation ranged from dating Greta Garbo to the best way to land a punch without breaking your thumb, to how he had popped in to 10 Downing Street to see Gordon Brown, or had been to a nightclub with Kate Moss, or had sold a picture for an eye-watering sum. He was witty, caustic and curious. Recitations of Goethe, Noël Coward, Eliot and Yeats tumbled out. It was somehow always a performance and never a declamation, whether it was Nat King Cole's 'There's Gotta Be Some Changes Made' or nineteenth-century French verse. He could recall spats in the 1940s with Ian Fleming, who believed Lucian was cuckolding him ('completely untrue, actually'), how Stephen

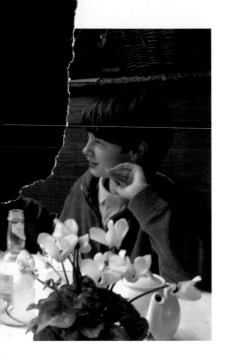

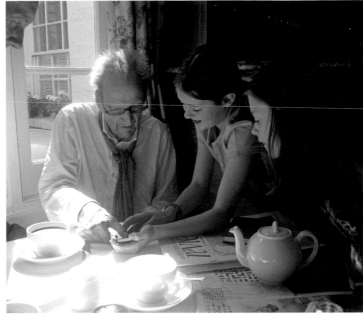

Lucian with Monica and Octavia
Greig

Spender had stolen some drawings, or how Jacob Rothschild had
taken him to the ballet at Covent Garden the previous night. Stories
might go back to his twenties, perhaps recounting his time as a film
extra in George Formby's musical comedy *Much Too Shy*. (Lucian
played a young painter at the 'School of Modern Art', while Formby
was an accident-prone handyman who paints publicity posters for
his local cinema. Asked by the manager to draw sexy women in silks
and satins in his pictures, Formby enrols at the art school, being
too shy to have anyone he knows model for him. 'One day when I'm
a famous painter they will sell like hot cakes,' he boasts to his boy
assistant, Jimmy. 'I'd rather have hot cakes,' replies Jimmy.)

Painters were often discussed, from Degas (whom he admired)
to Raphael (who he felt never became truly great). Top of his list
were Rembrandt and Velázquez. He would tell you how Chardin,
in 1735, had painted 'the most beautiful ear in art' in a picture called
The Young Schoolmistress. Conversation was chatty and informal and
gossipy and sometimes profound. He might suddenly say how he
hated the brightly coloured cupcakes in the fancy bakery that had
opened a few doors down, or talk about his latest painting, or which
of Flaubert's letters he especially liked. He was never boastful about

what he was doing or who he had known; both were spectacular
remarkable. He talked fondly of his time hovering in dark st
with criminals in Paddington, West London, and riding ho
in the 1950s in Dorset, and more recently near Wormwood Scr
prison in the noughties. His grandfather Sigmund was recollec
with warmth.

Lucian was scornful of any psychobabble link between hi
and Sigmund. 'I just never think like that,' he told me, believing very
simply that too much analysis led to paralysis.

GG: 'Did your grandfather have any of your pictures?'
LF: 'Yes, I gave him some things but my aunt Anna destroyed
 them.'
GG: 'Why?'
LF: 'I think because he liked them. But when I tried to borrow
 them back it was impossible. I was friendly with a maid in
 his house who told me that my aunt had destroyed them. She
 was absolutely ghastly.'
GG: 'Did you see much of Sigmund?'
LF: 'Oh yes, I liked his company very much. He was never boring.
 He told me jokes. I remember how nice he was to the maid.
 I loved seeing him. I remember I took a book by Norman
 Douglas out of his library and on the title page someone had
 written "Please do not show to Professor Freud". Well, there
 was one limerick which went:

 "Those girls who frequent picture palaces
 Have no use for this psychoanalysis,
 But although Doctor Freud
 Is extremely annoyed
 They cling to their long-standing fallacies."'

Another lyric often recalled by Lucian had a humorous dig at other
famous Jewish intellectuals, including his one-time father-in-law,
the sculptor Jacob Epstein (who once referred to Lucian as a 'spiv'):

There was once a family called Stein,
There was Gert,

There was Ep,
There was Ein.
Gert's writings were bunk,
Ep's statues were junk,
And no one could understand Ein.

An hour at breakfast would go by, sometimes two. Then it was time for work, and he gathered his bunch of keys and half-moon tortoiseshell glasses from the table; David would grab the papers. And so back to his Georgian town house with its perfect proportions, white sash windows, an iron gate at the front leading to the matt, dark grey front door, a bamboo hedge in the front shielding the house from anyone too inquisitive. No name was on the doorbell, and in any event the buzzer could not always be heard if Lucian was working upstairs. Unexpected visitors were discouraged.

Most of the great pictures of the last twenty-five years of his career had been painted a quarter of a mile away in the Holland Park studio. His house in Kensington Church Street had originally been bought to try to have a more comfortable life, and add an extra layer of privacy – always an obsession with him. He told one girlfriend that they might move in there together, but in the end that idea was far too entrapping.[1] It became an alternative workplace but was more domesticated than the grimy squalor of Holland Park, where old Fortnum & Mason porcelain jars of caviar sat on his kitchen dresser alongside a chipped vase of congealed paintbrushes, dust-laden audio cassettes of Johnny Cash and old Christie's catalogues and corkscrews. Only in his last four years did he essentially abandon Holland Park for Kensington Church Street, where he used two rooms on the first floor as his full-time studio. He had liked a split existence in two places. Both were properties which today are worth millions of pounds, so different from his impoverished start in Paddington, when he used to scrape together the rent from his apparently modest income generated by his grandfather's royalties. Wherever he was, the only real purpose was to have a sanctuary in which to paint.

Almost every day after breakfast in Lucian's final three years,

David would pose naked on an old mattress while Lucian worked on his last painting, *Portrait of the Hound*. It showed Eli the whippet dwarfed by the life-size nude figure of David. The title was a minor witticism for a major work, his finale: monumental and moving.

His last painting also cemented something that had been the case from Lucian's earliest days: he was wedded to the idea and practice of figurative art. He ignored abstraction, expressionism, postmodernism and conceptual art, and was disdainful about them, certain that prolonged and intense observation of the human figure was the core of an artist's purpose. A surprising amount of his early work has survived, stretching back seventy years. It includes some naive childhood drawings made in Germany and, more importantly, a sketchbook he had begun in 1941 when working as an ordinary seaman aboard the SS *Baltrover*, a cargo vessel chartered for Atlantic crossings. His canon is extensively varied, from delicate pencil drawings in the margins of love letters to mammoth canvases with swathes of naked flesh in oil paint, no two pictures the same in scale or composition.

Although eventually he became a symbol of figurative boldness as a modern artist, that was not how he was viewed in the 1970s and 80s, when America felt he had been left behind by the vanguard of expressionism and abstraction. He was entrenched in life-study portraiture and he made it provocative. 'It is the only point of getting up every morning: to paint, to make something good, to make something even better than before, not to give up, to compete, to be ambitious,' he said. It was often a lonely path. But while his art was deeply rooted in tradition, he made pictures that were at times considered shocking, dangerous, unsettling.

The bare facts of Lucian Freud's life also form a gripping narrative. As Sigmund Freud's grandson, born in 1922, Lucian fled Germany in 1933 with his parents, Ernst and Lucie, to avoid the Holocaust. It was a move prompted by the murder of one of his cousins by Nazi thugs in broad daylight outside a café in Berlin. The shadow of death and flight made Lucian hunger for the fullest life in England, smashing through conventional morality and ignoring any rivals. His was a race to leave a permanent mark, and painting was the obsessive centre of his life.

Eli resting in the artist's Notting Hill studio

Even in his eighties, lithe, lively and a global art star, he could walk into a room and turn heads, a charged presence. In his studio he would sit in a chair with his legs slung over its arms, almost louche in his pose, flexible as a teenager. As his picture framer, Louise Liddell, simply put it: 'He was dishy, always was.'[2] Intellect and emotion collided in his work and his life, as he used people to whom he was attracted to produce pictures which combined visual impact and psychological intent. They captured an intensely observed truth of what was before him, from the spread thighs of women exposing their genitalia to blank eyes of inconsolable men in awkward poses. He changed the mood and language of portraiture.

He married twice and officially fathered at least fourteen children.[3] His reputation in the bedroom as well as in his studio was newspaper fodder for many decades ('Is he the greatest lover ever?' asked the *Daily Mail*). Some of his children posed naked for

him, including his son, Freddy, aged twenty-nine, in a life-size, full-frontal portrait. Lucian was frank and fearless. When Sir James Goldsmith, the billionaire entrepreneur, sent him a letter saying if he painted his daughter he would have him murdered. Lucian replied: 'Is that a commission?' The only letter he sent me, before we met, read: 'The idea of giving you an interview makes me feel sick.'

In his final years, long after he had left the area, Paddington traders who worked in Smithfield meat market would shout out 'Hey Lou, what's doing?' when he popped into a café for breakfast. He liked this connection to the rougher parts of society, yet was equally at ease staying at Ascott, the Buckinghamshire family home of the banking grandee Sir Evelyn de Rothschild, where he particularly admired the eighteenth-century horse paintings by George Stubbs. He liked to mingle with high society and low society rather than with the bourgeois middle classes, but seldom travelled outside London. 'I travel vertically, rather than horizontally,' was his memorable description of this mingling of social axes.[4]

Freud was fascinating to every new generation and moved in many circles within each. In the 2000s he painted Jerry Hall and Brigadier Andrew Parker Bowles (former husband of Prince Charles's wife, the Duchess of Cornwall), while in the 1940s and 50s it had been Stephen Spender and Francis Bacon. He was considered a wunderkind when he arrived in England in September 1933 as a ten-year-old refugee with an extraordinary talent for drawing. Eight decades later, he was still making people stare in restaurants and galleries, his status almost more that of a rock star than a portrait painter.

In his final years, in the evening Lucian liked to sit at table 32 in a corner of the Wolseley, a café-restaurant in the grand European tradition, on Piccadilly. In the most glamorous restaurant dining room in London, other diners watched him twist his head round to see who was present. He was not name-checking, but focusing on napes, knees, faces, legs, arms and even ears. He was far more interested in how people looked than who they were. When the actress Keira Knightley sat near him one night when I was with him, Lucian had no idea who she was, as he never watched films or television. Admiring her, he asked me if I knew her.

Lucian, aged 87, in a moment of relaxation.

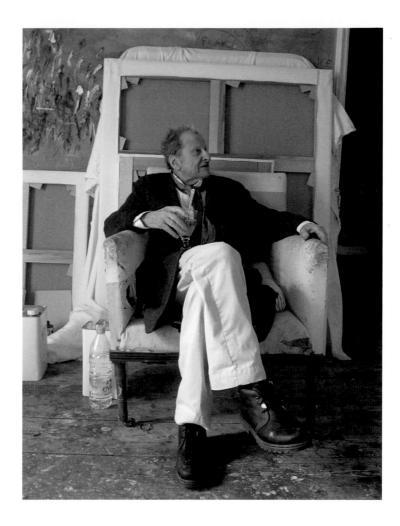

He was an extraordinary presence in an often celebrity-filled room. Richard Wallace, then editor of the *Daily Mirror*, sensed his charisma, emailing me two days after Lucian died. 'I was surprised how much I felt his loss. I didn't know him – apart from the odd staring match at the Wolseley. In fact, the last time I saw him was a few Saturdays ago when I popped in for a solo lunch and he was on the next table with a pneumatic young blonde. As I unfurled my paper he suddenly boomed with great ferocity, and a touch of hostility, "That man's reading the *Daily Mirror*." I could feel him glaring at me, but was too terrified to meet his gaze.'

Lucian's alternative table was number 25, nearer the entrance but still within the inner quadrangle of tables. He was a familiar

sight, night after night, the waiters extremely protective, shepherding away the over-curious. He always paid in crisp £50 notes. Often he ordered a half-pint of Atlantic prawns which he peeled and shared with his guests. He rather grandly liked food which might have come from one of the country estates of his aristocratic friends, such as pheasant and grouse.

In some ways, Lucian's upwardly mobile path in his adopted country closely echoed that of Sir Anthony Van Dyck (1599–1641), another European émigré who under Charles I became more English than the English. Van Dyck had the dukes of Buckingham and Norfolk as his patrons, Lucian had the dukes of Devonshire and Beaufort. Van Dyck painted Charles I, while Elizabeth II sat for Lucian. Both artists had sophisticated and varied social lives, although the Flemish painter was more modest in his procreational tally. He had just two daughters, one by his mistress and the other by his wife. Both men conquered English society as the most formidable portraitists of their age.

A sense of nobility was important to Lucian. When I asked if he had been bullied as a German Jew while working on a British merchant navy ship in the early 1940s, his reply was simply that the sailors saw him as a gentleman. And he could also be as boisterously disruptive as a member of an Oxford dining society. Aged eighty-four, Lucian once chucked breadsticks at a man who used flash to take a photograph in the Wolseley. The man approached him to remonstrate. Lucian, forty years older, squared up to him and was prepared to fight. The man complained later that Lucian had ruined their daughter's birthday. 'Let's be honest,' said Jeremy King, co-owner of the Wolseley, 'he made it. He was fearless, that's what I liked about him. He was not an aggressive person, but when provoked he was one of the most antagonistic.'[5]

Lucian told me how Francis Bacon tried to calm him down: 'He asked me why I always got into fights, and suggested a less abrasive manner: "Use your charm."' He had punch-ups all his life. In the 1960s the Thane of Cawdor crept up to him at the Cuckoo Club in Piccadilly at around 4 a.m. and lit a newspaper that he was reading. Lucian hit him in the face before they sat down and shared a drink and a cigar. In his eighties, Lucian had a fist fight

in a supermarket in Holland Park after a dispute at the checkout. Sometimes he went completely over the top, as he did once at Bibendum, the Fulham Road restaurant. It was late at night and as Lucian and his bookmaker and friend Victor Chandler sat down, a waiter – obviously gay – said, 'Hello boys, been to the theatre, have we?'

Lucian spat out, 'What fucking business is it of yours if we have been or not?' There was a stunned silence. 'Just because we're two men together at eleven o'clock at night, there's no reason to assume we're poofs like you.'

'For God's sake, shut up please,' said Victor.

'Well, why should he assume?' said Lucian. 'I don't care what anyone one is, but why should he assume?' He then hit the waiter while Victor grabbed his shoulder to hold him back.

When going for another meal together, this time at the River Café, Lucian and Victor once walked in at the same time as two North London Jewish couples. 'Lucian could be terribly anti-Semitic, which in itself was strange, and as these people entered the restaurant the scent wafting from the two women was overpowering. Lucian shouted: "I hate perfume. Women should smell of one thing: cunt. In fact, they should invent a perfume called cunt." He was drunk and loud but the other couple heard him and were highly offended. I pleaded to them, "Please don't think anything of it, he's mad and drunk,"' said Victor. 'The staff were horrified and I kept saying, "Shush, Lucian," and he kept saying, "I won't shush," and you know, the other usual things.'[6]

Jeremy King made sure Lucian was well looked after at the Wolseley, which was a relaxing diversion in the evening from the restricted space and intense work of his studio. The restaurant kept his own wines in their cellar, and at random they pulled out great vintages. (The Rothschilds had asked Lucian to design a label for their Mouton-Rothschild cuvée, and he offered a drawing done in the 1940s rather than a new one, as requested.)

Lucian chose an astute observer when he selected King as a subject, who sat for hundreds of hours for a painting during 2006–7, and then an etching that was incomplete when Lucian died. A powerful 'space baron' who controlled the best tables in town,

King had allegedly been immortalised by Harold Pinter in his play *Celebration* as the ultimate elegant maître d'. Lucian would teasingly tell people that 'Jeremy is a black belt and can kill a man with one move' – which was completely untrue, but Lucian liked to maintain this fallacy. He would sometimes invent a semblance of the truth, not exactly a lie, more a poetic truth, something which sounded right (or which he believed to be right).

King recalled that 'He loved to sing "Cheek to Cheek" or "You're the Top", and we would compete to see who knew the lyrics best. When it came to songs he was a great romanticist, but with limericks more visceral.' It was impossible to compete with Lucian anecdotally, because at the end of a song he would remember that he had danced to it with Marlene Dietrich. There were jokes, gossip, character assassinations, lyrics, limericks and much badinage. 'Every syllable he managed somehow to inject with an extra bit of character or exclamation,' said King. Sometimes it was just simple word play, such as in his jokey description of one critic's exhibition of paintings as being more like 'works of aunts' than 'works of art'. He made most things sound or seem less ordinary, be it the cut or shape of a lapel, or his thoughts on love, or even spinach: 'I can imagine that if a woman I was in love with cooked spinach with oil, I would also enjoy the slight *heroism* of liking it, although I didn't usually enjoy it served that way.'[7]

There was a playfulness and a contrariness, sometimes a desire to be noticed, in him and in his art, despite his love of privacy. It was partly why he was such good company. 'I do like to show off, not in the studio but when I am with people, I know that,' he said. His party trick had once been a headstand which his photographer friend Bruce Bernard captured memorably on film, with his daughter Bella sitting next to him, simultaneously bemused and impressed. He often shocked people. His imitation of a whale masturbating, witnessed at lunch at the River Café by Sue Tilley ('Big Sue', who sat for *Benefits Supervisor Sleeping*), did exactly that. Not everyone was amused.

He liked the last word, and could be tricky and impulsive, once sending a letter to a Tate curator stating 'Nicholas Serota is a Liar; I have never owned that picture'. The curator had simply been

following up a request, pre-arranged by Serota in his role as the Tate director, to borrow the Francis Bacon picture *Two Figures* (1953), which hung opposite Lucian's bed in his house in Notting Hill. Always known by Lucian as 'The Buggers' owing to its homosexual content, it had caused uproar when first exhibited. It was based on Eadweard Muybridge's photographs of naked men in motion, several volumes of whose work were among Lucian's books. The painting was technically owned by Lucian's friend Jane Willoughby, but while merely trying to say how grateful the Tate was, the curator had mistakenly implied in his letter that Lucian owned it, which was why he sent his extreme and unreasonable response. (The picture was never lent, although Lucian did donate a painting of the head of Leigh Bowery to the Tate, and Serota and Lucian remained friends.)

Lucian was not very interested in money, but delighted in knowing what price his paintings fetched at auction, even when he no longer owned them. Aged eighty-five, he was extremely pleased when *Benefits Supervisor Sleeping* was bought in May 2008 by the Russian oligarch Roman Abramovich at Christie's for £17.2 million, achieving the highest price for any living artist. Becoming rich did not alter his life. Even without money he had lived well. He was capable of great acts of generosity to those close to him (some sitters were given houses) yet would never give anything to a charity auction. It was too public a gesture. When Leigh Bowery was fined £400 in court for having sex in a public lavatory Lucian stepped in to pay, as he did for Bowery's body to be flown back to Australia after he died of AIDS. Lucian hated leaving a trail, and was reluctant to sign his name in any book, especially any art book or catalogue of his own work. If obliged he would sometimes write 'By himself' and draw an arrow pointing to his name.

Many sitters and lovers felt tethered and trapped by his sheer force of personality, but year after year, they came back for more. 'A lot of my sitters are girls who have some sort of hole in their lives that is filled by posing for an artist,' he once said. 'What I really need is dependability, for them to carry on turning up.' And there were casualties in his wake: discarded lovers, hurt and offended children, letters left unanswered or replies of stunning rudeness, debts left unpaid, insults traded. His rules, or indeed lack of them, meant he

Lucian, April 2010

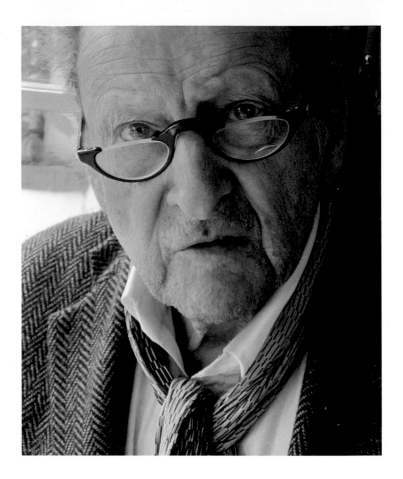

simply did what he wanted, pursuing his art and his own pleasures at whatever the cost, never compromising. It was a blatantly selfish life, but one which he was happy to explain and defend. Although he was glad to accept his Companion of Honour (CH) and Order of Merit (OM), when he wrote to the prime minister in 1977 to turn down a CBE, he said: 'I hope it will be understood that I have come to this decision for selfish reasons.'[8] (He always jocularly referred to his two honours collectively as his 'CHOM'. He lent the CH to one daughter for a fancy-dress party and it subsequently went missing. The OM insignia was handed back to the Queen by David Dawson in a private meeting at Buckingham Palace a few months after Lucian's death, as required by the protocol relating to this prestigious and exclusive honour.)

He was accused of infidelity, cruelty and absenteeism as a

father, yet in spite of sometimes defiantly selfish behaviour some of his children and girlfriends, and even the children of his girlfriends, would still defend him over what was pretty indefensible behaviour. All his life he got away with it. He was so charged with charm and charisma, few were immune to his power of seduction on some level. 'He was as magical as he was malign, a totally bewitching, terrifyingly clever figure who like a silver thread through a pound note had an undoubted streak of evil. I worshipped every inch of him while being terrified,' said Lady Lucinda Lambton, whose mother Bindy, Lady Lambton, was one of Lucian's lovers for over twenty-five years. He asked to paint Lucinda naked but she felt intimidated and uncomfortable and refused.

Irrespective of all these contradictions, what ultimately made Freud remarkable, of course, were the paintings. In the 1950s and 60s, when abstraction and postmodernism were in the ascendant, he continued obsessively painting the human figure in a studio. Although America dominated the art market for the next twenty years and viewed Lucian as a parochial sideshow, eventually fashion and the market caught up with him. In 2004, the art critic Robert Hughes justified his long struggle against the tide. 'Every inch of the surface has to be won, must be argued through, bears the traces of curiosity and inquisition – above all, takes nothing for granted and demands active engagement from the viewer as its right. Nothing of this kind happens with Warhol or Gilbert and George or any of the other image-scavengers and recyclers who infest the wretchedly stylish woods of an already decayed, pulped-out postmodernism.'[9]

Freud was the greatest realist figurative painter of the twentieth century. His naked portraits created a new genre. He entered the national conversation as an artist who pushed boundaries, artistic as well as sexual. He was resolutely unbiddable. 'If someone asked me to paint them, I would usually feel the opposite idea, even want to hit them,' he told me, 'and if anyone threatened or pressurised me in any way at all, I would never ever do what they wanted.' His art and his life joined seamlessly. He courted danger, took risks and lived a lusty, libidinous life, but often indefinably and untidily, contradicting himself, behaving in the opposite way to his public pronouncements.

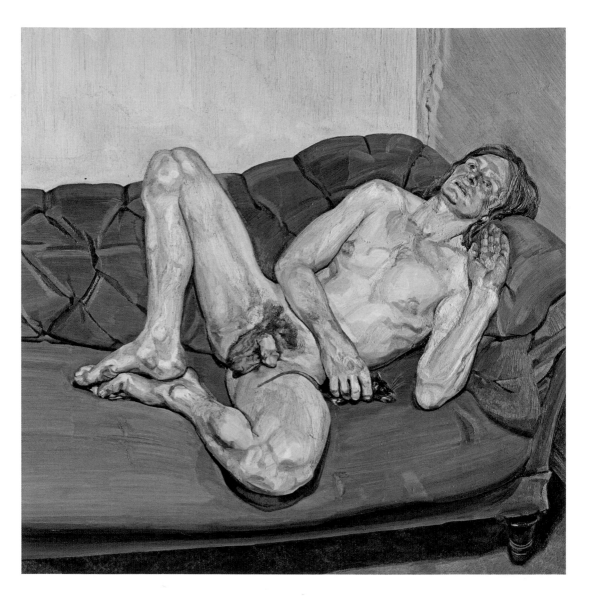

Naked Man with Rat, 1977–78

CHAPTER TWO # Stalking

I was a seventeen-year-old schoolboy the first time I saw a painting by Lucian Freud. It was on a day trip from Eton to London in March 1978 with my English teacher, Michael Meredith. The seventeen pictures hanging in the Anthony d'Offay art gallery ignited my lifelong interest in the artist and his work.

The painting that stopped me in my tracks that day was *Naked Man with Rat*, a portrait of a long-haired man propped up on a sofa, his legs apart, and in close proximity to his genitals he held a rat, its tail coiled over the man's inner thigh. Graphic and startling, this picture hung next to a sedate portrait of the painter's elderly mother in repose.

My school group had been taken to see the Freud show before going to the theatre to watch Peter Shaffer's *Equus*, our A-level set play about a teenage boy stripping himself bare mentally and physically to dispel his sexual and psychological demons. The portrayal of the boy who blinds six horses sticks in my memory alongside the paintings by Freud, particularly the image of the naked man and the rat.

The biggest picture in the exhibition was only three foot square, and the smallest one of Lucian's mother's head was just twelve and three-quarter inches by nine and a quarter. But they achieved maximum impact. Who was the long-haired man? Why was he naked? Why on earth would he place a rat so perilously close to his exposed genitals? Anonymity ruled. Was Freud's mother ill? Her stillness and patience dominated, sentiment and affection both absent in these extraordinary studies of old age. A strange

alchemy was going on. The figures appeared charged, psychologically disturbing, scrutinised, and with more than a hint of risk or danger. I was left in no doubt that the truth could hurt.

Inside the exhibition catalogue was a photograph taken by the artist's daughter Rose Boyt, in which Freud stares out aggressively with an air of menace. His heavy boots have no laces, the dishevelled white shirt and scarf give him a bovver-boy toughness crossed with a touch of the dandy. With his chequered trousers he is dressed like a cross between a pastry chef and a bare-knuckle fighter, eyes startled, with a sense of raw power.

In *Equus*, Martin Dysart, the kindly psychiatrist, understands and analyses the behaviour of the boy who gouged out horses' eyes. He is shocked by his primal urge, but also envies his freedom from restrictive middle-class morality, his breaking away from convention, even in such a depraved manner. While the boy indulges in wild Dionysian ritual and sacrifice, the psychiatrist buys fake souvenirs in package-holiday Greece on sexless holidays with his bored and boring wife. I could make the connection that Michael Meredith must have intended. Freud's paintings were a million miles from domestic or bourgeois entrapment and sent out an illicit, electric current with their unprocessed truths, erasing convention. They sought the exact experience of his encounter in the studio, however unsettling this might be for both the subject and the viewer.

The gallery in Dering Street, a narrow lane off Hanover Square in Mayfair, was more like a spare room in a private house than a public exhibition space. It contained sixteen portraits and one landscape. Every detail stayed with me, including the exquisite catalogue with its grey paper wrapper and a hand-glued label on the front cover. It was full of contradiction and drama.

For several days afterward Michael Meredith and I discussed the Freud show, analysing the order of the pictures and compositions and coming up with our own theories. But Lucian never gave explanations. Harold Pinter (who much later sat for Freud) had once teasingly described his own plays as the weasel under the cocktail cabinet, a carefully crafted throwaway quip to tease literary inquisitors. Most of the time the playwright hid behind the 'Pinter pauses', refusing to explain, leaving it to others to offer

interpretations. He too stayed in the shadows, never talking publicly at the height of his fame in the 1970s and 80s, realising that, as Ted Hughes once told me, 'the whisper goes further than the shout'.

If Pinter barely whispered, Lucian kept absolutely silent. He gave no press interviews from 1940 until the last decade of his life. He had been known to attack photographers physically, and verbally abuse those who came too near. Photographs of him were rare. He would hire gangsters to warn people off. It was only insiders who would gain access, and even then everything would be meticulously controlled, which was why the photograph for the exhibition catalogue was taken in January 1978 by his daughter who, like all his children, he saw only intermittently. He scorned a conventional family life, preferring not to live with his children.

Thirty years later Lucian would give me some insights into the process and the people that he had been painting in those pictures, and how they fitted into his life. He spoke of his frustration at his mother's depression and attempted suicide. He said he felt fury at her pervasive curiosity about his personal life, and resented that he had to deal with her interference and unquenchable desire to know about his life and also to try to share it. He saw his mother more frequently only when she was incapacitated by depression over her husband Ernst's death in 1970. He then saw a lot of her and in 1973 she sat for one particularly compelling portrait, *Large Interior W9*, sitting in an armchair, with his then girlfriend Jacquetta Eliot lying on a bed behind her with her breasts exposed.

I learned that the man in the rat picture was called Raymond Jones, a sought-after interior decorator with artistic aspirations who was born in 1944 in Radcliffe, near Manchester. He was Freud's first model for a male nude painting. The rat was usually drunk. Every day it was given Veuve Clicquot in a dog bowl, with half a crushed sleeping pill. Lulled into a state of compliant inertia it would then sit motionless for hours on end, day after day, on Raymond's upper thigh.

Raymond had charm, talent and was also – crucially for Lucian – extremely willing. Indeed, he was somewhat besotted by the artist, even styling some of his own pictures similarly. As with everyone entering Lucian's inner circle, secrecy was obligatory in

order to avoid exclusion. I had tried to track Raymond down but he had vanished to India for many months and was, I was told by his friends, uncontactable. It was only when he sold a paint-splattered easel that Lucian had used for the rat portrait, given to him by Lucian, that I was able to trace him. It was sold in October 2012 for £3,000 at Christie's to Evgeny Lebedev. Only when Lucian was no longer alive – and more than three decades after sitting for him – did Raymond feel that it was somehow permissible for the *omertà* surrounding his time with Lucian to be lifted.

The initial and unlikely link between Lucian and Raymond was a cockney burglar called George Dyer who in 1963 had broken into Francis Bacon's studio in South Kensington in the middle of the night only to be seduced, becoming Bacon's most significant boyfriend until Dyer's suicide in Paris twenty years later. Dyer was painted several times by Bacon, and also by Lucian.

Raymond bought Lucian's portrait of Dyer for £1,000, even though initially he had no idea who the subject was. Raymond was delighted to own a Freud painting as he had admired his work from the age of eleven. Lucian wanted to meet Raymond and found him quirky, funny and difficult to pigeonhole. Lucian asked him to sit for a portrait – at first quite conventionally, with no mention of rats.

Lucian introduced him to his painter friends Frank Auerbach and Michael Andrews, and also his girlfriend Jane Willoughby. They were brought closer by Freud's spiralling gambling debts when Lucian asked to borrow money. Raymond was non-plussed but flattered. 'I couldn't understand why he wasn't trying to get this money from Jane or the Duke of Devonshire, or whoever else he knew, all of whom would have had far more money. But anyway I had a bit of money put aside and made my mind up to give it to Lucian. Alarmingly, he then said, "I won't give you your money back." I thought "Oh God!" until he then explained. "I'd like to paint a portrait of you which you will then own, thus cancelling any debt."'

Lucian borrowed about £2,000. Raymond did not sit for Lucian until more than a year later. 'Lucian would pick me up in his navy blue Roller. I nearly fainted when he first got out all dressed in his black and white butcher's clothes, my neighbours all looking on wondering who was this tramp in a Roller,' he recalled.

Lucian asked him to help make his new flat into a workable studio. 'He said: "I will get plastic bags and we will knock this wall down." I said: "You can't do that. It might be a structural wall." He just replied, "Sod that, it's coming down."' For two nights they demolished walls. 'When the dust settled in the flat he started to paint me,' he said.

The first picture was a tiny portrait of Raymond's head, just three inches by four, 'magnificently powerful', Raymond thought. He believed that Lucian was actually secretly working on two portraits of him at the same time. The sittings carried on for a year, sometimes three of four evenings a week. But just when he thought he was about to take delivery of it, Lucian asked him to start the whole process again. Frank Auerbach, the person whose judgement Lucian most valued, said the picture was not good enough. 'When I got there Lucian said, "Don't be alarmed, Raymond, but as you know I take Frank's judgement on my pictures, and he doesn't like it." I protested that there was nothing not to like and that I would be pleased to have it. Lucian said, "No I can't allow that. It is going to be destroyed. So Raymond, please sit for another picture."'

Raymond believes the 'destroyed' picture was actually sold or given to Jane Willoughby. He claims he went to stay with her in Scotland several years later at her estate and saw it in her bedroom. He was too shocked to say anything to his hostess or to Lucian, and never mentioned it.

'They were the tricks that Lucian could get up to and that's one of the things I admired about him so much. I knew he was a naughty boy. Think of the quarter-inch steel plate he had on the door of his Holland Park studio. It was only some time later when he was asking me about what colour baize he should put on to cover it that I realised the door was not to protect the pictures. It was to protect him, because of the villains he knew.'

Lucian painted a second portrait of Raymond and did give it to him. (Raymond kept it for ten years before eventually selling it to buy a house.) It was then that the idea for the rat picture emerged. 'In 1977 Lucian told me, "I want you to sit in the nude. You'll be the first man I've painted in oil and I am confident I can do a major picture of a man naked." He then paused, before saying,

". . . With rat. Would you mind being naked with a rat? That's more important." I said, "Oh not at all Lucian, I wouldn't mind one little bit. But how will you get it to behave on my thigh?" He said, "Leave that to me." So I get undressed and he brings out this black rat. It belonged to his friend Katie McEwen. There was nothing said about it being an odd picture to paint, nothing about the fact that the rat is near my testicles. This was never discussed with Lucian. The only thing I asked Lucian was "Is it necessary right from the beginning of the picture that I should be holding the rat? Can't the rat come in later?" Lucian said "No, because it is the whole emotional attitude that matters. Being with the rat would affect the whole portrait. If the rat was not there your mind would be working differently." I went along with that

'The rat was given the champagne and half a sleeping pill in the dog bowl, but would wake two or three hours later, starting to flap its tail and all that. Lucian would then get hold of it, but sometimes it would jump from out of his fingers. That was the funny bit, it running round his studio behind the canvases and plants. We had to catch the bugger. Once we did, it would go in Lucian's kitchen and be given some cheese and then some more champagne and after a quarter of an hour it was nodding off again. We would go back to the studio and carry on for another hour.'

For nine months Lucian, Raymond and the rat went through this ritual. The portrait was to change the perception of male nakedness in contemporary painting, as Freud emphasised a brazen and raw male physicality. There was a psychological drama to the man stripped of all his clothes lying with a rat. It had overtones of discomfort and exposure, like a man in a prison cell, but seemed more perverse by virtue of it being in a domestic setting. There was no nobility or idealisation. His penis and balls are deliberately in the centre of the canvas and are meant to be stared at. It was far away from the posed classicism of almost all previous male nudity in art. It startled. The picture hinted at odd undercurrents, yet no clue was given in the title as to who was painted or why.

Raymond found sitting for Lucian was intense. 'It was quite charged. Lucian once said to me, and I almost jumped off the sofa when he did, "If you'd been a woman I would have gone with you, but

you are not and I am not into that." I was just a piece of meat on the sofa and that was it.' Lucian's desires were, as always, directed widely elsewhere, as Raymond witnessed. 'Sometimes there was a knock on the studio door at Holland Park and a woman would come in and go straight into the bathroom. Then they would go at it, bang, bang, bang. Lucian would have said to me, "I am just taking a break. I won't be that long." He would tell the woman "I have just got someone called Raymond here." More often than not there was then the bang, bang, bang noise of her being shagged, not on his bed but always behind the bathroom door. Lucian would have a bath after his exertions, wandering back into the studio naked. He would say, "I've just had a bath to settle myself down and now we'll carry on."'

Raymond also sat for a double portrait, *Naked Man with His Friend* (1978–80), with his platonic companion John, with whom he lived for more than thirty-five years. It was another picture ahead of its time with its suggestion of affection and intimacy between the two men which hinted that they might be lovers. 'For me, the funny thing is the pyjamas that John wore. Lucian provided them and said they had belonged to his grandfather Sigmund,' said Raymond. Both men have their eyes closed, Raymond's right hand on his friend's left ankle, their limbs interlocked, the tip of his penis concealed under John's calf. It is a scene which poses many questions about their identity and relationship. Both naked portraits of Raymond were key to Lucian fearlessly marking his territory as a cold-eyed observer. They became crucial images in his canon.

As a seventeen-year-old schoolboy, seeing the Freud show with *Naked Man with Rat* was like encountering Keith Richards crossed with Picasso: libidinous, risk-taking, bold and threatening. I was hooked.

* * *

On my return to school I almost immediately sent a letter to Lucian asking to interview him for our school magazine. No reply. I wrote several times. Nothing ever came back. There were other cultural diversions like punk, but Lucian seemed to me just as disruptive and alluring as the Sex Pistols or the Clash. I had a sense that he would somehow be important. I was doing history of art for A-level and

he seemed far more exciting and unsettling than most of the dead artists we were studying. Fuelled by the impact of his pictures, I was on a mission to know more about him and his paintings which was to last thirty years.

Lucian was fifty-five when I first wrote, and eighty-eight when we met for the last time for a moving farewell on his deathbed. It was a long, unpredictable journey, arching across the two centuries, beginning with silence and suspicion, even a spot of subterfuge and stalking. It ended in friendship and mourning.

To fill the silence from Freud, instead I wrote to David Hockney who sent a handwritten reply, but I could not decipher the scribbled signature for several days. I visited him at his top-floor studio in Powis Terrace in Notting Hill, arriving in my corduroys and tweed jacket with a bad 1970s schoolboy's haircut, mesmerised by his blond mop, pop-star aura and extraordinary drawings.

The most ambitious journalistic target in my first year at Oxford was Francis Bacon. I telephoned his Mayfair gallery, Marlborough Fine Art (from where Raymond Jones had bought Lucian's portrait of George Dyer), and spoke to his patient gatekeeper, Valerie Beston — 'little Miss VD', as Bacon called her — as I did every week for six months. Bacon's illiterate cockney boyfriend John Edwards helpfully intervened, as he later told me, smoothing the way for me to see him.

Brilliant, Wildean, darkly seductive and dangerously charming, Bacon got me completely drunk after a long lunch at Wheeler's in Old Compton Street, a thick wad of £50 notes tumbling out of the inside pocket of his leather jacket. One bottle of champagne after another followed at his drinking club, the Colony Room in Dean Street, where he signed me up as a member. He referred to Lucian as 'she', like a pantomime queen. He was cutting and disparaging but affectionate and admiring. Fortunately, I taped the interview, otherwise I wouldn't have remembered any of it. I asked what he would paint if he did my portrait: 'Your vulnerability,' he answered.

In 1951, Freud was the first subject who was named as a sitter by Bacon, who went on to paint Freud in nineteen portraits. Freud returned the favour, and his 1952 portrait of Bacon was to become one of his most powerful and well-known paintings. In 1988, it was

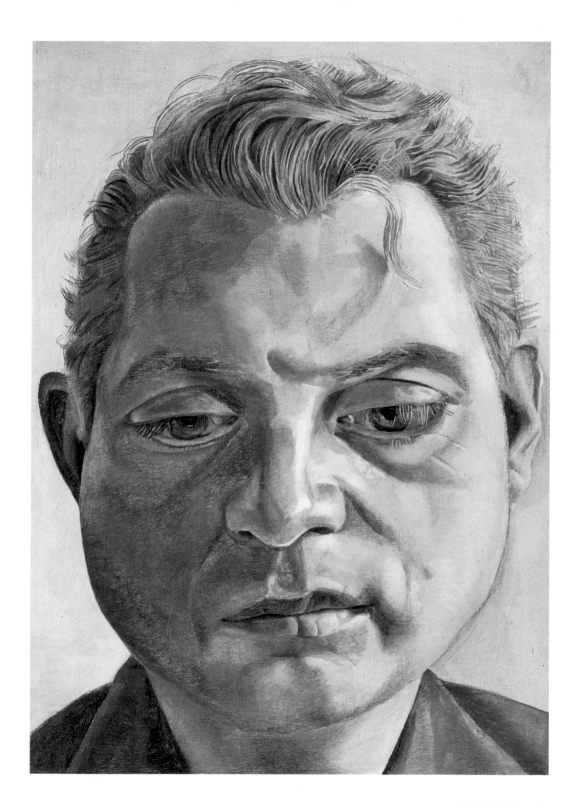

stolen from a gallery in Berlin while on loan from the Tate. Years later Freud speculated that it might have been stolen on the orders of a German Bacon collector, since Bacon was so highly regarded in Freud's mother country.

Lucian's working methods were notoriously slow, often involving sittings that lasted many months. In the 1940s and 50s, he was employing a painstaking, almost miniaturist technique with tiny brushstrokes. 'I worked with the painting [of Bacon] on my knees rather than standing at an easel, as I do now. I always take a long time to paint a picture, but I don't remember the Bacon portrait taking particularly long. Francis complained a lot about sitting – which he always did about everything – but not to me at all. I heard about it from people in the pub,' he told me much later. In any case, the result was a remarkable study in suppressed tension. Robert Hughes compared Bacon's face to a grenade a fraction of a second before it explodes.

During this period and through the 1960s and into the 70s, Bacon was the most important man in Freud's life, influencing how he lived and painted. The way Bacon used paint so freely and expressively to simulate emotion, tension or anxiety, was what Lucian required. He wanted his paintings to show how he felt. For many years they met most days. They were intensely close, Francis sending Lucian a frantic telegram in 1966, pleading loneliness and pledging undying friendship, so unlike his hard, iconoclastic art. Lucian kept that telegraphed message of coiled affection. But the friendship eventually splintered in jealousy and petty rows until by the end they never saw each other. The painter Tim Behrens remembered Francis Bacon in the Colony Room talking campily of Lucian's self-portraits: '"She doesn't put herself through the same third degree as her other sitters." Everyone laughed but at that minute Lucian walked into the room. Francis immediately was all polite and normal to Lucian who never heard what had been said'.[10]

'I think Lucian couldn't countenance the success that Francis was enjoying, particularly in France,' observed David Hockney. 'Bacon was also the first serious artist who dismissed abstraction as *l'art de mouchoir* [decorative marks on a handkerchief]. He also dismissed Jackson Pollock as a lace-maker. You have to remember

that in the 1960s abstraction was the biggest thing and some thought figurative art was over.'

Lucian had been remarkably fast out of the starting blocks in his teens and early twenties (the Museum of Modern Art in New York had bought a picture in the 1940s), but then there was a very long period when his paintings sold only to a small number of English people and he enjoyed almost no international recognition. In the early days of their relationship Freud was encouraged by Bacon and eventually he followed his more reckless, free-style approach, abandoning his Germanic tightness of line and fine surfaces. While he admired Bacon's ambition, he envied his global success. Bacon had had a Tate show as early as 1962, enjoyed an international reputation and was revered in Paris, which was incredibly important for artists of that generation. Bacon had a second show at the Tate in 1985, while Lucian had no exhibition there until 2002, and had just one major non-commercial show in 1974 at the upstairs rooms at London's Hayward Gallery in the less appealing South Bank art complex.

I saw Bacon as a route to Freud. I remember how some waggish curator had wittily put together a show called 'English Breakfast': the painters were Freud, (Augustus) Egg[11] and Bacon. As an undergraduate I was conscious that Freud remained for me the one that got away. He was a no-go area for all journalists, so it was no easy task to gain access to him. Although I never got a reply, I persisted – intermittently. Nothing was to happen for another two decades, except that my interest in him remained, and whenever a show opened, I went. Like Banquo, he was conspicuously absent. More letters, more silence. But I never lost hope.

A large art book on the English painter Stanley Spencer turned out to be the bait with which I finally lured Lucian to contact me. One morning in April 1997 the monograph arrived on my desk when I was the Literary Editor at the *Sunday Times* and I whimsically wondered if I could commission Lucian to write a review of it.

Leafing through the book, my instant reaction was that Spencer's nudes, with flesh exposed in unflattering ways, were not unlike Freud's. I wondered if they approached the depiction of the human body in a similar cold-eyed way: non-sentimental, with skin

and flesh as it actually is rather than portrayed in some idealised way. Would Freud explain for me his relationship with the naked body? Would he reveal a debt to Spencer? Would he even reply? One breakthrough was that I now at least knew where he lived, and sent a printed postcard embossed with 'From the Literary Editor', adding the number of my direct line.

I had discovered his address because my eldest brother Louis had moved into the ground-floor flat of a large Holland Park villa and had informed me that Freud worked on the top floor. He told the story of how Lucian had wandered into one of the other flats, and when asked his occupation, simply said that he was a painter. The neighbour then asked if he would consider decorating the kitchen. 'Not exactly that sort of painter,' was Lucian's amused reply. Louis would sometimes see Lucian scuttling up the black and white marble steps to enter the building either very late at night, or very early in the morning as Louis headed off to his job at Goldman Sachs. These glimpses of a ferret-thin figure, vigilant, purposeful and intriguing, were rare. Freud had only the briefest contact with his neighbours. He desired anonymity. The doorbells at the front of the house all had names except his, which just said 'Top Flat'.

Off went another of my postcards, but this time it was different. He called me. 'It's Lucian Freud on the phone for you, or someone who says it's him,' said my deputy Caroline Gascoigne. I thought she was joking.

What utterly threw me when I took the phone was his subtly inflected accent. It seemed straight from pre-war Berlin, educated, sophisticated, a slight burr but without any harshness. It was definitely very different from that of his brother Clement, the Liberal MP, broadcaster and participant on the BBC Radio 4 comic quiz game *Just a Minute*, whose slow, deep, sonorous voice – plummy, with a distinctive pronunciation of almost exaggeratedly correct English, and without a scintilla of German inflection – was so familiar to millions of listeners. Lucian was fast, direct and sparing with words. 'I got your card. I would like to see the book. But I have to tell you that Spencer's work is absolutely nothing like mine. It is the opposite. Anyone who thinks there is any similarity is simply not looking properly. But it might interest me to say that,' he said.

I sent the book. Ten days passed. Then: 'Hello, it's Lucian Freud here.' It came out as 'Looshan'. He said no to writing a review, but we chatted about his dismissive take on Spencer's sentimentality and inability to observe. No article, but at last a connection.

I tried various ploys to entice him to give me an interview, and by this stage I used to hear from others who knew him that he did see and read my letters, only there was nothing to say back in reply as he did not want to do anything with me. My only letter from him was the one in which he said that the thought of granting me an interview made him 'sick'.

In 2002, by which time I was editor of *Tatler* magazine, I again wrote to him again, saying very simply: 'I have a brilliant idea you will like. I can only explain it in person.' I was banking on his curiosity. The same voice: 'Lucian here.' It was hypnotic, more so than any other voice that I have ever heard. It had a rhythm, resonance and force that was so individual and alluring. No spare words.

'Do you want to come for breakfast?' was the sentence which changed our relationship. 'Come at 6.45 tomorrow morning to the studio,' he said. 'Perfect,' I replied, and he rang off. He never said goodbye. It was just not his style.

I was on time, rang the bell and when the door buzzed open I walked up four flights of stairs. Lucian was on the top landing looking out through his open door as I came up. He stood in his chef's trousers with a filthy torn sheet tucked round them like an apron, which from a distance looked blood-stained. There was no handshake, but there was a warm if cautious greeting, as a spider might make to a lowly fly about to enter his web. His voice was soft and his manner delicately courteous. He was staring intently. It was not rude or hostile but somehow powerful. He stood still for a moment and then darted in. He moved quickly, with athleticism.

Privacy among his piles of rags in his Aladdin's cave of paint was of paranoid importance, as was his drive to do only what he wanted. Lucian was obstinate. 'If anyone asked me to do something I just wanted to do the opposite and I usually did,' he said later. 'If I had been dropped off at a cinema by a driver I might easily get a taxi to another cinema just so that no one would know where I was.

I liked privacy,' he said. He once changed his telephone number four times in a year; not only was it, of course, ex-directory, but the bill was also sent to his solicitor. The flat was not even in his name; it was owned by his ex-girlfriend Jane Willoughby, who lent it to him – in effect, he did not officially exist. The Kensington and Chelsea electoral register would sometimes enquire if he was Lucan Freed, or L. Frode, and he did nothing to correct their miscued attempts to identify him. He never filled in a form, preferring privacy to the opportunity to vote. 'I suppose I would have voted Liberal Democrat if I had registered.' He was one of life's eels, always wriggling away from any and every grasp.

He was not materialistic and had no desire to keep any bric-a-brac. No photographs of any of his children were displayed in his flat. It was as if such casual photographs would have seemed inconsequential, even trivial compared to the images he created over months and years when members of his family sat for him.

Lucian always wore his scarf, either silk or light wool, in subdued greys or browns. He had at least a dozen in his wardrobe. The fashion designer Stella McCartney, a friend introduced by his daughter Bella, had taken one of his favourites when it had become too tatty and copied it exactly in her factory in Italy. She noted he had remarkable fashion sense without ever being fashionable. Long vanished were the fez and tartan trousers he had once affectedly worn in his twenties. He had an iconic look, in his grey cashmere overcoat and crumpled white shirt, scruffy-chic, breaking every sartorial rule, mixing aristocratic tweed with a shabby informality that redefined but also defied dandyism. Jerry Hall gave him cashmere jerseys when she sat for him, which he loathed. He was an odd mix of vanity with a touch of the vagrant. When he flew to New York to see a show of his work at the Metropolitan Museum of Art, in a private jet chartered by his art dealer William Acquavella, he packed just one shirt which he carried in a plastic bag. 'Nice jacket, where is it from?' he would habitually ask in Clarke's, always noticing what people wore. It was also a deflection, giving him an extra moment of observation. He was not predictable in what he liked, but never had what John Betjeman called 'Ghastly Good Taste'. He never followed patterns; the world inside his studio was bohemia's last blast.

In his seldom used drawing room
in Notting Hill, September 2009

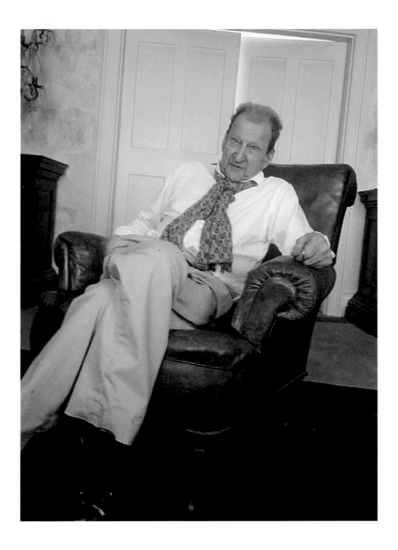

Finally, I had found myself in Freudland. It was all so familiar
from the paintings – bare floorboards, torn sheets piled up, rickety
kitchen chairs, a decadent sense of neglect. A partridge had been
cooked the night before, the remains lying in an old roasting tin
on the kitchen table, its cold carcass slightly congealed. A bottle of
burgundy was half finished. The gas stove was stained and much
used. We shared a breakfast of partridge wing, a glass of red wine
and some green tea in chipped cups.

I felt like a wannabe scriptwriter in Hollywood knowing
that I had only one chance to sell my idea. 'You do not want to be
interviewed, do you?' I ventured.

'No.'

'You do not want to be photographed, do you?'

'No.'

'Well, I have the perfect idea.'

He waited for my spiel. I suddenly felt my confidence drain away, fearful that the idea was a terrible one, a false start, even slightly daft. But it was all I had. My idea centred around his greatest friend, Frank Auerbach. 'You have had breakfast with Frank every few weeks for almost half a century. I am going to photograph Frank and want you to be in the picture. This is not about you, which you hate, it is about Frank, and you will just happen to be in the photograph because you are having breakfast with him.' Lucian did not pause. He just said OK. Breakfast with Lucian had produced another breakfast with Lucian. What he did not know was that I had not yet asked Auerbach. I finished my wine and left.

Frank had come into my consciousness back in 1978 at the small Freud show that I saw when I was seventeen. A portrait of his head was remarkable for its muscular sense of great intellect, framed with warmth and affection. It was another image that revolved in my mind, the dome of the head intensely close up. At the time I had known almost nothing about him, but when I was nineteen, I had written a letter to him and subsequently interviewed him, and we had kept in touch. Like Lucian he never gave out his telephone number, so we always wrote to each other.

I rushed off a postcard and asked Frank if he would be photographed with Lucian. Thankfully he agreed. A date was set to meet at seven o'clock in the morning at the Cock Tavern on East Poultry Avenue, Smithfield, a cross between a greasy spoon and a pub frequented mostly by butchers in the meat-packing district of London. I was trying to time publication to coincide with Lucian's retrospective exhibition at Tate Britain, which was to open the following month.

On a fresh Tuesday morning the two painters turned up, both in scarves and overcoats. Kidneys on toast with bacon and cups of tea were ordered. One or two traders in the street shouted out, 'Morning, Lou.' He was amongst some of his old friends from Paddington. The two men did what they almost never did in public.

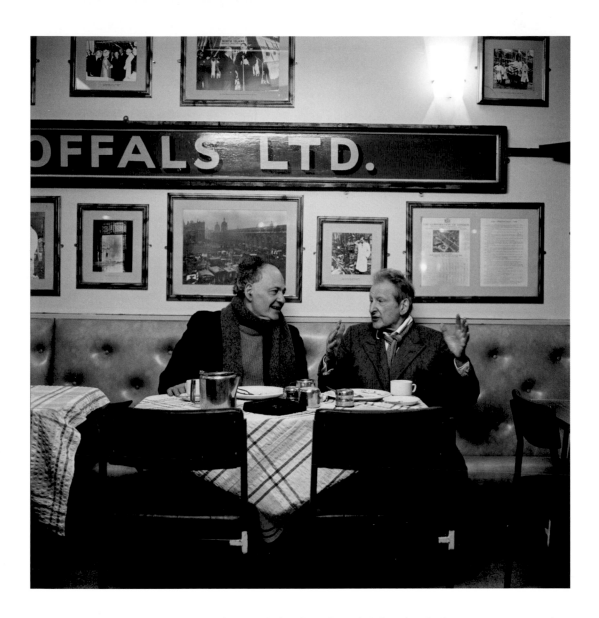

Frank Auerbach and Lucian at breakfast at the Cock Tavern, Smithfield, 2002

They smiled. They chatted. They laughed. A portrait was taken by the photographer Kevin Davies showing their friendship, and Lucian was happy for it to be published in *Tatler*, even supervising the design of the page layout, as I ferried proofs back and forth from my office in Mayfair to his studio.

Frank admired Lucian, and told me: 'I was interested in his work and, slightly against my will, impressed by its intensity because mine was a different idiom, and when one is young one tends to

think there is a particular virtue in one's own idiom. But as time has gone by … I think perhaps there is something that linked us through our common historical bond. Actually, our backgrounds were intertwined too. A cousin of mine was an assistant to his father, my aunt knew his parents.'[12]

Like Lucian, Frank had escaped from Hitler's Germany as a small boy, but his parents were unable to follow him and were murdered by the Nazis. 'During the war there were Red Cross letters which had just twenty-five words, so all you got was a very brief message, but then these letters ceased coming to me in 1943. It marked an end but I can't even remember someone saying your parents are no longer alive. It was just gradually leaked to me. I think I did this thing which psychiatrists for very good professional reasons frown on: I am in total denial. It's worked very well for me. To be quite honest I came to England and went to a marvellous school, and it truly was a happy time. There's just never been a point in my life where I felt I wished I had parents.'

He was often virtually penniless in his early days, spending almost all his money on paint. 'Until I was fifty I never had a bank account, always lived from hand to mouth. I used to lie awake at night wondering if I'd be able to go on with my paintings or whether the paint would run out.'[13]

After the breakfast in Smithfield, Lucian drove me back to Notting Hill in his Bentley, seeming to ignore every other car and all traffic lights. His conversation was warm, witty and incisive; his driving was insanely hazardous. I wondered if my first journey with him would also be my last.

*　*　*

A link to Lucian had been formed. He started to ring me, at all hours – 6 a.m., 2 a.m. – and we began to talk. Sometimes he seemed to have ages to chat, other times it was just five minutes. It led to him suggesting we meet again for breakfast, which invariably meant Clarke's.

He was never ever anything less than surprising to me and to others. He would quote the Northern poet Tony Harrison as well

as the verse of Bertolt Brecht. He liked the seventeenth-century poet the Earl of Rochester and his obscenities, particularly the quatrain 'Lines Written under Nelly's Picture':

> She was so exquisite a Whore
> That in the Belly of her Mother,
> She plac'd her cunt so right before,
> Her Father fucked them both together.

Rochester was very different from Lucian but they shared an exuberance and a disregard for what anyone else thought.

Freud also enjoyed Anne Somerset's historical books. A copy of *Unnatural Murder: Poison in the Court of James I* was in his Holland Park studio. So were Rudyard Kipling's *Kim*, Douglas Dunn's poems, short stories by Henry James and the letters of Flaubert. Often he would remember ephemeral or trivial lyrics or old dance tunes which he would share. A lifelong friend from the 1940s, the legendary *Sunday Times* Magazine editor and literary *éminence grise* Francis Wyndham, liked to reminisce with him. Lucian would recite to him the couplet 'I'm gonna change my tall dark thin gal for a short blonde fat/I'm even changing the number where I'm living at'.[14] Wyndham remembered how Lucian would recall deeply obscure anthology pieces learnt during his English schooldays, such as 'The Everlasting Percy', a parody by E. V. Knox of John Masefield's 'The Everlasting Mercy' which was, as Wyndham puts it, 'an inspirational verse narrative once celebrated but now equally forgotten'. He tailored his conversations for whoever he was talking to.

Poetry was an important stimulus, reinforcing his imagination, almost like a litany, a substitute for religion. He learnt it, declaimed it and was comforted by it. He told me how he used to invent little rhymes to distract his children from the boredom of sitting for him. His eldest daughter Annie remembers 'a shared sympathy felt for Yonghy-Bonghy-Bo's lonely life on the desolate coast of Coromandel in the Edward Lear poem, and our sense of dread for when Lewis Carroll's Snark turned out to be a Boojum'.

In essence Lucian used poetry as an extension or expression of the spirit of his own life. He savoured the truth of a line from

Rochester's 'A Ramble in St James's Park': 'there's something generous in mere lust'. Thomas Hardy's 'The Turnip-Hoer' was another favourite: a macabre story of obsessive love involving stalking and an uncontrollable, destructive passion. The verse he enjoyed was about likes, hates, idiosyncrasies, obsessions. The poems often encapsulated for him the significant as well as inconsequential point of life, from playful humour to dark sex and the finality of life, and the sheer delight in looking. Like his art, Lucian's armoury of poetry was about condensed, observed truth.

CHAPTER THREE Early Days

'I was born on the Feast of the Immaculate Conception,' Lucian told me with a hint of self-mockery. For an atheist with few concerns for the concept of sexual sin, the timing of his birthday was a delicious irony. It also contained an undercurrent that he wanted to exist outside the orbit and control of his parents, which was exactly what he engineered. 'I never knew anyone who wanted to deliberately cut themselves off from their parents to such a degree,' said one former girlfriend.[15]

His was an easy birth in the early hours of 8 December 1922 in Berlin, where his father Ernst was a modernist architect and the youngest son of Sigmund Freud, the most famous Jew in Europe. Lucian attributed a superstitious value to his birth date, gambling on the number eight or making bids in multiples of eight. Some friends noted that it was appropriate, and even preordained, that he died aged eighty-eight.

He was named after his mother Lucie (née Brasch), the daughter of a prosperous grain merchant, who doted excessively on him. 'She would ask me to draw for her friends, which almost made me never want to draw, and even worse she wanted me, aged four, to teach her to draw. It really made me feel sick,' he said.[16] It was the start of a complex mother–child relationship.

Lucian, the middle of the three sons, remained Lucie's favourite. Perhaps to create distance from her, at least in his mind, he sometimes claimed that he was named after the Russian-born psychoanalyst and author Lou Andreas-Salomé, who had been a

friend of his grandfather as well as of Nietzsche, Rilke and Wagner.[17] Her library had been confiscated by the Gestapo a few days before her death in February 1937, allegedly because of her friendship with Sigmund and because she practised 'Jewish science' and owned books by Jewish authors. Despite such a possible grandiloquent provenance to his name, though, within his family it was always assumed Lucian was named after his mother. His parents called him Lux (pronounced 'Lucks').

The few surviving possessions from his childhood included letters written in a German Gothic script to his parents, and juvenile matchstick drawings in crayon which Lucie preserved. His mother later explained to Lucian that Ernst had wanted to be an artist, but had not been allowed to fulfil his aspirations; Ernst felt a responsibility to be the breadwinner for the family, and saw architecture as a more dependable means of supporting them. Lucian inherited and kept watercolour landscapes of German lakes and mountains painted by his father. In her will, Lucie left Lucian the most valuable legacy with a low Chinese table, an Austrian chest of drawers and a square mahogany tray, valued at £550. Clement received his father's gold pocket watch and gold cuff studs, a sculptured head of Ernst by Oscar Nemon as well as a silver pill box kept on his father's bedside table, all valued at £230. Stephen was left a bronze mask of his mother, a barograph, nine Venetian six-sided glasses and a black and gold tray, valued at £350.[18]

Much of his early childhood was lived in a respectable quarter of Berlin near the Tiergarten, the magnificent park in the centre of the city. Lucian skated there, and competed with his two brothers at long-jump in their garden at home. Hanging on the walls, Lucian remembered prints of Bruegel's *Seasons* given to him by his grandfather, Hokusai prints, and Dürer's engraving of a hare.

Although he was proud of his lineage, he tried to escape his mother and come to terms with a degree of rejection by his father. Lucian told me of the hurt he felt at Ernst being dismissive of much of his work, but he also said elsewhere that 'my mother was so keen on my becoming an artist it was a good thing my father was against it. If they had both been in favour I'd have had to become a jockey, which was my other idea for a career.'[19]

A family portrait of the three brothers Clement, Stephen and Lucian *c.* 1927

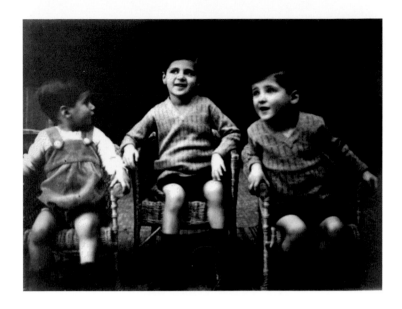

One of his first memories was of making a jointed wooden horse whose screws and bolts gave him 'a sense of the mechanical attachment of ligaments to bone'.[20] Another was of horses rearing in panic trying to escape a fire at the stables on his maternal grandfather's estate near Cottbus. He had learned to ride there, and horses remained strongly and figuratively significant to him. 'I feel a connection to horses, all animals, almost beyond humans. They have always been important,' he told me. He even slept with them in the stables when he first went to school in England. Horses also brought him luck – the sculpture *Three-legged Horse* became his entry ticket into art school. (Asked why it had only three legs, Lucian answered simply: 'I ran out of stone.') He rode and painted horses all his life.

In Berlin Lucian was surrounded by governesses, nannies, maids and a cook – but, as ever, it was his mother who made him feel trapped. Ann, his brother Stephen's second wife, said that 'Lucie seemed to want to know everything he did, what he was thinking, and this drove him mad.'[21] Lucian and Stephen, the two elder brothers, ganged up and teased Clement, the youngest. 'I felt sorry for Clement,' said Ann, 'as they made him go up to some Nazi soldiers in Berlin and ask if they had seen a monkey. Then he would hand them a mirror, which got him into trouble. The other two brothers found it terribly funny.'[22]

In many ways Berlin was a comfortable and secure place to be a child, but the Nazi presence was of course evident at this time, and some of Lucian's older school friends were in the Hitler Youth. Although too young himself to have been eligible to join, Lucian did, however, manage to see Adolf Hitler, as he explained to me:

LF: 'I photographed Hitler when I was nine. I was walking round Berlin with my governess and I happened to have my camera with me. I was fascinated by him because he had huge bodyguards and he was really very small. I backed along and snapped him.'

GG: 'Did you sense he was evil or feel vulnerable as a Jew?'

LF: 'Politics loomed over everything, even when I was nine. I was at an ordinary school in Berlin and some boys would say "Oh, we are going to the Nazi rally," and I would say, "Can I come?" and they would say, "No you can't, but you're not really missing anything. We sing songs." They made it sound innocent. I was allowed to invite those Nazi boys home.'

Everything changed in 1933. In January, Hitler became Chancellor, followed in February by the Reichstag fire and subsequent reprisals. To be kept unaware of the fire's damage, pupils of the Französisches Gymnasium, including the Freud boys, were sent to school by a different route. In March, Dachau, the first Nazi concentration camp, was completed.

Then in April, a member of the Mosse family, the Freuds' closest relatives in Berlin, died in horrific circumstances, possibly shot while having a cup of coffee on a terrace of a café on Kurfürstendamm on his routine weekly trip to Berlin. Rudolph died simply because he was a Jew. Another version of events is that he was driven to suicide 'by throwing himself before a lorry while being brought under escort to a concentration camp'.[23] His brother Carl was married to Lucie Freud's sister, Gerda. Their father Rudolf was the owner of a well-known Berlin publishing house. Volker Welter, the biographer of Ernst Freud, noted that 'Even before that, the Freud family experienced German anti-Semitism, when, for example, in the summer of 1932 Lucie Freud was verbally attacked by a neighbour when she played with her own and other children outside their holiday home on the

The three Freud
brothers, Clement,
Lucian and Stephen
c. 1932

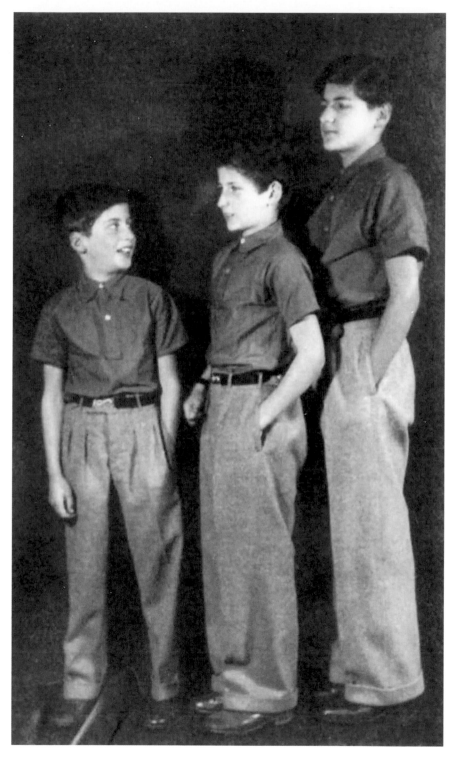

island of Hiddensee.' Lucian's cousin Carola Zentner recalls the fear and the intimidation. 'My uncle Rudy was arrested at five in the morning in his home and marched off minus braces, minus belt, minus shoelaces. The indications were very clear: you're not going to enjoy where you're going, and what then happened nobody really knows, other than he died.'[24]

Soon after the Mosse brother was killed in early April, Julius Streicher, the Nazi Party propagandist, organised a one-day boycott of all Jewish-owned businesses. In June, Lucian's father went to London to find schools for the boys, to whom he had given copies of *Alice in Wonderland* and *Black Beauty* as their introduction to Britain. Further Anglicisation would see 'Stefan' becoming 'Stephen' and 'Clemens' becoming 'Clement', but Lucian retained his original name. In September, when Lucian was still only ten years old, Lucie and the three brothers left Germany for ever. Two months later Ernst joined them after their furniture and other possessions had been packed and shipped. 'They wanted to murder us. Horrible as that was I am not sure I thought a lot about it as we just had to get on with our new life,' he said.

Sigmund stayed in Vienna until just after the *Anschluss* in 1938, when he made London his final home. His four sisters, all in their late seventies, stayed behind in one flat. 'All four ended their lives in extermination camps,' confirmed Anton Walter Freud, Sigmund's grandson by his eldest son, Jean-Martin, at a lecture given at Sigmund's Hampstead house at 20 Maresfield Gardens (now the Freud Museum).

Sigmund himself survived only a year in exile. Film footage exists of Lucian as a teenager fondly walking with his grandfather in the garden at Maresfield Gardens. He remembered how Sigmund would clack his false teeth together in his hands and how especially kind he was to the maids in their house.

Lucian's life is indelibly linked to his grandfather, of whose playfulness and encouragement he had happy memories. Just like Sigmund, it was Lucian's business to get people to sit on beds or couches, and to reveal more about themselves than perhaps they wished to show. According to Picasso's biographer John Richardson, who was also Lucian's confidant and subject, perhaps the most

important influence was Sigmund's biological study of animals, which had a far greater impact on his grandson than anything to do with Oedipal complexes or interpretations of dreams. 'Lucian was tremendously proud of his grandfather, not for having invented psychoanalysis but for having been an extremely distinguished zoologist. That is what he took from his grandfather, not the psychoanalysis at all. That is what he banged on to me about a lot, his grandfather as a zoologist,' said Richardson.

Lucian was proud that Sigmund was the first person to be able to tell the sexual difference between male and female eels, and other seemingly ambivalent or indeterminate species. 'Lucian's passion, absolute passion, for animals, even dead animals, like having a stuffed zebra head and dead chickens and things, all that came straight from Sigmund,' said Richardson.

The friendship between Lucian and John Richardson started in the late 1930s. He remembers Lucian being compared to E. M. Forster's description of the poet Cavafy: 'A gentleman standing at a slight right angle to the universe.' 'I was just seventeen and we met in the Café Royal and there was Lucian standing as thin and sharp-profiled as a cut-out, on one leg like a stork at the bar, which was still as it was in the days of Oscar Wilde, with all sort of Wildean figures hanging around muttering, "What did I tell you, Freud's grandson."'[25]

Sigmund was key to Lucian's liberty in England during the war. Lucian liked to tell it as a story of wonder and gratitude:

> It was very odd, like a very snobbish fairy tale. My grandfather had a great friend called Marie Bonaparte [Napoleon's great-niece] who married Prince George of Greece, the Duke of Kent's best friend. As the situation in Germany became more dangerous we applied for naturalisation but our applications were blocked and things got really dodgy. The Duke of Kent then got on the telephone and that same afternoon some people came round to see my parents and our papers were sorted. The Second World War broke out a week later. If we had not had our papers we would have been interned on the Isle of Wight.[26]

This intervention by the royal family was partly why, seventy years later, Lucian gave the Queen the portrait he had painted of her: it was repayment for his freedom. Sitting in Clarke's shortly after he had finished the painting, he was moved and amused at how he had repaid the debt to his adopted country, and how his grandfather's name had safeguarded him. He was fascinated by the Establishment, a very different attitude from that of his friend Francis Bacon who turned down every honour offered him. Lucian felt he was in debt to the Establishment and eventually he became part of it, often befriending grandees, but never would he suffer dullness. It was not because people were from aristocratic lineage that he liked them, but he certainly moved in high circles as well as low. Whereas Bacon was a descendant of the earls of Oxford but put no value in pedigree or lineage, Lucian was far from dismissive of such things. As John Richardson noted, of all the art schools in the country, Lucian happened to choose to attend one run by a baronet, Sir Cedric Morris.

Lucian's fondness for his grandfather was in bitter contrast to a rift with his two brothers, partly stirred by their outrageous claims concerning his legitimacy. Stephen and Clement suggested that Lucian was not Ernst's son, and so was not Sigmund's grandson. 'It was a really disgusting thing to say. Vile and very difficult to forgive,' he said. Whether this was a bad joke, or the brothers' belief, Lucian never forgot or forgave it. Aged eighty-seven, he was still complaining about this slur on his bloodline to Mark Fisch, a New York property developer and collector of Old Masters who in 2009 sat for two portraits. Having closely studied photos of Lucian and his grandfather at the Freud Museum, Fisch is convinced that the accusation was unfounded and untrue, but the slur was felt no less keenly. It was not so much the fact of being born out of wedlock that he minded – Lucian himself had at least a dozen children who were not 'legitimate', and having or being a child outside marriage was not an issue – it was the dishonesty of the slur and being excised from the family. It was about a blood link to the man with whom he had bonded closely, and who gave him his famous name and identity.

'His biological link to Sigmund mattered to him. It was key to his identity, where he had come from and also why and how he had survived in England. It hurt him more than seventy years later,'

said Fisch. 'He was incredibly sensitive, like an exposed nerve, much more than anyone would imagine. His self-portraits always showed him as he wished he was, or how he wanted the world to see him. What they do not show is a picture of somebody who has spent seven decades worrying that he was an illegitimate son. He was still harping on about it to the point that it no longer mattered if it was true or not, the accusation had become part of his psyche.'[27] The tension between the two brothers had early roots. A school report from Dartington noted 'Mr Allen commends Clemens for his keenness in games but adds that he still craves attention and special treatment. When he and Lux were playing on the same side in cricket, and Lux caught out Stephen, who was playing for the seniors against them, Clemens seemed to show real annoyance, his feelings for his older brother quite outweighing his feeling of fair play.'[28]

Not to be a Freud would undo much of what defined him, and Lucian found it difficult to forgive his brothers. Lucian did not mince his words when rowing with Stephen. In the late 1980s they fell out over money. Lucian always borrowed money to gamble, but in this particular case it was Lucian who had loaned money to Stephen. On 12 January 1987 Stephen tried in a letter to explain their financial arrangement and any misunderstanding between them: 'Herewith my cheque for £1,000. I am almost sure the loan was for less than that, so please let me have your cheque for the change. I find it disappointing that after spending twenty-plus hours in my company in the last year or so you are now able to believe that I am both a crook and an imbecile . . . I could say plenty more but as I cannot remember a single occasion in all the years we have known each other when you admitted that you had been wrong it would seem a little pointless.'

It resulted in a classic spite-bomb reply, sent on a postcard showing on the back Lucian's pen and ink drawing, *I Miss You*: Thanking him for the cheque he chastised him for not sending the right amount, bitterly blaming Stephen's selective amnesia. Lucian ended up saying Stephen was certainly a king-size wanker, colourfully adding that his pockets were stuffed with red herrings. It was followed by a two-page missive from Lucian saying that he

was beyond caring if Stephen paid back the money or not but that he would never lend him anything ever again.

Many years later, Lucian partly made up with Stephen, sending a girlfriend round to his house in Chiswick, West London, on Stephen's eightieth birthday to deliver a bottle of champagne and a handwritten card. At Lucian's memorial service, Stephen's wife Ann handed me the card, keen to assure me that the rift had been mended. Lucian had painted a portrait of Stephen in 1985, which he specifically included in his National Portrait Gallery exhibition.

He never forgave Clement, though, towards whom his bitterness endured. He later variously accused him of cheating in a race at sports day and of failing to honour a debt. Their trust never recovered, and nor did the friendship return. They did not exchange a word in forty years.

Lucian liked feuds, and he fell out with Francis Bacon, Stephen Spender and Graham Sutherland, amongst others. Once I took to the breakfast table a biography of the painter John Craxton, who had travelled to Greece with Lucian and lived on Poros. Craxton had sent him giant-sized elaborate intimate letters with drawings and doodles, using the family nickname 'Lux'. Lucian later accused him of stealing his ideas and copying his drawings. On seeing the book I had brought with me, he made a blistering assault: 'Is he still alive? Has he done anything for the last twenty years? Does he still paint? He was a liar and a cheat, an absolute cunt.' This is what his friend Francis Wyndham called his powers of 'eloquent vituperation'. It sometimes distressed Wyndham, but equally fascinated him as Lucian would 'mount an elaborate, imaginative case against the accused which might be arbitrary and unfair but which was pitched at such an extreme level of fastidious distaste that it fleetingly acquires a semblance of poetic truth'.[29] With enthusiastic fervour he explained his fraternal feud to me in the bluntest manner:

LF: 'I was never friendly with either of my brothers. I had
 illusions about Stephen. I thought he was incredibly dreary,
 pompous, timid, but more than all that I thought he was
 honest and then I had to give up that illusion. Clement, I
 always despised.'

GG: 'And the reason?'

LF: 'Well, it sounds rather pompous: because he was a liar and I minded it. If you liked someone you wouldn't have cared if they were a liar or not. He's dead now. Always was actually.'

GG: 'At breakfast on the day of his funeral I pointed out a photograph of Clement in the newspapers and asked you what you were thinking. You said how it reminded you what a cunt he was.'

LF: 'Well, he was.'

GG: 'Were you never close to your brothers?'

LF: 'No. Because of our middle names we were known as the Archangels. [Stephen's is Gabriel, Lucian's was Michael and Clement's was Raphael.] But no. I was treated differently from my brothers just by the fact that I went to Bryanston and they went to St Paul's. I don't know why but perhaps because I was known to like the countryside.'

GG: 'What was it like?'

LF: 'It was not a great learning process academically. I never really learned to speak English so I didn't really understand when the other children started talking to me and so I started fighting. I couldn't understand so I hit and you can't really make friends like that.'

GG: 'Who would you fight?'

LF: 'Hard to say, but "snobs" comes up in my head. I was not very conscious of being Jewish but I was very conscious of anti-Semitism. In Paddington, where I lived later, they would go on about "fucking Jews, bloody saucepans [cockney rhyming slang: saucepan lids = Yids]". I would say, "Now, none of that. I am a saucepan," and they would say, "No you are not; you are a gentleman."'

Even without such anti-Semitism, the pre-war years in Britain were not easy for Ernst. He moved his family in 1935 into a very narrow (15' 9") Victorian house in St John's Wood Terrace, North-West London, where Ernst used his architectural skills to try to make the house appear more spacious. He was a modernist, emphasising that 'the idea of the house centred round the hearth was gone'. He

wanted 'to break down the division between the house and out-of-doors'.[30] Lucian had an aversion to this sleek Germanic minimal and progressive sense of design. It was further reason for a lack of closeness with his father. 'Ernst was very hands-off with Lucian and far more demonstrative to Stephen,' said Annie. He affectionately called Stephen 'Gab', a reduction of his middle name. Ernst and Lucian shared a similarity in defying tradition in their different ways, only neither quite saw it like that. Also both held dogmatically to their contrasting views and tastes. There was a definite distance between the two of them which left Lucian with no obvious role model for a close and supportive father.

In around 1948 the family moved to 28 Clifton Hill in Maida Vale, West London, which Lucian helped decorate, showing a hint of showmanship with his display of a stuffed fish. Lucie wrote how Lucian had made a rare good impression on his father with his decorative elan. It was unusual enough for her to comment on it:

> Lux painted the entire house in oil with his own hands
> and those of friends. I have never heard Ernst being so
> enthusiastic about the work of anybody else as he was about
> Lux's colours and his architectural and other ideas. The
> bedroom, for example, seems to be painted in a strangely
> matt green (Lux used paint for slate tablets) and Ernst said
> the effect of the colour is that one's eyes want to fall closed
> as soon as one enters the room. Above the bathtub a stuffed
> fish is suspended in a glass box. One room, the conservatory,
> accommodates Lux's drawing table and otherwise only plants
> and birds.[31]

Lucian liked to talk about his early paintings, describing them as 'visually aggressive'. His technique was intense observation to create a sense of his subject's core. 'I would sit very close and stare. It could be uncomfortable for both of us [painter and sitter]. I was afraid that if I didn't pay very strict attention to every one of the things that attracted my eye the whole painting would fall apart. I was learning to see and I didn't want to be lazy about it. I sometimes looked so hard at a subject that they would undergo an involuntary magnification.'[32] On another occasion he spoke of how he 'hoped

that if I concentrate enough the intensity of scrutiny alone would force life into the pictures'.[33]

These early works were drawn with a steely precision and literalness. They sometimes seemed to embrace death more than life, with dead chickens and the corpse of a monkey (bought from a vet who also sold dead snakes by the foot). Lucian liked to cite from T. S. Eliot's play *The Family Reunion* as evidence of his desire to create tension and a drama of the unexpected.[34] One of Eliot's characters mentions a stuffed bulldog in Burlington Arcade designed to attract the attention of shoppers. Lucian liked to think it scared people before they realised it was not alive. It created confrontation or a contradiction of the expected. That startled pause, when the viewer is momentarily disconcerted yet deprived of enough information to produce a rational calm reaction, attracted him. He liked touching nerves, erasing complacency and confounding conformity. 'I don't like to repeat what I think I know about them. I would rather learn something new,' he said.

* * *

As soon as they had arrived in England the Freud boys had been sent to Dartington Hall, near Totnes in Devon, a progressive school with an emphasis on freedom of choice for its pupils. Lucian loathed his art teacher and avoided his classes, instead spending hours riding horses. However, he liked the quirkiness of Dartington, and delighted in telling me: 'It had only one single rule: you weren't allowed to push people into the swimming pool. I used to sleep with the horses in the stable as there was no rule forbidding this. I used to have quite an intimate life with them. The first person I liked was Rob Woods, the farmer, who ran the school farm. So I'd sleep with them in the stables with a blanket over me and the horse. I never went into school classes, I went straight to the school farm which was a quarter-mile walk.' Some of the boys complained of Lucian's smell due to his intimacy with the horses.[35]

His Dartington career was short-lived. 'My parents then wanted to take me away from Dartington, but Bryanston, where they wanted to send me, said they couldn't take me unless I had been

to a prep school. So I went to Dane Court for a year, which I liked. There was a sculptor who was Czech and I had a key to his shop in the basement and I spent all day every day sculpting. I thought if they didn't see me they wouldn't miss me so I sculpted instead of going to lessons.' He didn't do much painting or drawing 'because the painting teacher was so bad'.

He relied as much on his fists as his wits. 'I won the boxing cup at my prep school. I think the best three boxers were ill. Many years later I went to a sporting event and saw this man who was six foot four who'd been the one I'd beaten in the sports final.'

After one year at Bryanston in Dorset he was expelled after redirecting a pack of hounds into the school hall and up the stairs. He had just also dropped his trousers in a Bournemouth street as a dare. He lasted just one term at the Central School of Arts and Crafts, before moving to the East Anglian School of Painting and Drawing, run by Cedric Morris, the self-taught painter and horticulturalist, whose method was to complete a small detail of his pictures first rather than working simultaneously on the whole, a strategy which Lucian borrowed. 'I got a feeling of the excitement of painting, watching him work, because he worked in a very odd way as if he was unrolling from the top to the bottom, as if he was unrolling something which was actually there.'[36]

His portrait of Cedric Morris, painted in Dedham in Suffolk in 1940, shows his teacher with a pipe in his mouth, staring out beadily, one eye with a blackened iris. A red scarf is tied round his neck, a fashion that Lucian adopted. His portrait of Morris is direct but unsophisticated, a tightness of concentration and style yet to be achieved. Morris also painted a picture of Lucian which Lucian saw as 'rather quick, a bit soppy, hair made a bit much of'.[37] It was the perfect place: individualistic, inspiring and run by a free-thinker Lucian felt that he had been taught that portraiture could be 'revealing in a way that was almost improper'.[38] His parents were grateful to Morris and his companion Arthur Lett-Haines, although they worried about their son's endeavours. 'We are interested to hear that you are delighted with his progress. He may have told you but I could not help but loathe the last picture he brought to London but his style and his subjects will as I hope

change,' his father wrote to Morris.[39] It was another instance of why Lucian felt less close to his father.

Lucian had a new life and it was steeped in English verse and art, and also in English men of letters. What remained a unique hybrid was his accent. According to John Richardson, 'Lucian's voice, so much his own, was a slight work of art, carefully honed and worked on.' Lucian's distinct English accent by way of Berlin had a cultivated sound, 'very like Stephen Spender or Cyril Connolly talking in the 1940s', and, of course, they were his early models and mentors, as well as an intimate friend and love rival. 'It had a kind of clarity and precision of articulation which you only hear in a second language. It wasn't so much German as just a preciseness. It was spoken as though this was a language that had been taught, not just acquired,' said Neil MacGregor, who as director of the National Gallery later was to give Lucian twenty-four-hour access to the gallery.[40] Often security guards would see Lucian wandering around after midnight, accompanied by his dinner date or model, or alone with his easel.

What was emerging was a young man of extraordinary talent and personality who was resolutely focused. He was not going to be sidetracked, as his father had been, and he was to cut his mother out of his life ruthlessly. Lucian was brutally candid to me about his feelings towards her, and said he could not stand being near her. Her curiosity, he felt, invaded his privacy. Only when she was badly afflicted by depression, caused by the death of Lucian's father in 1970, could he tolerate being in the same room as her for any length of time. 'After years of avoidance there came a time that I could be with her, and I thought that I should do so. Doing her portrait [in the 1970s] allowed me to be with her. I suppose I felt I needed her to forgive me,' he said. The portraits of her as an elderly woman, *The Painter's Mother Resting I* and a more close-up version, *The Painter's Mother Resting II*, lying on a bed, staring apathetically out of the canvas, stuck in my memory from his d'Offay exhibition in 1978. Not all his family liked these pictures of her without make-up in a paisley dress. His cousin Carola Zentner explained how she felt he took advantage of his mother's decline.

The Painter's Mother Resting I,
1975–76

To some extent it was terribly morbid, what he was doing,
and I'm not sure that I respond emotionally to the idea of
painting somebody who is no longer the person they were.
He perhaps was after a kind of truth about her state of being
when in reality he was looking at a mask because she was
no longer portraying emotions. I mean she rarely smiled.
What he revealed was despair and grief and I who loved her
as a wonderful, vibrant, vivacious, bright individual hate
seeing this particular view of sort of semi-mortality, because

basically she was still alive physically but she wasn't really alive any longer mentally.

Lucie suffered a shocking decline after she attempted suicide. 'She took an overdose, was rushed to hospital and had her stomach pumped but there was some damage and the result was that she was a shadow of her former self,' said Zentner.[41] But actually, Freud's paintings go far beyond the biographical. He takes us through the vicissitudes of age. She is an archetypal old woman, her quietness, passivity and acceptance, arms up, hands on her pillow in surrender show her vulnerability, but we are never allowed to forget the intense experience of the sittings with the detail and fierceness of his gaze on senility.

The death of Lucian's father was a critical point for him both psychologically and professionally. 'Lucian got depressed and felt he could not paint people,' said his daughter Annie.[42] It was a bitter realisation that someone with whom he had not spent much time but who was a critical part of his life was gone. It was an end to knowing his own beginning. His mother remained, of course, but he still felt she was oppressive, even predatory towards him. Unable to paint people, Lucian instead chose as a subject a rubbish-strewn landscape, the view from his window. It became *Waste Ground with Houses, Paddington* (1970–2). While working on it he paid the dustmen not to remove the detritus in the abandoned garden which became the foreground of the picture. This showed grey skies over the back of terraced houses with orange chimney pots and grey London brick. It spoke of absence. He had been urged by his then girlfriend Jacquetta Eliot to try to paint the view, to jump-start himself out of that rare mood of despondency.

'When my father died she [Lucie] tried to kill herself. She had given up. I actually felt I could finally be with her because she lost interest in me,' Lucian said. 'I tried to be unavailable to her when I was young. She was very intelligent and highly observant. I felt oppressed by her because she was very instinctive and I've always been very secretive. It was hard to keep things from her. The idea of her knowing what I was doing or thinking bothered me a great deal. So it was a strained relationship.'

Her intrusion was often well-intentioned, but for Lucian it was still unwelcome. For instance, in the 1960s she wrote to him in panic from her house in Walberswick in Suffolk after she had been telephoned by the police who were pursuing Lucian for allegedly being involved in a hit-and-run accident on the Euston Road. She warned him that the police knew that he lived at 227 Gloucester Terrace in Paddington. She stalwartly defended him to the investigating officer who suggested that Lucian had acted badly. 'You may not know that an artist is not as well equipped for everyday life as you probably are and I am.' In her letter she tipped off Lucian that the police were threatening to circulate his description unless he gave himself up. She kept this episode secret from his father, partly out of kindness as Ernst was then having a rare break from his migraines and she did not want to kick-start another. 'Please go to the police and square things up. You probably could leave the country, but think how sad it would be for all who love you. And I for one would not feel ashamed of you even if you had to spend a month in prison. And what does it really matter if you will not be allowed to drive again? We never miss it.' However kind she was, she never fully accepted that Lucian wanted her to leave him alone.

Lucian always felt watched, and his predilection for escaping scrutiny and maintaining his obsessive privacy never left him. 'All the real pleasures were solitary. I hate being watched at work. I can't even read when others are about,' he later said.[43] He had started to try to restrict his mother's access to him as a teenager. When in hospital after an appendicitis scare, he wrote some poems in English and also drew a few of his fellow patients, but he was determined she should not see them. This was when some of his first notably arresting images were made, and it coincided with a startling awakening of his libido and imagination, as he told me over breakfast.

LF: 'I had very bad stomach ache and they didn't know if it was
 appendicitis or what, but I was in hospital for three or four
 weeks. I was sent to the country because it was wartime.
 The hospital was outside Cambridge and it was where I
 developed my passion for nurses. I thought I had never seen
 such marvellous girls and it had something to do with their

being nurses. I loved the conversation as they were making my bed: "Didn't die till five o'clock in the morning . . . kept me up all night, selfish bastard." I thought, my God, you are wonderful. I drew and did a lot of poems. I remember one: "When on a chalk-white bed you lie with loathing in your yellow eye swimming in sickly fat." I liked the nurses talking and sitting on my bed. That was very stimulating. I could hardly move but I did make a little book.'

GG: 'Did you write love poems?'

DAVID DAWSON: 'Wasn't there one about snails? Just two lines?'

LF: 'Something about fucking someone in a telephone box . . .'

GG: 'A good subject but not exactly spring blossom and other symbols of love.'

LF: 'Blossom! Oh yes I remember Blossom all right. I had her in a telephone box.'

GG: 'I give up! Did anyone see your poems?'

LF: 'I liked poems but didn't want them to be about that much in case my mother found them. I started hiding them to avoid the awful possibility of her saying "These are the poems of my son."'

GG: 'Were you her favourite?'

LF: 'I was the middle one of the three boys. I can't really tell but I was always very secretive in every way. Every word I said was a lie but I knew they were. My mother got me to give her drawing lessons from the age of four, which is going a bit far isn't it?'

GG: 'Were you affected by your father's failure to become an artist?'

LF: 'I was aware how aesthetically my father embarrassed my mother, but what I didn't know then was that my father had wanted to be an artist or had started to be an artist. When he met my mother – she came from sort of a grand family . . . well, rich, anyway – she was on a hospital visit during the First World War where my father was in hospital. I think that's how they met.'

GG: 'Did she prevent him from becoming an artist?'

LF: 'I wouldn't have thought that at all, but my grandfather,

who had six children, was naturally worried because that's not how to make a living. I know my father was absolutely horrible about my work very early on. I looked at my mother when he left the room in the hospital and she said not to take any notice as he had wanted to be an artist.'

GG: 'Did his criticism of your work hurt?'

LF: 'Yes, I thought "What a bastard," only because he never talked to me and he was always distant. Yes, I did mind and he was offensively rude about them. I did mind. My subject matter was always to do with my life, who I saw, who I was thinking about. I wouldn't consider painting someone unless I was interested in them.'

GG: 'Do you learn about them in the process?'

LF: 'Sometimes yes. If the picture works that's exactly what does happen.'

GG: 'But not about yourself? You were always very protective of information about yourself?'

LF: 'Yes, that's quite true: devious and secretive. I was described as that.'

GG: 'Was that accurate?'

LF: 'Yes. I'd have thought so. But you know you don't really think of yourself in that way.'

GG: 'Is it important to you what happens to your pictures?'

LF: 'If my pictures have a life then I am pleased. But from early on I was aware that I didn't want to think anything of mine that I didn't like was out and on the market, so I used to go to rather elaborate lengths to stop that and one was stealing them and destroying them. Another was setting light to the place where they were. I took a lot of trouble to get rid of them and I knew professional thieves and got them to steal things of mine.'

GG: 'Can you give me an example?'

LF: 'No. I would have to say places and names and shops and galleries but even those details were unknown. Rather deliberately people were afraid to deal with my things because they knew something funny was going on. Say, for instance, that I gave a picture to someone and then they

heard something of mine sold for a lot of money, they would put the other things of mine up for sale in an auction and I would have then stolen things like that. I wasn't ideal to deal with.'

GG: 'Was it upsetting when people sold things?'

LF: 'Yes, if I had given things and then they ended up in a horrible gallery surrounded by things I loathed. Yes, I did mind. I felt a cunt and also minded it looking treacherous.'

GG: 'Were you aware of the war?'

LF: 'I was very stimulated by it.'

GG: 'In what way? Did it seem frightening or exciting?'

LF: 'Glamorous.'

GG: 'And did you have family or friends in the war?'

LF: 'Well, my family came to England because my mother didn't like the Nazi Party getting stronger and the consequences of that.'

So smothered was he by his mother's claustrophobic affection and inquisitiveness that he felt an urge not to be controlled by or obliged to any woman, perhaps to recast his relationship with his mother in such a way that his was the controlling role in all relationships. He sidelined his father, although he would still ask him for money. The sweet relationship with his parents he had enjoyed when he was a child, with letters written in German full of affection, ended in his teenage days.

He had a sense of his own destiny, with a towering ambition to be an artist. He was reckless and absolute in his personal judgements, and from early on got away with the selfishness that he never abandoned. His steel core of ambition was matched by a magical ability to charm. Both were ruthlessly marshalled in his aim to compete with the greatest artists of all time, and to lead a life unrestrained by moral scruples.

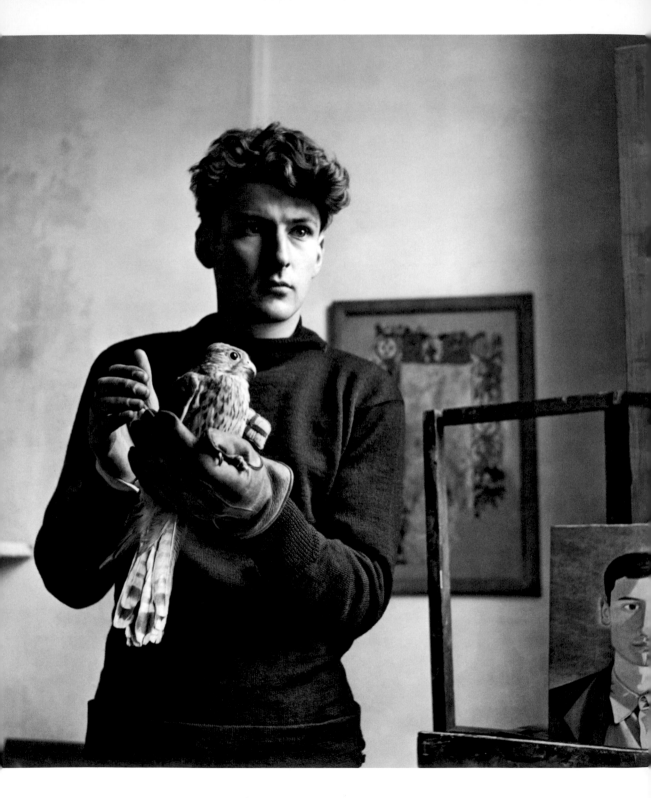

CHAPTER FOUR

First Loves

Lucian made an extraordinary impact as a young artist with his lithe, feral presence, sharp intellect and waspish wit. His reputation as a wild child who had burned down his art school preceded him, and it was instantly clear that he was in thrall to nobody. He was taken up by London's intellectual elite — middle-aged moths to his youthful flame. Part of his allure was being the grandson of the man who had changed the way sex and psychology were understood, but also as someone who had escaped almost certain death if he had remained in Hitler's Germany. Unlike Cyril Connolly, the cultural grandee of his generation who became obsessed by Lucian, and of whom so much had been expected but who had delivered so little, Lucian from his earliest years was set on achieving greatness. He was never idly to waste time. He had an obsessional work zeal which made him very distinctive from most promising youths who attract attention.

At the same time as the intelligentsia and certain aristocratic grandees wooed him, his life was driven by his libido as much as by artistic ambition. Very quickly women became a defining essence of Lucian's life. He was not to be deterred from what or who he wanted. 'He was never wired for fidelity or fear,' said Mark Fisch. Most women in his life were to some degree betrayed because he was never faithful, and he never seemed to feel a scintilla of guilt. His aversion to monogamy started in his teens at art school in Suffolk, and never left him.

The dates of his pictures document his infidelity, as lovers overlap. But during his lifetime Lucian's women were nearly all

Opposite: Lucian holding a kestrel in Delamere Terrace, by Clifford Coffin for *Vogue*, 1948

discreet, and did not complain at his two-timing of them or at his serial sexual opportunism. At times he was also complicated, even contrary, towards women. 'I didn't like girls being forward and there was a girl who when I was quite young was very friendly, she was called Diane Gollancz, [the publisher] Victor's daughter. I minded that she was forward with me. Having had no sisters it didn't seem right,' he told me (displaying the chivalrous attitude towards women that existed alongside his chauvinism). All his relationships were kept separate. The central planet was Lucian, like an energy-giving sun around whom the minor planets revolved.

There was a high expectation of secrecy and censorship. 'I cannot even tell you where his house is, no one is allowed to know,' John Richardson told me in the 1980s. But after his death, that silence, the extreme confidentiality that he insisted upon and which surrounded him, started to break down. Two very early girlfriends, both in their nineties, felt released from the unspoken code of silence that he had seemed to impose.

Felicity Hellaby was a seventeen-year-old art student with chocolate brown eyes, who features in one of his earliest full-scale portraits, *Girl on the Quay* in 1941. She was a year older than the boy-painter she first met in 1939. She remembers him standing out in rural Suffolk with his German accent, sharp tongue, piercing blue eyes and gamin looks.

'He was very, very funny, incredibly charming, and there was something about him that made me think, even then, that he was going to do extraordinary things,' she remembered at the age of ninety-one, recalling their time together at Cedric Morris's art school. Every day Felicity bicycled eight miles there from her parents' home in Dedham. As their romance developed, they painted each other's portraits.

In the portrait, Felicity is depicted almost as a cut-out figure, standing on a cobbled quay. A single-funnelled boat comically puffs out steam on the horizon, and another docked vessel has a gangplank leading to shore. Unsmiling, she stands tall in her yellow and green-striped T-shirt and short-sleeved brown cardigan. The painting suggests pinched, wartime Britain. The colours are autumnal, an early example of his muted palette. 'I sat for him on and off for quite

Girl on the Quay, 1941

a long time in the studio at the school; Lucian added the sea and boats afterwards. They were made up,' she said. Primitive in style, the picture shows little perspective or depth. There is a playful enjoyment in the painting of pebbles and the yellow and brown parts of the ship making it seems almost like a patchwork. Realism and fleshly reality have not yet been attempted, nor the mastery of concentrated observation which was key to his development. The artist seems in search of a style.

Felicity's father, Richard, was a New Zealand-born shipping merchant who had met her mother, Ruth, while they were in France on an art course. After studying at the Slade School of Fine Art, Ruth sold paintings to *Homes & Garden* magazine for their covers. With a comfortable private income Richard liked to ride and play polo, and in the late 1930s they moved to Dedham.

Felicity Hellaby, 1940

Cedric Morris established the East Anglian School of Painting and Drawing there in April 1937. The school was moulded by its charismatic, pipe-smoking teacher who lived in a farmhouse with his married but gay boyfriend, Arthur Lett-Haines, known as 'Let'. Felicity Hellaby remembers Morris excitedly telling his students that they were being joined by Sigmund Freud's teenage grandson, a wild boy who had never stayed long in any one school. 'He was small, scruffy-looking and not the sort that young girls would automatically have a crush on, but he was confident and incredibly focused on painting and drawing. It was all he did,' she said.

In July 1939 the school went up in flames, after which it was re-established at Benton End. Many of the students believed Lucian was responsible, careless with one of his cigarettes. 'I don't know if he did do it, but we sat on the side of the road afterwards all of us painting the ruins. The school burned right down. I can still see the timbers in flames and the glowing embers,' she said. The day after the blaze the *East Anglian Daily Times* published a photograph of all the students at the scene, including Lucian. 'We are shown going through the rubble trying to retrieve things, looking for our belongings. The saddest person was Cedric, who lost so many paintings,' she recalled. From the wreckage Felicity grabbed a picture of two ducks by Morris. Still in its charred frame, it hangs today in her home on the Isle of Sark. Lucian revelled in his role of suspected arsonist, enjoying the aura of being dangerous. He did admit responsibility for the fire to me, but some friends wondered if this was wishful thinking.

Felicity was very taken by Lucian and they kissed and canoodled in a hay barn near the school, but nothing more. Yet for seven decades she preserved his letters and postcards. Lucian gave her a drawing of sailors, which many years later she exchanged with the art dealer Anthony d'Offay for his pen and ink portrait of her from 1941. The affair was short, playful, and – unusually for Lucian – unconsummated. 'He would sometimes send saucy Victorian postcards of bathing belles and would draw on top of the images. Neither of us had a telephone so writing was the only way to arrange to meet up,' she said. A favourite gift from him was a scarlet military jacket with brass buttons. 'He wrote to me about

a zebra's head, a stuffed bird and a cactus that he had been given,' she remembered. These details indicate that he was already seeing other women because Lorna Wishart, the first woman with whom he seriously fell in love, had given him the zebra.

It was a refreshingly uninhibited time for the students at Cedric Morris's, according to Felicity. 'Everyone was homosexual or lesbian at the school, or so it seemed, except someone called David Carr and his girlfriend. I remember Lucian being very close to some other older people like Peter Watson [the margarine heir and arts patron] and Stephen Spender.'

Like Greta Garbo, whom he dated and admired, Lucian wanted to be alone, ruthlessly controlling who he saw and who saw him. 'She was the most famous person in the world at that stage. I used to take her out. She was very nice, apart from paying, which was then a help. I remember her saying, "I wish you were normal, I think you are very attractive," meaning something erotic, which I suppose she had not had with a young boy as I then was. I did not know what to say: "I AM on Thursdays!" was the kind of thing. I was very young. She was in her late thirties. The people in the clubs could not believe it. Cecil [Beaton] used to say "Come along Garbo, old bean, you will enjoy it when you get there," I never forgot it. The queer tarts in Soho clubs all used to dress as Garbo or Dietrich and here I was actually taking Garbo to the clubs where these young tarts dressed as Garbo were.'

Lucian was drawn towards bohemian, intellectual circles. Felicity remembers seeing him with Dylan Thomas at a pub in Soho ('a sad figure propping up the bar on his own, but quite friendly'). 'Lucian used to shift around. He used several flats, one being in Abercorn Place in St John's Wood which he shared with his painter friend John Craxton,' she said.

The war was a strange time for Lucian with his parents as immigrants, and his newly adopted country locked in combat with his former homeland. He avoided getting conscripted by turning up when requested in flamboyant clothes and painting his boots pink, or so he told Victor Chandler more than thirty years later. He was thus never called up, instead going to Liverpool in April 1941, signing on to the merchant ship SS *Baltrover*. The ship crossed to Nova

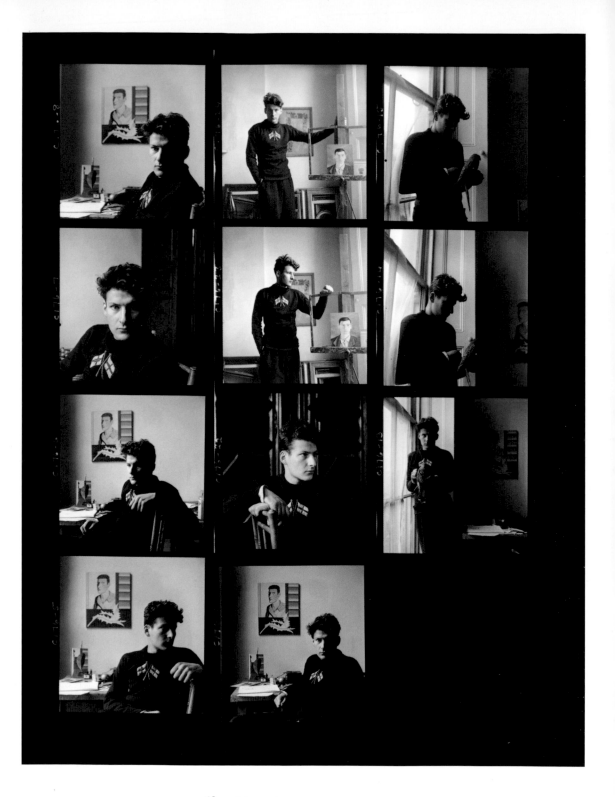

Opposite: Lucian in his studio in Delamere Terrace

Scotia on an uncomfortable journey in a North Atlantic convoy. He remembered the vessel behind him being hit. 'Two lifeboats got away and then the whole thing blew up. Bits of the ship and bits of people rained everywhere.'

After three months Lucian was invalided out of the merchant navy with tuberculosis, bringing back with him a pair of blue jeans, in Felicity's view probably putting him ahead of the biggest fashion revolution in Europe. 'No one had ever seen jeans before. He was the first person to wear jeans here,' she said. His time as a sailor was far from plain sailing, but according to his friend the Duke of Beaufort, it was where he learned to fend for himself. 'The worst thing on the trip was that he was then young and presumably rather nice-looking, that some of the older sailors on the boat took rather a fancy to him, and that's when he said he learnt how to defend himself.'[44]

Felicity joined the Wrens in 1943 and they never met again. 'It had been a very happy time. We were quite fast in some ways. I can remember double whiskies down at the pub, everyone smoking including Lucian and myself. Lucian was often rather catty, but also terribly sweet. He was great fun to be around, but had a reputation for quarrelling. We managed to avoid that happening,' she said.

At the same time as he was seeing Felicity Hellaby, Lucian was also involved with Bettina Shaw-Lawrence, another young art student who he met in 1939 at the Café Royal in Regent Street. She was a year older than him. 'My mother said she knew some nice boys that I'd like to meet, 'she told me. 'I had come back from studying in Paris and the war had just started when she took me there. There were about five boys from Bryanston including Lucian and someone called David Kentish.'[45]

Lucian was impressed that she had studied under Fernand Léger in Paris. Her father, Laurie, was a First World War Royal Flying Corps pilot with an MC for gallantry. Her mother was a commercial artist for *Vogue* and Selfridges. With her and Kentish, another art student who later became an actor, Lucian shared a sexual competitiveness.

Lucian liked Bettina's brazen confidence and sometimes liked to play fast and loose with the truth, downplaying his father's professional status by telling Bettina that Ernst was a toothpaste

Bettina Shaw-Lawrence, 1939

salesman. 'He could say anything and often did,' Bettina recalled. The unlikely threesome of Bettina, David and Lucian became close-knit, dubbed the 'infernal trio' at art school by Morris and Lett-Haines. It established his liking for complex relationships, playing people off against each other and grabbing what he wanted. Officially Bettina was David's girlfriend, but Lucian seduced her. 'He was exceptionally good-looking and had this slightly foreign accent which was rather attractive,' she said. The two boys ended up in a fist fight over Bettina. The spark was a blue jersey given by David to her but which was worn by Lucian. 'I said, "Give me my sweater," and Lucian said, "No, I am keeping it,"' recalled Bettina. David then stepped in, which resulted in a punch-up. 'David and I were then both thrown out of the school, somehow leaving Lucian triumphantly with the sweater and still a place.' It was even more bitter for Kentish, according to Bettina, as his father – a school governor and an admirer of Lucian's famous grandfather – subsidised Lucian's school fees at Bryanston.

Their friendship survived this fallout, and in late 1939 all three travelled to Capel Curig in North Wales, to escape the wartime bombing. They stayed somewhat tensely for some weeks in a small cottage. Kentish wrote to a friend that he was 'terrified of being alone with Lucian for any length of time'.[46] By seducing Bettina, Lucian had made him feel insecure. At art school Lucian and she had become secret lovers. 'Cheeky Lucian', as she called him, left notes under her pillow with instructions to meet for 'secret assignations' in the silo tower at Benton End. 'I may have been Lucian's first proper girlfriend. It was funny because after the jealousy over the sweater he could not bear to be left out. He put himself in the position where he was the outsider so that he could break in and be the winner. He was very alluring, sometimes reading me poetry, some in German. It is very possible that I was the first girlfriend because the boys had all just come to London from Bryanston. It was very brief and intense. If there was any other relationship it was with another boy, and that was one of the things, other affairs were going on as they do,' she said.

Stephen Spender joined them in this Welsh interlude, which took place in what his second wife Natasha Litvin called his

'homosexual phase' that ended, she would always firmly insist, with his marriage to her in 1941. In the period between his marriages to his first wife Inez Maria Pearn and then Natasha, Spender had considered becoming a teacher, a 'reserved' occupation which would exempt him from military service. With this in mind he had given occasional lessons at Bryanston and became friendly with the senior boys, including Lucian and David Kentish.

Spender's biographer John Sutherland suggested that his relationships with young men followed a pattern. 'There would be "interest", followed – after whatever relationship – with a benign campaign to promote the career of the youth. This is what happened with Tony Hyndman (unsuccessfully), with Reynolds Price (successfully), and his last great homosexual love, Bryan Obst (successfully).' In a sense his relationship with Lucian followed the same course.

According to Spender's son Matthew, from the time the older poet and the young painter met there was a sexual frisson between them. Stephen was clearly taken with Lucian – who he said 'looked like Harpo Marx' and was 'the most intelligent person I have met since I first knew Auden at Oxford'.[47] He was spectacularly 'backward' in a way that fascinated the narcissistic Spender. Before they fell out, Stephen was very helpful to Lucian, as he often was to gifted young men. For instance, he introduced him to Peter Watson, the wealthy connoisseur who funded the wartime magazine *Horizon*, and got him 'placed' in its pages. It was a notable career boost for the precocious seventeen-year-old artist, and became the launch pad for him artistically and intellectually. *Horizon* was edited by Cyril Connolly, and although it was a very amateur set-up, the running of it was executed with brilliant judgement. 'The essential feature of *Horizon* was dual control,' wrote Connolly, 'As Hardy, I emulated his [Watson's] despair; as Laurel, he financed my optimism.'[48]

Matthew Spender confirmed that 'Dad certainly fancied him [Lucian]. He was his physical type: curly hair, lithe, very insinuating and a brilliant talker. Lucian was very attracted to homosexuals and was very happy to cock-tease, if I can put it like that, because you have to deal with sadism when you are dealing with someone like Lucian – cruelty, as in wanting to make them suffer, if only to make

them look up and be more alert as they were lying there waiting for the painting to be finished.'

On whether Lucian and Spender had a physical relationship, Matthew said 'I have no idea. Some of my father's relationships with men were intense but not physical. You will have a fine time working out that part of Lucian's attitude towards sex. A lot of his paintings are pretty cruel. This business of getting underneath somebody's skin and being destructive with it is something you will have to pursue. It was never really clear what they were doing in Wales except that Lucian was drawing and Dad was writing. They shared a commonplace book in which Lucian drew and Dad wrote.'[49] Virginia Woolf gave her rather acidic view on the Freud–Spender axis and suggested that in the wake of his marriage, Spender had 'fallen into vice' again and that he was 'sentimentalising' with Lucian.[50]

Whatever happened, the month Lucian and Stephen spent together at the start of the war cemented a mutually beneficial friendship. Although the relationship eventually imploded, a high point came in 1957 when Lucian painted Stephen's portrait, witnessed by Matthew in the artist's studio. 'I sat through various sittings next to my dad. Lucian would ask quite probing, interesting questions of his sitters. He had this cunning ability to ask the most shrewd questions, and I can remember my father getting quite excited about the conversation. The painting took a long time to get going and then when a deadline for a show approached it was suddenly finished. Dad then wanted to buy it for £500, a huge sum at that time. You could buy a house for that. Luckily, Michael Astor stepped in and bought it on behalf of Dad. The idea was that Dad would eventually be left it by Michael,' he said.

Both the portrait and the commonplace book were to play a part in the ending of their friendship. After Michael Astor's death, the portrait was shown by his widow Judy to Lucian for him to authenticate, but Lucian instead abruptly accused Astor of having touched up the lower half of the picture and ruining it. Consequently he did not want to acknowledge it. Instead, he said he would buy it from Judy Astor, for a fraction of the price. 'At that time Lucian's reputation for being incredibly devious on the subject of his own work was well known, so no one took any notice. Lucian must have

known an old story of a painting by another artist which Michael had retouched. When Lucian accused Michael it was plausible but not true as Michael would never have altered Lucian's work. It was a sort of low blow,' suggested Matthew. In the end the picture was put up for sale, but it never went back to Stephen's ownership which had been the original intention of Astor stepping in to fund its purchase. The commonplace book also mysteriously disappeared, and Stephen was convinced it was stolen by Lucian after he visited him. The drawings were cut out and later sold by Lucian.

There is little documentation of the Freud–Spender relationship, but some letters of an intimate nature from Lucian to Stephen have survived, according to two sources close to Lucian. 'They include drawings and words and remain locked away. Stephen might have destroyed any further letters he was so angry with Lucian,' said one source. As to the surviving secret correspondence: 'they might be love letters but not of the sort saying "When can we meet again?" or "Longing to meet you"', said one person who had read them but wished to remain anonymous.

Through Lucian, Stephen came into contact with others in the Freud family, specifically Ernst. It was at times a friendship based on light-hearted playfulness as well as a serious appreciation of art and literature. For instance, Stephen and Lucian liked to play-act being 'two old Hebrews, Freud and Schuster [the maiden name of Spender's mother, who was half Jewish]'.[51]

In January 1942, at Lucian's instigation, Stephen — by then married to Natasha and working for the National Fire Service — took up residence at Sigmund's house at 20 Maresfield Gardens. Lucian used the largest room in their four-room upper-storey flat as a studio ('full of dead birds', Stephen later recalled). In Sutherland's compelling biography there is a photograph of Stephen and Lucian on the roof, along with Tony Hyndman (at this time working at *Horizon*, on Stephen's suggestion).

All that Natasha would later ever say about Lucian to Sutherland was that he was 'very complicated'. Lucian's attitude was particularly hostile, telling me he absolutely loathed her. In turn, Natasha had no contact with him at all during the twelve years that John Sutherland knew her. Lucian vehemently rejected any

suggestion by Natasha that since the notebook contained material by Stephen, the Spender estate had an interest in it. Natasha remained angry over the ownership of the portrait of Stephen by Lucian, now in the National Portrait Gallery, given that it had not been passed to the Spenders on Michael Astor's death.

The Spender–Freud friendship eventually petered out completely as Stephen in his final years avoided seeing Lucian at all costs. One of their disagreements stemmed from the disappearance of another of Lucian's pictures that Stephen owned. It had hung gathering dust in Spender's house for many years, and then after Lucian came to dinner one night it disappeared. 'It was later sold for a great deal of money,' said Matthew, who was sceptical of Lucian's default-position defence that whatever he said or did was defensible because he was always only being truthful. 'I can hear his disdain, of that feeling of being under the skin of Society, or in its thrall; him being in the clear while everyone else was common and conniving. That was his view. His scale of values was absolutely ruthless. He was longing to be independent of everyone and not tied down – all supposedly in the name of truth. But you can't treat people like that. You can't change rules halfway through.'

Back at art school after the Wales holiday, Bettina, David and Lucian attended morning life classes, for which Lucian also modelled. Bettina's drawing of a nervous-looking Lucian, near-naked and protective of his modesty, survives. 'He was so embarrassed by the whole thing that he refused to take off his underpants,' she said. Bettina remembered walking up the hill with him and meeting the local prostitute in her high heels on a man's bicycle in search of clients.

Lucian gave Bettina clothes vouchers, much sought-after because of wartime rationing. 'I bought a lovely summer dress and some sandals. I wore them to the Freuds' house where I stayed and ate tinned peaches. There was nobody there, his parents having gone away. There was nothing about it that wasn't lovely. We were not in love but we were lovers, briefly. There was nothing to be ashamed of. We had this lovely barn at Benton End where we used to make love and then watch the dogfights in the sky.'

Bettina's romance with Lucian was further complicated when

she fell for another boy, Nigel MacDonald, a teenager who had been taken in by Peter Watson. Nigel, Bettina and Lucian went on a trip to Scotland (funded by Watson) where Lucian produced one of his most memorable landscape drawings, *Loch Ness Drumnadrochit*, 'an obsessional pen and ink one', according to Bettina. It has a broad panorama in exquisite detail, but it was a cul-de-sac for his artistic development. 'I am staying at a really hot-stuff tip-top hop-scotch luxury dive for old dames,' he wrote to his friend Elsie Nicholson.[52] The trio were quite a spectacle in the Drumnadrochit Hotel. Bettina wore a Ross tartan kilt and a red Tyrolean hat with two feathers, her hair in pigtails; Lucian wore tartan trousers, which he told Bettina he had obtained at the Ritz bar in exchange for his own from a soldier of a Scottish regiment; and Nigel was also in a kilt. Lucian was experimenting with the two things which obsessed him and defined the rest of his life: painting and women. It was a preparation for the most blistering affair of his life, which left him totally burnt out.

Lorna Wishart photographed by Francis Goodman *c.* 1942

CHAPTER FIVE # Obsession

Lucian fell in love for the first time in his life with Lorna Wishart. She was dark-haired, eleven years older than him and from a family with a reputation for licentiousness. She was more than a match for him, and it was an affair that scarred him. 'I had never before fallen for someone – that is where a girl really meant something to me,' he recalled over breakfast at Clarke's almost seventy years after he met her. She was 'very, very wild, without any inhibitions or social conventions, and I got really caught up with her'.

In 1942 Lucian was nineteen years old, impecunious and seeking his way as an artist after a chequered education. She was thirty-one, married, rich, beautiful, sophisticated, adventurous, drove a Bentley, read T. S. Eliot and Rilke and, with a tolerant husband, was seemingly without moral restraint. He was bewitched by this siren with hypnotic eyes and he painted her twice, as *Woman with a Tulip* and *Woman with a Daffodil*, both finished in 1945. They are significant because with these paintings a sense of distress, discomfort and psychological unease was introduced into his work. He was on the threshold of his 'disturbing' or 'hallucinatory' period, which led Herbert Read, the critic and co-founder of the Institute of Contemporary Arts, to describe him as 'the Ingres of existentialism'. It was a compliment that Lucian enjoyed, Ingres being one of the painters he most admired. The two pictures are defiantly primitive and direct, but the intensity of his feelings for Lorna is startlingly captured. *Woman with a Daffodil* is a tiny picture, almost pinched in size, and it is severe, even odd, in its depiction of Lorna with her

Woman with a
Daffodil, 1945

brown slit-eyes looking askance at the flower lying on a blue surface. The palette is rather sickly apart from the yellow brightness of the cut flower. She looks slightly haggard and very different from the more flattering photographs that exist of her. More flattering is *Woman with a Tulip*, with her wider-eyed in an identical composition. 'We Garman girls all have these eyes,' Lorna's niece Anna said. 'They arrest people's attention. They are very large: "*Ils dévorent sa figure*," as a French woman said of mine. They seem to drive people (not only men) slightly dotty. I know this happened with Lorna.'[53] Lorna's presence in this painting is hauntingly intense.

Looking back in old age, Lucian saw his time with Lorna as consequential to his inner life, as well as his painting. 'I was more concerned with the subject than I had been before,' he said.[54] 'I was always wanting to move forward and not feel trapped by what I was doing. I would never consciously say here is a new style, but I was aware that what I was doing always needed to feel new to me.' In these early paintings his art seemed Germanic in origin, with critics pointing to the influence of Otto Dix or the painters of the Neue Sachlichkeit, such as Christian Schad. Lucian downplayed anything German; he was fast immersing himself in English life, and Lorna was a major staging post.

Born on 11 January 1911, the youngest of seven sisters, Lorna had two brothers who were equally fast and risqué. Her birth date, 11/1/11, was like a magic sequence to Lucian and she seemed to have powers of enchantment. 'Magical' was the word used over and over again by her contemporaries.[55] The Garmans were evocatively described by their astute biographer Cressida Connolly as 'licensed muses'. They were not part of the Bloomsbury set or the Bright Young Things; they were both in and outside of society, she argued, never easily definable, but very much rebels against middle-class morality; theirs was a crusade for art for art's sake.

The sisters blazed a trail through bohemia. Kathleen had three children by the sculptor Jacob Epstein; Mary wed the South African poet Roy Campbell and became the lover of Vita Sackville-West; Sylvia was a stick-thin lesbian who wore a pilot's cap and had possibly been T. E. Lawrence's only female lover; Helen was a resistance fighter in France during the Second World War and

Woman with a
Tulip, 1945

had been legendarily libidinous. The most beautiful was Lorna. According to her contemporaries, there was, a Hollywood glamour to this brown-eyed temptress who changed the lives of all who fell under her spell. The Garmans 'created a magic that could sometimes be destructive,' admitted her nephew Sebastian.[56]

Remarkably precocious, at sixteen Lorna had married Ernest Wishart, a rich twenty-five-year-old left-wing publisher, whom she had seduced in a hayrick when he came to stay with her family when she was just fourteen. He was a friend of her card-carrying Communist brother, Douglas, the party's education secretary. Ernest became her ticket out of Herefordshire and into wealth. He owned Lawrence & Wishart, the anti-fascist publisher (of which Douglas was a director) which printed the literature of the Communist Party.

Lorna's older husband was devoted to her but seemed to accept she would have affairs because she had married him so young. Lucian, however, was far from being her first lover. Five years earlier on 23 August 1937, she had spotted a young man standing alone with a violin on the beach at Gunwalloe on the Cornish coast and commanded him, 'Boy, come play for me.' It was the start of a shattering love affair with Laurie Lee, with whom she then had a child who lived with her and her ever-generous, exceedingly tolerant husband.

Lorna was truly exotic; she drank Guinness in the hairdresser's, painted landscapes by moonlight, and rode out at dead of night muffling the sound of her horse's hooves with cloth tied to their feet, so as not to wake people in the village. Her favourite horse was also given stout to drink. She gathered glow-worms and placed them in wine glasses covered with vine leaves to make lanterns. She dived naked into lakes, making others join her. She was a muse who defied definition: a cricket lover, voracious reader and a figure of ethereal beauty.

In some ways she was an unlikely temptress. Her father, Walter Garman, had been a devoutly Christian doctor, as had her grandfather. Walter had studied medicine in Edinburgh and Heidelberg and was a respected figure in Wednesbury, Staffordshire, remembered, amongst other things, for introducing flushing lavatories to the local area, which saved many people from cholera and typhoid. He rode to hounds, and lived at Oakeswell Hall, a

Jacobean country house, and stayed faithfully married to his wife, Marjorie, who bore him his nine children between 1898 and 1911. He had hoped that his daughters would marry into the clergy, but instead they were trouble. And that appealed to Lucian.

Her disregard for the conventional codes of behaviour entranced him. 'When Lorna discovered her powers a floodgate opened. She was wild; she was rampant,' said her daughter Yasmin many years later.[57] *Woman with a Tulip* shows Lorna's large almond eyes. Lucian became obsessed with her. 'In every way I was taken. It was very exciting,' he remembered. But she was no innocent and both of them would end up hurt. 'She was amoral really, but everyone forgave her because she was such a life-giver,' remembered her daughter Yasmin.[58]

Lucian first met Lorna in 1942 at Southwold in Suffolk, where his parents had a summer house not far from where the Wisharts took a wooden beach house each year. (It is the setting for the novel *Sea House* by his daughter Esther.) Even then he was impossible to ignore. 'People who met Freud in his teens recognised his force: fly, perceptive, lithe, with a hint of menace,' recalled the art critic Lawrence Gowing.[59]

David Carr, his 'accomplice' in the burning of the East Anglian School of Painting and Drawing and a fellow student, had also been a lover of Lorna's. He had taken Lucian on a visit to Suffolk for a few days. When Lorna started her affair with Lucian in 1943, she simply swapped one lover for another. John Craxton vividly recalled their affair:

> Lucian was a real star turn, very, very good-looking, witty, amusing, clever, fun to be with. He was neither English nor German; he found English very exotic. He was *déraciné*, he wasn't bound by conventions. He was very free. And so was she. Lorna was the most wonderful company, frightfully amusing and ravishingly good-looking: she could turn you to stone with a look. And she had deep qualities; she was not fluttery, she wasn't facile at all. She had a kind of mystery, a mystical inner quality. Any young man would have wanted her.[60]

Lucian Freud by John Deakin,
for *Vogue* (unpublished), 1952

During their affair, Lucian was renting a flat in Delamere Terrace in Paddington, very close to the Regent's Canal. It was 'north of the park', a phrase Lucian remembered, with its snobbish inference that anywhere north of Hyde Park was social Siberia. It was a poor, run-down neighbourhood but with beautiful Georgian houses. It suited Lucian. There was a mood to grab what happiness arose as the war cut short so many lives. 'Delamere was extreme and I was conscious of this. There was a sort of anarchic element of no one working for anyone,' he said.[61]

A fierce rivalry over Lorna arose between Laurie Lee and Lucian, which ended in violent recriminations and jealousy for both men. Lee described how Lorna always left an imprint, 'a dark one,

her panther tread, voice full of musky secrets, her limbs uncoiling on beds of moonlight'.[62] They were both ensnared and helpless. Lee loathed his younger rival, describing him as 'dark and decayed-looking'. He demonised Freud, writing in his diary: 'This mad unpleasant youth appeals to a sort of craving she has for corruption. She doesn't know how long it will last. She would like to be free of it but can't. Meanwhile she says she loves me. Oh, I can't express the absolute depths to which this has brought me . . . I pray she will get over it but I don't know. I don't know. She is tender enough towards me but devastating with her tender confessions. She goes to him when I long for her, and finds him in bed with a boyfriend. She is disgusted but she still goes to see him.'[63] This entry was shown to Lucian when it was published and he was 'tickled by it'. Valerie Grove, Lee's biographer, said 'clearly he liked to be seen as a louche young man and a true bohemian'.[64]

The passionate affair between Lucian and Lorna almost pushed Lee to thoughts of suicide. On 12 September 1943 he wrote: 'I took a razor blade to my throat. There was a dazzling burst of light, a sense of the good life calling. I put the razor down, put my head on my hands and sobbed as I have never done since I was a child.'[65]

The feud culminated in a fight in front of Lorna at a bus stop in Piccadilly. Lucian won the fight, but it was Lee who took Lorna home that night. She asked a passing soldier to separate the sparring lovers, but he took one look at her and said, 'I expect you're the trouble,' and walked on. Lorna later told a distraught Lee, as he sat on the bed with her, 'The trouble is he's falling for me. It isn't fair of me I know.'[66] Lucian had won her heart; Lee's six-year affair was over.

The end was painful for Lee, who was drip-fed mixed messages of hope and despair. Lorna seems to have enjoyed keeping both men in a state of uncertainty. Lee agonised at how she had changed and was now 'light-headed, detached and heartless'. He had dedicated his first book of poems *The Sun My Monument* to her, and never lost his infatuation for her, wearing her signet ring on his deathbed.

Lorna now went to stay with Lucian during the week at his flat in Delamere Terrace, and returned to Ernest at the weekends.

Lorna Wishart and Lucian
photographed by Francis
Goodman *c.* 1945

Her son Michael, who was born in 1928, a year after her marriage,
often accompanied her, sleeping on Lucian's floor. She fed Lucian's
imagination by buying him a stuffed zebra head from a taxidermist
in Piccadilly, which he then painted as a somewhat surreal object
with red and cream stripes in *The Painter's Room* (1944). The head
stares out from a window into a room where a top hat and red
towel have been abandoned on a brown carpet in front of a sofa
that appears to have only two legs. There is a sense of Magritte
migrating into this London room, but also a certain gimmickry.
Lorna bought the picture for £50 at Lucian's first one-man show at
the Lefevre Gallery in 1944. She also gave him a dead heron which he
made into one of his most extraordinary early paintings, *Dead Heron*
(1945). Here he showed a new confidence and sense of adventure and
experimentation. He used the stuffed zebra head again in *Quince on a
Blue Table* (1943–4), where the zebra's head pokes out from the wall, a
strange oddity in war-rationed London where almost nothing exotic
or even colourful seemed to exist.

Their affair ended as it had started, with infidelity — only this time on Lucian's part. Lorna discovered love letters in his studio and became hysterical. In his memoir *High Diver*, Michael Wishart described the woman who had stolen his mother's place, an actress Lucian spotted as she descended the stairs at the Gargoyle Club where he liked to take Lorna. (Michael loved this notorious nightclub. 'One night I saw Dylan Thomas measuring his cock with a pocket ruler, eagerly watched by some lady poetry lovers.') He wrote of the actress that she was 'as beautiful as it is possible to be . . . in an irresistible scarlet dress, her blonde tresses flying'. He did not name her. Even in 1977, more than thirty years later, Lucian was fanatically protective of any knowledge of this affair becoming public. He hated Michael Wishart's book, furiously dismissing it as fiction. In his last years, though, he confirmed that the woman in the scarlet dress was Pauline Tennant, one of the most glamorous actresses of her generation. Born in 1927, she was five years younger than him, and knew him through her father David Tennant, who owned the Gargoyle.

The death knell was when Lorna telephoned Lucian's studio. At the end of the call he failed to put the phone down properly and she heard Pauline ask him who had called. 'It's nobody,' he said. On hearing that, Lorna abruptly ended the affair. Lucian was beside himself and determined to win her back, heading down to Sussex where he stayed with his friend and patron Peter Watson. From there Lucian went to Binsted, the village where Lorna lived, with a gun. He threatened to shoot her or himself if she would not return to him. He stood among the cabbages in the kitchen garden and fired the gun into the air. Later he rode a large white horse bareback into the field above the lawn and, like a 1930s Hollywood matinee idol, made the horse rear up in front of the house where she could see him. It was dramatic, but too late. Lorna was hurt by Lucian's behaviour but, ever the game Garman girl, she had the perfect last word. 'I thought I'd given you up for Lent, but I'm giving you up for good.'

Shortly afterwards Pauline Tennant, aged just nineteen, married the anthropologist Julian Pitt-Rivers, cutting short her acting career when he became purser to the king of Iraq. Her most

noted performance was as the young countess in the 1949 film *The Queen of Spades*. The newlyweds briefly shocked Baghdad when they went to a fancy-dress party as Oscar Wilde and his lover Lord Alfred Douglas. Their marriage ended in 1953. Lucian later admitted that he regretted his dalliance with her – 'she was too actressy' – because it had brought an end to his relationship with Lorna.

All three in the original love triangle had their infidelity rebound badly on them. 'Make me not want you so much I can't get any peace always thinking about you so much – I want to be able to live in peace again,' wrote Laurie Lee, who had thoughts of killing her as well as himself. Lorna had stained both lovers' lives. 'Lucian was genuinely in love with her, but she never went back to him,' remembered John Craxton. 'He said to me, "I'm never, ever going to love a woman more than she loves me," and I don't think he ever did again. He never really forgot her. He wrote letters saying, "I still love Lornie and miss her." She was a muse, a true muse in the best possible way.'[67]

Years later Lorna met Pauline and showed no anger or resentment. They talked about who had written on the wall underneath the raised bed in Delamere Terrace some lines from Shakespeare about being powerless and enslaved to those you love. Lorna admitted to having done it. When Pauline asked Lorna why she was being so nice, Lorna replied: 'Because you saved me from a terrible obsession.'

And she had. Lucian seemed to be unable to commit to any woman. He loved women, but never enough to stay solely with just one. The present was all-consuming, so that whoever he was with or whatever he was painting at that time, was all that mattered. But although he lived in the present, he never took on the responsibility of relating the present to the future.

He insisted that no one question or know what he did, and never regretted his selfishness. 'I have never wanted to share where I was or what I was doing with anyone,' he said. One jilted lover said, 'He had already sped off, left the scene when everyone was still talking about what he had done. He was on to the next thing. He never stayed to see the fallout, or dodged it if he could.'

Some theorised that he was scarred by the family's escape

from an oppressive and frightening regime. Both he and his fellow émigré Frank Auerbach chose resolutely always to face forwards and never looked back to their escape from the Holocaust. ('Of course I am in denial,' admitted Auerbach readily.) Lucian too had to deal with the legacy of avoiding extinction mainly owing to his grandfather's genius and fame. The sense of being an enforced outsider, an alien where Jewishness was sufficient to warrant a death sentence in Germany made him feel fundamentally different from most people he met in his adopted country. It reinforced his desire to be part of England, but also to remain separate while generally hostile to most things German. A further explanation for the selfishness that imbued many areas of his peculiar way of life is that he simply needed to escape his claustrophobically curious mother. Whatever the psychological cause, he continued to be obsessed by independence and privacy.

CHAPTER SIX # Lorna's Legacy

So much in Lucian's life stemmed from his relationship with the bewitching Lorna Wishart. It triggered a pattern of overlapping affairs which repeated itself throughout his life. Like a farce, lovers, sitters, strangers and his own children went through an ever-revolving set of doors, often unaware of each other but with damaging repercussions when they did. He was the only person who knew the full cast of characters who sped in and out of his studio or bedroom. When the plot thickened too much, a little knowledge amongst them proved a dangerous thing, causing rivalries, jealousy, competition and violent rows.

Shortly after the split with Lorna, he started an affair with her niece, Kitty Garman. They were introduced by Lorna in 1946, and married two years later. Kitty was the illegitimate daughter of Lorna's sister, Kathleen, and Jacob Epstein, the American-born sculptor. Kathleen had been Epstein's lover since 1921 and was the mother of three of his children. Epstein's wife, Margaret, tolerated most of his infidelities but erupted in anger and jealousy over Kathleen, shooting her in the shoulder with a mother-of-pearl-handled pistol in 1923. The incident occurred after she had encouraged Epstein into multiple affairs in the hope he would tire of Kathleen and return to her. In 1955, eight years after Margaret's death in 1947, Kathleen became Lady Epstein and his sole beneficiary, finally removing her from penury.

Kitty was born Kathleen Eleonora Garman on 27 August 1926. Hers was a chaotic, unsettling childhood. Rather than sharing her mother's primitive Bloomsbury studio, she was sent to live with her

maternal grandmother Margaret in Hertfordshire, and later in South Harting, Sussex. Margaret and her companion, the former governess Toni Thomas, instilled a lifelong love of books and nature, while Kitty's older aunts Lorna and Ruth became her mentors.[68] In the 1940s she studied painting at the Central School of Arts and Crafts in London, which Lucian had also attended, but she temporarily abandoned her artistic ambitions when she met him.

Up until then, Lucian had been known principally for his drawings, and he wanted to alter this perception. 'People thought and said and wrote that I was a very good draughtsman but my paintings were linear and defined by my drawing,' he noted later. '[They said] you could tell what a good draughtsman I was from my painting. I've never been that affected by writing, but I thought if that's at all true, I must stop.' As a consequence, he claimed he largely set aside the habit of drawing.[69]

Kitty appears in *Girl with a Fig Leaf*, *Girl in a Dark Jacket* and *Girl with a Kitten*, all executed in 1947. She is also the subject of *Girl with Roses* (1947–8) and *Girl with a White Dog* (1951–2). In the last picture Kitty sits with a white bull terrier resting on her leg, a dressing gown slipping from her shoulders to reveal her right breast. This is a significant picture as it marks a change in style, so different from the naive, flat depictions of Lorna. This is the beginning of Freud as a painter of naked portraits, even though Kitty is mostly clothed, and it is a move into realism. Kitty's breast is notable because it is so convincingly depicted, making the viewer feel we have intruded into a very private space. She seems tranquil and content, her wedding ring visible, as is her birthmark on her right hand. It was something she had once been very embarrassed about, but she later grew to appreciate it as a mark of her identity. This is a portrait of a grown-up woman and not the startled ingénue for whom Lucian had fallen. There is no amelioration of any of her features, her face has widened and wrinkles are beginning to emerge, while on her naked breast a dark mole is defiantly shown. There is a ripeness to this picture of the mother of his two children as if he is at last starting to understand how to depict the beauty and sensuality of a woman. The loose curl on her forehead makes her appearance seem informally realistic as the dog happily rests its head on her leg. It is also significant as Lucian's first

Girl with a Kitten, 1947

picture of a dog with a human, a leitmotif that was to punctuate his work right up until his final painting.

Lucian was showing considerable promise as a portraitist in his paintings of Kitty, after abandoning the lurking element of caricature in his pictures of Lorna. He was also developing an entertaining surrealist's vocabulary, creating his own style, and was starting to gain access to the top levels of the artistic and social worlds. Because he was attractive and charismatic, wherever he went someone else wanted to know him. He played on his charm and looks, but it was far more his talent that seemed somehow magical. Spender, Cyril Connolly and Lady Rothermere were just some of the many powerful characters in the cultural elite who pursued him. At the same time,

Lucian kept his connections to the lower, more criminal strata of society. In the high–low life he liked, one element made sense of the other for the alien Briton who liked to escape definition. The attention he attracted, though, was not always favourable. The journalist Quentin Crewe described him at this time as 'a nervous man whose eyes dart around like fleas in a snuffbox'.[70]

Lucian and Kitty lived mainly in Maida Vale, where they saw much of Cyril Connolly and Francis Bacon, and the complexity of his private life continued to be extraordinary. In 1948, the year that he married Kitty and also when his first child Annie was born, he met Anne Dunn, the daughter of the Canadian industrialist and financier Sir James Dunn. She was a stunning, charismatic eighteen-year-old artist with whom he would have an intermittent affair for the next twenty-five years. One time in Lucian's studio, Anne was struck by some pictures she saw stacked up there, painted by Lorna's son, Michael. Two years after Lucian started an affair with Anne, she married Michael, and Michael then confessed to Anne that he had had a brief sexual relationship with Lucian. To complete the circle, Kitty later revealed to her daughter Annie that she had had an affair with her aunt Lorna's former lover and rival to Lucian: Laurie Lee. (And in 1950, Lee married Lorna's niece Catherine Polge, the daughter of Helen Garman.).

Of Lucian, Anne Dunn said, 'He was completely unstoppable. He would go for anyone and anything.' But she never had regrets. 'He was so alive. He was like life itself, pulsating with energy. It was what I had always sought and never found again.'[71] When I asked Lucian what he did in this period when not painting, he said with wry understatement, 'Well, there were girls.'

For Anne, the introduction to him started, as it did so often in those days, with a dance. She was picked up by him at the Antilles, another Soho nightclub, when he approached her to join him on the dance floor. 'He was a wild mover, suddenly sinking to his knees, leaving you not knowing where to turn,' she recalled, laughingly, more than sixty years after they first met. Anne herself, who lived with her mother in Belgravia, was then engaged 'almost by accident to Jasper Sayer. I was so surprised to be asked that I said yes and then had great difficulty extracting myself.'[72] Jasper's sister, Honor,

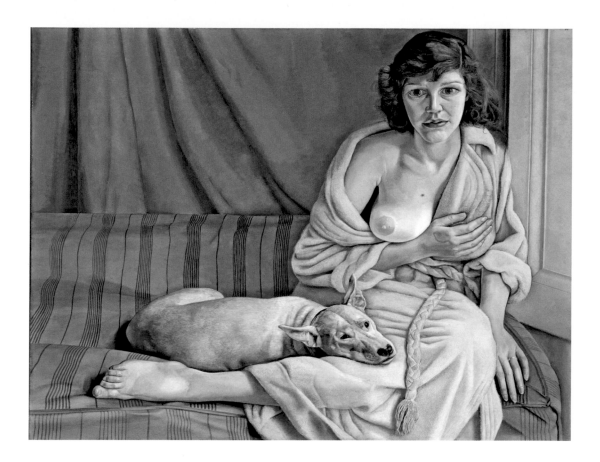

Girl with a White Dog, 1950-51

had been the first to mention a painter called Lucian, planting the first seed of interest. 'I had been aware of him in the Gargoyle Club, watching his manoeuvres, and had heard about this tiger woman he was involved with, called Lorna.'

'Let's meet tomorrow at the Café Royal,' Lucian said to her in the Antilles. After lunch the next day they went straight to Delamere Terrace and consummated the affair.

The extent of Lucian's desire for privacy soon became apparent. 'I had no idea Kitty was his wife when I met him, nor did I know Lucian was a father, until one night we were having dinner and someone came up and asked him how the baby was. I was absolutely astonished. "What baby?" I thought.'

The affair appalled Anne's mother, who did not think this tartan-trousered, married artist from Germany (the war had ended only three years before) was remotely suitable for her very eligible

teenage daughter. 'He would come round occasionally and my mother would say "Get that rat out of here,"' recalled Anne. There were also harrumphings at White's, the gentlemen's club in St James's. 'My stepfather Morrow Brown heard in White's about my affair and said he really couldn't go there any more because of my terrible reputation,' she said. Lucian did not care. Guilt was not an emotion which affected or restrained him. (More than fifty years later he would occasionally have lunch at White's with the Queen's private secretary, Robert Fellowes, brother-in-law to Diana, Princes of Wales, who helped negotiate for the Queen to sit for him. Lucian was the only man never to wear a tie there, and no one challenged him for ignoring the club's strict sartorial rules.)

Despite the feelings of her family, Anne was besotted and invited Lucian to stay with her in Ireland, which resulted in his portrait of her *Interior Scene* (1950). (Anne believes the picture has been wrongly dated and was painted in 1948 or 1949.) It suggests a hidden identity, as a half-revealed face peers out from between dark curtains while a thorny branch of a blackberry bush looms in the foreground, more prominent than Anne's blue eyes.

The Irish visit, however, was overshadowed by her horrific rape, which Lucian was never told about. When he arrived at Galway station, Anne, who had come to meet him, somehow ended up missing him. 'I thought he hadn't come and I was heartbroken. He had actually been so swift, typically of Lucian, that he had managed to get a taxi to the Zetland Arms in Roundstone near where we were living in Cashel Bay, Connemara, before I saw him. I got drunk in Galway station and was raped by a porter. I was devastated. Only the next day did I manage to get to Cashel Bay. I spent the night on a bench, drunk because I had been so disappointed. I never told Lucian about the porter. I don't think he would have been sympathetic at all. Discretion was needed at that time,' she said.

Once they did meet up they stayed almost a month together, paying for a hotel room with some money Lucian had once again been lent by his ever-generous benefactor Peter Watson (painted by Lucian in 1941), who always had an eye for beautiful young men. 'He told Peter he needed money for paint,' said Anne. They headed to Dublin where they met Helena Hughes, wife of a prominent Irish

actor, to whom Lucian was instantly attracted. 'It was a fraught time. We also met a dealer called Deirdre McDonagh, who had been interested in Lucian's work, and I took mine. She said about mine, "Oh you have improved, Lucian." He was so angry.' Her work had been mistaken for his, and Lucian never liked rivals.

Lucian's obvious attraction to Helena Hughes was the first realisation for Anne — even though she was his lover and Lucian was married — that she was far from immune to his infidelities. 'It was terrifying. You couldn't take your eye off him for a second,' she said. (To muddy the waters further, Helena had been the first girlfriend of Michael Wishart and had stayed with Lorna at Marsh Farm, at Binsted. Later, in 1951, Lucian had an affair with her and painted her.)

Anne was out of her depth and became even more so when she fell pregnant. 'I was curiously innocent about the facts of life. My mother had never instructed me, and so I got pregnant very easily. Any form of birth control Lucian considered "terribly squalid". And he wasn't very helpful when I had to do something. A friend called Derek Jackson provided £100 because my mother refused and Lucian naturally couldn't. It was done in Harley Street. I was eighteen. Lucian really didn't want to know about it but, mind you, I didn't really want to talk about it much. Really, it was: "You get on with it."'

The complicated connections within Lucian's world continued in another mind-boggling merry-go-round of liaisons with him at the centre. Anne's friend Derek Jackson was a leading physicist who had inherited co-ownership of the *News of the World*. He was married to a beautiful, talented painter called Janetta Woolley. Janetta had a very brief dalliance with Lucian, as well as a long affair with Cyril Connolly, who in turn fell for Lucian's second wife, Caroline Blackwood (whom Lucian married in 1953). Janetta later had an affair with the Duke of Devonshire, a great patron of Lucian's (he painted six members of the Devonshire family), while Lucian intimated to friends that he had had an affair with the duke's wife Deborah 'Debo' Mitford, whose sister Pamela had been Derek Jackson's wife before his marriage to Janetta. Forty years after Janetta's brief affair with Lucian, her daughter Rose had an affair with him and sat for him.

In 2008, Debo gave a fond recollection of her old friend Lucian. 'Very attractive, an original. As well as his prodigious talent, he is

delightful company, can be very funny, always unexpected. He was a will o' the wisp, appearing and disappearing in a disconcerting way, day and night were the same to him. Scathingly critical of those he does not like, he is a real friend to his loved ones. Admittedly he does discard them sometimes, but Andrew [her husband] and I were lucky in that we remained friends for more than fifty years.'[73]

After her abortion Anne lived in Ireland for several months on her own to try to establish some sense of separation, but Lucian returned for her nineteenth birthday. On the day he was supposed to arrive she was informed a man was waiting for her downstairs but was appalled to see another friend, Philip Toynbee, with whom she had earlier had an affair, and quickly sent him away. A little later she was called again but this time it was Cyril Connolly. 'I said, "This is terrible, Lucian is coming. You must go." Cyril wanted an affair with me but I was not interested.' Lucian eventually appeared about four days later.

By now, according to Anne, his wife Kitty had realised that she had essentially lost him and had started an affair with the novelist Henry Green. Anne remained drawn to Lucian, and moved back to London to a flat near to him, in Alma Square in St John's Wood. Then she got to know Lorna's son Michael and decided that if she couldn't have Lucian permanently, Michael was the next best thing. The fact that Michael was gay didn't deter her.

Anne revealed a more Machiavellian agenda. 'When my affair with Lucian was collapsing, I saw paintings in his studio by Michael. I asked Francis Bacon to introduce me, which he did in the Colony Room. I thought my best revenge when Lucian was off with someone else would be to go off with Michael, which I did.' Michael claimed he saw a kindred spirit in Anne when he noticed a live Australian fruit bat or flying fox hanging from the ceiling in her flat. 'She opened the door like a spinster expecting a rapist; it was on the chain. I saw a tightly bandaged wrist. I fell in love with the bandage on sight and very soon afterwards with the wearer, when we were dancing at the Gargoyle,' he wrote in his memoir.

Of course, one thing they had in common was their passion for Lucian. Although Michael told Anne that he and Lucian had had some sort of a physical relationship, Lucian would not have accorded

Anne Dunn, with her husband
Michael Wishart

it any significance. 'We have to assume they did something. I actually
think Lucian had an affair with anyone who was handy,' said Anne.
The interior decorator and social chronicler Nicky Haslam, who later
had a long affair with Michael, confirmed that his lover had had a
brief frisson with Lucian.[74] But Lucian never considered himself gay,
and in the eyes of those close to him he was notorious for relentlessly
pursuing women at every turn. (Francis Bacon told John Richardson
at a dinner hosted by Lady Dufferin that the reason that Lucian was
not gay was because he was poorly endowed – a flippant and asinine
remark, but one which nevertheless revealed that Lucian and his
undoubted attraction were at the centre of conversation.) It was more
that he took advantage of any sexual opportunity, and was conscious
that a great many of his male friends were gay. He admired their
courage, especially in the years when it was still a crime, and regarded
homosexuality simply as just another flavour in life. As Bruce Bernard
wrote, in an astute biographical essay about his friend, 'It has also
probably never displeased him that homosexuals do not offer any
rivalry in his own field of amatory manoeuvre; but these are deep
waters that cannot be plumbed with any certainty.'[75] Clearly, at this
time Lucian was sexually opportunist and omnivorous.

The theory that Michael was in love with Lucian is too
simplistic, according to Anne. Michael knew how passionate the
relationship between Lucian and his mother Lorna had been, and by
having Lucian he was stealing something of hers. Anne inevitably had
to share Michael with Lorna. 'I half adored her and half didn't, but
we were close. I always had the feeling that she couldn't believe my
son Francis could be anyone's but Lucian's. I don't think she thought
Michael could have a child and I don't think she wanted him to. She
was half in love with Michael and he was half in love with her.'

Lucian did not attend the wedding at Marylebone Town
Hall, although Kitty did. 'She was seen glued to the telephone
telling Lucian who was there and what was happening,' remembered
Anne. An awkward lunch followed. 'Everyone hated everyone except
my brother who fell in love with Lorna. My mother refused to eat
and drank only brandy and milk. My father-in-law, a God-fearing
Communist, didn't like what was happening at all,' said Anne. That
it was an unusual marriage was demonstrated by who landed in bed

with whom that night. It defied not only convention, but also logical explanation. 'I ended up with Lorna at the Royal Court Hotel and Michael ended up with Peter Watson,' said Anne. 'My mother-in-law and I slept in the same bed, but I don't think anything happened. It was odd to wake up with her rather than with my husband.' This was musical beds on a grand and anarchic scale.

The bohemian disquietude continued after the honeymoon. 'We got back from Paris at the beginning of October 1950 and got a room somewhere off Knightsbridge, but Michael then disappeared. He had gone off with Francis Bacon, who I think also had an affair with Michael.' And so, like a rogue homing pigeon, Anne went back to Lucian, although she did love Michael too. 'I was very, very close to Michael. He was more like a brother, almost like a blood relationship but very intense. He and Lucian were both amazing mentors,' she said.

Michael and Anne's son Francis had an unorthodox start to life in 1951 in the private maternity hospital at 27 Welbeck Street in Marylebone. 'Michael dropped me off and I didn't know what I was in for, knowing nothing about babies or childbirth. Michael then got very drunk and landed up in jail on a charge of being drunk and disorderly. So the first people to come round to see me were Francis Bacon and Lucian. It was so unlikely and they even brought flowers. I think Lucian partly came round to investigate if the baby was his,' said Anne. He read to her *Memoirs of a Midget* by Walter de la Mare and *Voyage in the Dark* by Jean Rhys.

Parental responsibility often took the back seat. During the Festival of Britain, Lucian took Anne out for the evening when Michael was away in Ireland and they brought baby Francis with them. They were extremely reckless by today's standards. 'I left him in a carry cot in the ladies' room at Northolt while Lucian and I went on the big dipper. I gave him a bottle and just left him with the attendant. He was still asleep when I came back,' she recalled.

They continued to see each other, and Anne found herself again pregnant by Lucian. She could not cope with another child, certainly not one by anyone other than Michael. 'I had to get one of those backstreet abortions. I think the barman from the Montana arranged it,' she said. She pretended to stay in Italy, sending a postcard to

Lucian and Caroline and one to her husband, before sneaking back to Paris to stay at the Hôtel Saint-Pierre until she recovered.

Even after 1957, when Anne left Michael for the Spanish painter Rodrigo Moynihan, whom she married in 1960, she and Lucian remained intermittent lovers. Lucian did not always end relationships with clear finality. Some women – and indeed men, like Francis Wyndham and Francis Bacon – stayed in his life for decades. In Anne's case, it was for a quarter of a century. Anne's view was that although she was deeply fond of him she also saw his faults, and the physical side of life with Lucian was at times dark. With Anne he appeared to be occasionally a relentless and somewhat cruel lover.

AD: 'One had to be very careful not to show that one wished he would stop. I heard from someone else with whom he had an affair that he became quite vicious, really hurt breasts and things and became painful and sadistic.'

GG: 'Did that happen with you?'

AD: 'The very last time, I didn't want to see him again in that way. It was horrible; he was hurting my breasts, hitting and squeezing, really painful.'

Unusual among his lovers, Anne rarely sat for him. 'It was so boring and if you are an anxious person, which I am, all one's anxieties flood and you can't breathe. I remember myself hyperventilating,' she said. When Anne did sit for a nude some years later, it was abandoned because she could not face the stream of passionate eruptions and interruptions from another of Lucian's lovers, Jacquetta Eliot.

Jacquetta was a competing girlfriend and muse, hot-tempered, beautiful and probably the most dexterous of his sitters, contorting herself into tiring, troubling positions. She was also the mother of Lucian's son Freddy. 'I was doing a night-time session,' said Anne, 'and would hear Jacquetta shouting outside. It really was unbearable. I was just being a model. Even so, he was very angry with me because I had walked out on him when he was in the middle of a picture and I completely understand that.' All that remained of one incomplete portrait was her bare breasts.

Lucian was self-centred but never shy in defending his position

of needing utter dedication from those in his life. His wiles and whims were sometimes comic, and sometimes furiously impulsive. After he had a row with one lover he sent a postcard with a crude drawing of her defecating. She considered suing before a friend told her to hold on to it, as its value one day would exceed any compensation. He sent Jacquetta pencil sketches, one a jokey cartoon showing him naked with an erection and the word 'moan', his nickname for her, written on every part of the body,.

He had first met Jacquetta, a stunningly beautiful and captivating woman, in 1968 and started using her as a model a year later. It was one of the most passionate and enduring relationships of his life. She was born Jacquetta Lampson, the third daughter of Lord Killearn, and was a famed society beauty with a sharp intelligence and independence. Born in 1943, she had married Peregrine Eliot, the 10th Earl of St Germans, in 1964. Their marriage lasted twenty-six years, and her charged relationship with Lucian ran in parallel. Even in Lucian's final years he gave her drawings and paintings, and sent her hundreds of intimate, sometimes furious, letters and sketches.

Jacquetta was funny, original, creative and bluntly forthright with Lucian. She recognised that he was as badly behaved as he was utterly magnetic. 'When he was not there it was as if the light got dim. In the same way, he made everyone who was with him feel more illuminated and somehow more alive and interesting. No one else had that capacity to light up everyone and everything,' she said.[76]

Always, the painting took precedence over everything in his life. Anne said, 'He did dedicate himself to his art completely as well as packing in an awful lot else; he wasn't unsocial. He had this incredible energy to go on working deep into the night, plus go out to lunch and juggle his love life. Furtive is a good word to use about him; he slid sideways through doors.'

Every girlfriend had to accept that they were one amongst many. Anne recalls being bundled into the bathroom in Delamere Terrace, the bath filled with coal, while he painted other women, including Augustus John's daughter Zoe, and Henrietta Moraes.

GG: 'It must have been strange as Lucian was most likely making

love to them upstairs while you were in the "coal cellar"?'

AD: 'Exactly . . . You couldn't quite believe what was happening
 but in retrospect I did. I often think, "How could I have been
 so dumb?"'

The liaisons continued. Rodrigo Moynihan's first wife, Elinor
Bellingham-Smith, also sat for Lucian. 'John Moynihan, their son,
used to go and collect her and sometimes from his descriptions it
seemed to me that she too probably did have an affair with Lucian.
I suspect they did. It was another of those things going round after
I had gone off with Rodrigo, another revenge. They were revenges,
but not vengeful.'

<center>✳ ✳ ✳</center>

The link to Lorna through her son Michael and grandson Francis
continued into the early 1970s, when Anne had an exhibition at the
Redfern Gallery in Cork Street. Francis's girlfriend at the time was
Tanya Harrod, and Lucian was immediately attracted to her. Tanya
was just twenty-two, and he was fifty. She sat for him but they did
not have an affair, but not for want of Lucian trying. 'He was like a
hawk going for her. He started walking up and down and gesturing
as he undid his belt.' It was manic, clumsy and strange, just short
of undoing flies, according to Francis. Francis's next girlfriend Liz
Kneen was seduced by Lucian. She was an illustrator who had lived
with Francis but when they broke up and separated, Lucian asked
her to sit for him. 'It was she who told me that he was vicious in bed,'
said Anne. 'She had refused to sit for him because he would not give
her his telephone number and as an ardent feminist she thought this
unfair.' She died of cancer in 2007. A third girlfriend of Francis, Rose
Jackson, also became a model and muse for Lucian, for about a year.
He stopped seeing her after she had a child.

As with affairs, disputes were also ever present. When Michael
was dying of cancer and short of money, he tried to sell a drawing
Lucian had done of Lorna in a fur coat. Lucian jinxed the sale.
'Lucian did not deny he had drawn it but claimed that Lorna had
fiddled with the nose and Christie's should drop the picture from
auction. I think what he said wasn't true but it stopped the sale,' said

Anne. In the end it sold for £60,000, less than the projected auction price, through the dealer Thomas Dane.

One day during his final years in France in the 1990s, long after he was divorced and was staying with Anne, Michael asked to drive over to see the novelist Edward St Aubyn, who was to fall in love with another Lucian muse, Janey Longman. Born in 1955, she was translucently beautiful and clever, with an aristocratic elegance and learning which was lightly worn, and had sat for several portraits in the mid-1980s. She also fitted into the close-knit Freud web. Her previous boyfriend had been Tim Behrens, subject of a 1962 portrait *Red Haired Man on a Chair*. Lucian fell for her when they met at a party given by the Duke of Beaufort for his daughter Anne. He made two naked portraits of Janey on her own and then a double-portrait of her and India-Jane Birley, the daughter of the club-owner Mark Birley, also naked. The picture of the two women, Lucian told her, was inspired by Gustave Courbet's *Le Sommeil*, another double portrait of two naked women voluptuously entwined which caused a sensation when exhibited in 1866. When she met Lucian, Janey was working for Lady Arabella Boxer, Food Editor of *Vogue*. After the three portaits Lucian quietly and undramatically ended their affair.

As Michael turned up at Teddy St Aubyn's house in Provence, the Lucian links came almost full circle – St Aubyn was a protégé of Francis Wyndham, who was Anne's oldest friend, and after whom she had chosen to name her son. Michael had agreed to the name because it was shared by *his* closest friend, Francis Bacon. When Edward and Janey went on to have a baby boy in 2000, they named him Lucian. It was always an entwined world, and continued to be so – in 2011, Janey's niece Marina Hanbury married Ned Lambton, the son of Lucian's former mistress Lady Lambton.

As Anne said: 'Lucian was the split atom in the midst of us all.'

CHAPTER SEVEN # Caroline

Lucian's recollection of falling in love with Lady Caroline Blackwood, the wilful Guinness heiress, was sharp and fresh even more than fifty years later. He had painted her at the start of their affair, in a hotel in Paris in 1952, in the picture *Girl in Bed*. Caroline is radiant, seemingly naked between the sheets, with honey-blonde hair and enormous, forget-me-not blue eyes. There is no hint of the unsettling drama that would eventually unfold. She was twenty-one, rich, shy and alluring. He was nearly thirty, barely earning a living, divorced and renting a dilapidated house in Paddington.

A sense of the pain and anxiety of their eventual parting was later captured in his 1954 painting *Hotel Bedroom*, in which his aristocratic, Anglo-Irish wife lies awkwardly dressed, between the sheets, looking vulnerable and distressed, in a cramped hotel room in Paris. Lucian had painted himself standing apart from her, apprehensive, furtive, anxious and unsettling, his hands stuffed in his trouser pockets. Caroline is tremulous and pale, with her fingers touching her cheek, as if in shock. The image suggests a sickbed rather than a marriage bed. It marked the stressful end of his impulsive love affair with the eldest daughter of the 4th Marquess of Dufferin and Ava and his wife, the brewery heiress Maureen Guinness. The two portraits mark the start and end of their relationship and, more than half a century later, sparked a bitter-sweet memory of the affair and their short-lived marriage, which ended in acrimonious divorce.

Turning the pages of a book of his paintings that I had brought to show Lucian while we had breakfast in Clarke's one day,

Girl in Bed, 1952

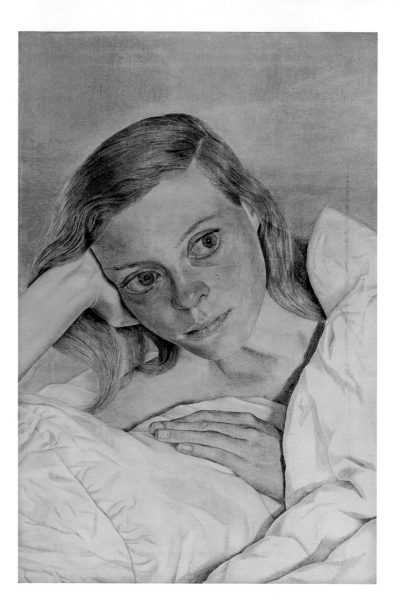

he looked with a degree of detachment at the later portrait of his
second wife. His memories fell into focus. 'I had broken the window
to get myself more room to paint. She looked miserable because she
was cold,' he recalled. As is so often the case the painting reveals
truths beyond mere outward appearance. As he talked about how he
had fallen in love and why she had left him, it was almost as if he
was describing the disjointed narrative of a film that he had seen a
long time ago.

Lucian met Caroline through Ian Fleming's wife, Ann, whom he had painted in 1950 with hard pursed red lips, a diamond-encrusted tiara on her head, a single pearl on her right earlobe, her chin jutting forward, purposeful and forceful, ever the grand society dame. 'She asked me to one of those marvellous parties, semi-royal, quite a lot of them were there, and she said, "I hope you find someone you'd like to dance with," and that sort of thing. And then suddenly there was this one person and that was Caroline,' he recounted. 'So Freud now takes Princess Margaret out dancing in yellow socks,' wrote Evelyn Waugh in capital letters on a postcard to Lady Diana Cooper in October 1951.[77]

Ann had very publicly taken up Lucian, showing the wunderkind off at her soirées, and they later spent time together in Jamaica, where the Flemings had their house Goldeneye. Ian had married Ann in 1952, and started to write his first James Bond book *Casino Royale* while on honeymoon with her; he always disliked and distrusted Freud, suspecting him of having had an affair with Ann. 'It was simply not true. It was just the sort of absurd thing he believed. I thought he was ghastly,' Lucian said. But despite her husband's ill feelings towards Lucian, Ann kept him in her circle. The antipathy between the two men was no secret. Noël Coward visited Ian and Ann on 16 February 1952, to dine with the newly engaged couple, along with Cecil Beaton. Coward offered his thoughts on what they should and should not do to inflame the Freud–Fleming tensions:

> Don't Ian, if Annie should cook you
> A dish that you haven't enjoyed
> Use that as an excuse
> For a storm of abuse
> At Cecil and Lucian Freud.[78]

Lucian's recollection of his first sight of Caroline chaotically attired is almost visceral: 'I remember she wore sort of dirty clothes, the wrong way round,' he said.

'What else caught your eye?' I asked.

His reply had urgency. 'I think it was really her. She was just exciting in every way and was someone who had taken absolutely no trouble with herself, looking like she hadn't had a wash. But then

Lucian and Caroline Blackwood
on their wedding day in 1953

Opposite: Lucian, Lady
Rothermere and the
choreographer Frederick Ashton,
Warwick House, Green Park,
London, 1950s

someone actually said that she hadn't. I went up to her and I danced
and danced and I danced and danced.'

She and Lucian were viewed by their contemporaries as rebels.
In the very conformist 1950s they stood apart from the post-war
puritan spirit, not consciously in any deliberate political way but
instinctively. Ignoring what anyone else thought, as he nearly always
did, he was utterly bewitched by Caroline. 'I don't really think of
myself in a dramatic romantic way. I just thought of what I wanted
to do, you know, take her home alone, that sort of thing. That night
I went home and started painting her,' he said.

It was a time of social change, the dark shadow of the Second
World War receding. In some ways Lucian's paintings captured
the starting point of a more permissive society in Britain. They
seemed modern, dangerous, brimming with psychological drama
and unrestricted behaviour, so different from other portraiture at

Lucian (centre) with Simon
Hornby (left) and Osbert
Lancaster's daughter, Cara at
Warwick House, Green Park,
London, 1950s

that time. The tension in their marriage was frozen in time in *Hotel
Bedroom*. To her family and immediate social circle it was outrageous
that someone of her background (being the daughter of a marquess,
she had the courtesy title Lady Caroline) should be exposing herself
so brazenly in bed for public display. For Caroline, of course, that
was half the thrill.

Caroline's mother Maureen, Lady Dufferin, was especially
horrified by her daughter's involvement with Lucian and had one
aim: to split them up. Her anti-Semitism fuelled her fury. In her
eyes he was dangerous and subversive, but above all, he was beyond
her control. Through the censorious eyes of society matriarchs,
Caroline was deemed wild, even wanton ('A mermaid who dines
on the bones of her winded lovers' was her third husband Robert
Lowell's crushing judgement, albeit much later). Her contemporaries
acknowledged her blithe insouciance.

Lucian adored Caroline's careless abandon which merged into self-centredness. As an artist, he understood selfishness. In some ways, with Caroline he had met his match. She rebelled against the flamboyant but narrowly mannered pretensions of Maureen, with her smart house parties, grandiosity and snobbish social ambition, simply by being with Lucian. Caroline always found her dysfunctional and restrictive childhood too painful to speak about and Lucian gave her a means of escape.

I told Lucian that when I had first seen *Hotel Bedroom* it had reminded me of Robert Browning's poem 'My Last Duchess', a dramatic monologue about a psychotically controlling husband who ruthlessly destroys his women, in seemingly civilised circumstances. 'But doesn't he end up killing her?' he asked, smiling. 'Even I have never done that.'

However, in *Hotel Bedroom* I see a willing victim being used and using, waiting for as well as weathering the storm of an unstoppable love affair as it wound towards its difficult end. In this picture Lucian has broken new ground in allowing the drama of his personal life more effectively to move the senses of the viewer and show an intensification of reality while at the same time acquiring a life of its own as a work of art. Its spare style and narrative tension show a marked progression from his earlier pictures of Lorna and Kitty. Lucian's painting seems more assured. There is a suppressed drama and conflict, and the silence between Lucian and Caroline is palpable. Her eyes appear red-rimmed through tears or tiredness, her yellow hair is radiantly bright while Lucian is in shadow, darkly silhouetted against the shutters and stone of the buildings in the Paris street opposite. In *Girl in Bed* she is again obsessively observed, for such a long time, pinned down like an exotic butterfly. She stares out with an empty vagueness. The tonality is subdued, almost bleached. Her vulnerability and sensuality are suggested by her blue cloudy eyes, the size of gull's eggs.

The end of the love affair left Lucian hurt and wrong-footed after Caroline rejected his extraordinary charisma that had once been so magnetic. She had loved his outsider edginess, a route of escape from her claustrophobically inhibited and inhibiting parents, but sensed that she would be hurt by him if she stayed. She could

Outside his home in Delamere Terrace, Paddington, West London, 1963. Photograph by Lord Snowdon

not tolerate being betrayed by him and knew that he would stray. His memory was partly nostalgic for the beauty and originality of Caroline but was also spoiled by thoughts of his hated mother-in-law, who had waged a vitriolic campaign against him, which in the end led Lucian to escape with Caroline to France.

'Caroline was in Paris with me because of her mother, who tried to have Caroline kidnapped in London and had me followed. Well, since I had lived among villains in Paddington you can imagine I was not going to be intimidated by such things. I looked round, of course, but all that couldn't bother me. But Caroline was very nervous and it made me feel horrible. She bit her nails even further down. So all that was partly why we left London.'

He held Maureen Dufferin in acid disdain: 'Look, she called herself Lady Dufferin when she wasn't titled any more — she was really Mrs Maude, having got remarried. It was just odious snobbery. I do not mind ordinary snobbery but she was really vile.'

Part of the attraction of Caroline was that she was funny and

clever with an original turn of phrase: more Wit-girl than It-girl. But she was also desperately shy and to compensate would drink excessively. (As one contemporary who witnessed her disruptive behaviour put it, albeit harshly, 'She was simply drunk; she redefined the word "fast".') Together with her sister Perdita and brother Sheridan, she stood out at society balls filled with debs in pearls and well-behaved English public school boys. Caroline was risqué, decadent, sly and experimental.

There was still at that time a constant undercurrent of anti-Semitism among the Establishment. In 1951 Evelyn Waugh wrote to Nancy Mitford: 'I went to London for the General Election — just like last time, same parties . . . [Duff] Cooper got veiners [a term used by Waugh's wife to teasingly describe him when so angry his veins protruded] with a Jewish hanger-on of Ann [Rothermere's] called "Freud". I have never seen him assault a Jew before. Perhaps he took him for a Spaniard. He has very long black side-whiskers and a thin nose.'[79] Later she wrote back, 'Yes. I don't like Freud. I knew him before he got into society & didn't like him then. Boots [Cyril Connolly] does though.'[80]

There was resentment amongst the stiffer, conservative element of the artistic establishment as Lucian inevitably drew attention. But, liked or disliked, he was noticed, especially with Caroline in tow. Ned Rorem, the American composer and diarist, met Lucian at the Paris apartment of Vicomtesse Marie-Laure de Noailles, the society hostess and patroness. Picasso had painted her portrait and she put on the first viewing of Salvador Dalí and Luis Buñuel's film *Un Chien Andalou* at her Paris home in the Place des Etats-Unis. The couple had caught her eye. Rorem wrote:

> Lucian brought his fiancée for lunch. Lady Caroline
> Blackwood was heart-stoppingly beautiful, but vague.
> There she sat, in Marie-Laure's octagonal drawing room,
> on the edge of a sofa, legs crossed, one knee supporting an
> elbow extending into a smoking hand which flicked ash
> abstractedly onto the blue Persian rug. Caroline, very blonde,
> with eyes the hue of the Persian rug and large as eagle eggs,
> uttered nary a word, neither approved nor disapproved, just

smoked. Marie-Laure was wary of her, as of all attractive females.[81]

They soon became the most talked-about young lovers in London, with hide-bound society agog as the Jewish, German-born artist, grandson of the famous psychiatrist, swept the Guinness heiress off her feet. 'I was chasing her and finally I caught up with her and then we went off to Paris. We came back to England to be married,' he recalled of their rollercoaster romance. They became Lady Caroline and Mr Lucian Freud at Chelsea Register Office on 9 December 1953, one day after his thirty-first birthday.

But why had he married her, I asked more than fifty years later as we sat in Clarke's, sunlight streaming in from the window overlooking the rear garden? He was so obviously not the domesticated kind, and loathed the entrapment of family life. 'Oh, we got married because Caroline said she would feel less persecuted. And there was a technical reason. She had a bit of money from her father and she couldn't get that if she was living in sin. Remember this was the early 1950s.'

The marriage, of course, was doomed as Lucian would never be tied to one woman, as he openly admitted: 'When I finally caught her, I celebrated in a way that wasn't really suited to being with someone. Before we were together I felt much more intensely towards her than when we were together.'

'You mean you went after other girls?' I asked.

'Yes,' Lucian nodded. He was never embarrassed by the truth about his conduct. He had never pretended that he was going to behave conventionally. He made clear his rules, or lack of them, to whoever he was with, and he kept to them. It was the expectations and assumptions of others that hurt them.

Nevertheless, he was still very upset when she deserted him. This was an important time professionally for Lucian as he sought to find a new way to progress with his painting, away from the minuscule detail and tiny brushstrokes, abandoning the fineness of his early works for a more explorative use of paint. It was also a time when he physically altered how he painted. He no longer sat trapped in a chair, but began to paint standing up. Lucian was on the move.

An important influence was Francis Bacon, with his dramatic and liberal application of paint. They saw a lot of each other at this time and Lucian sat for eighteen different portraits. They drank in Soho, talked incessantly and were quietly competitive. Lucian admired the grand aspirations of Bacon's paintings with his ambitious themes, extraordinary imagination and unrivalled genius with paint. He wanted to make his own brushstrokes less still and controlled. He was impressed by Bacon's carefree approach to life, and by the fact he didn't mind what anyone else thought.

Lucian sometimes used the fact of having an heiress in his life for Bacon's benefit.

GG: 'Was part of the excitement Caroline's wildness and wealth?'

LF: 'Absolutely, the fact that she was independent and rich. I know I asked her for some money to give to Francis to go to Tangiers. I explained I had a friend who was always giving me money whenever I wanted it and that now I would like to do the same for him as he's met someone special out there.'

GG: 'Did she give it?'

LF: 'Yes and said, "Is there anything else you really want?"'

They both played off each other's surprises. For instance when Lucian took Caroline to meet Picasso something happened between them. He was aware that they had disappeared together but did not really want to know exactly what had occurred. Perversely, he was both boasting and blaming her as he described how Picasso may have had a sexual liaison with her right under his nose.

GG: 'You thought something happened between Caroline and Picasso?'

LF: 'Well, they came back about three hours after they went out. That was enough time, to put it mildly! But then my own memories of Caroline are not entirely physical. I was much keener physically on Caroline than she was on me. One can never say these things with more than a little bit of sureness, don't you think?'

GG: 'I think instincts on such things are usually correct.'

LF: 'Yes I feel that.'

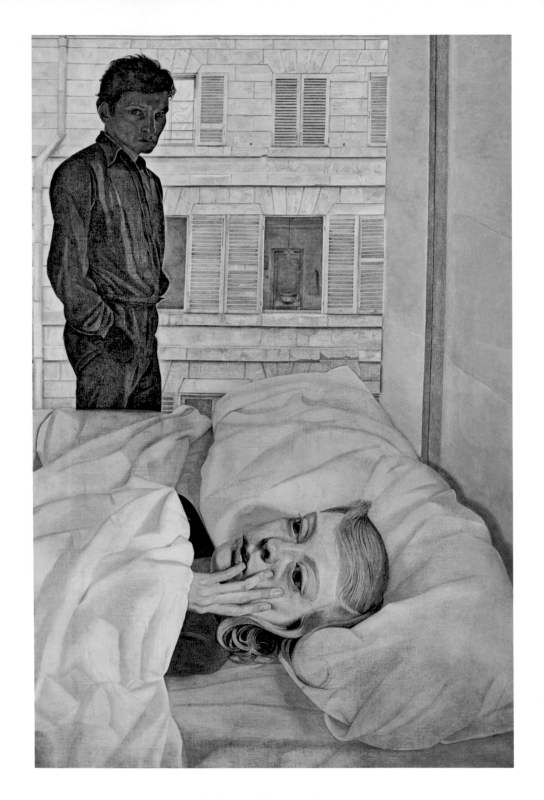

GG: 'Did you mind that she might have had a fling with Picasso?'

LF: 'No.'

GG: 'Because you're not possessive?'

LF: 'I remember coming home one day to the house in St John's Wood and there was someone in bed with her and they were asleep. I remember being so careful to shut the door so as not to wake them. I didn't go home that much to my house.'

Caroline told him she did not want to remain married and ran off to Spain. She felt he was too dark, controlling and incorrigibly unfaithful. Her mother was jubilant; 'It was marvellous. Caroline ran, ran, ran,' Lady Dufferin crowed.[82] But despite the hostility of his mother-in-law, Lucian was not prepared to give her up.

Lady Dufferin was willing to resort to the lowest possible tactics to disentangle Caroline from Lucian's clutches. 'She was absolutely ghastly, what I would call really corrupt,' he said. 'Maureen said she had tried to get my father Ernst deported back to Germany in order to put an end to my relationship with her. It was disgusting. She was vile, worse than the caricatured evil mother-in-law.'

Lucian did not give up even when his wife hid herself in a secret address in Spain. 'I could not think of anything else for a long while. Maureen thought if Caroline was out of the country, she'd be safe. Caroline became a tutor, teaching English to some children in Madrid.' He went on a somewhat quixotic search, as he did not even know her address. 'When she left me I just knew I had to find her. All I knew was she was in Spain and I had the number of the door but not the street name. I knew I would find her,' said Freud. 'Meanwhile, her mother hired people to tell everyone how appalling I was, asking if I had a criminal record. I had one or two speeding offences,' he said.

GG: 'How tense was it?'

LF: 'Very. I'll give you an example: *Maureen to Caroline*: "I don't mind Lucian being married to you but only if he is nice." *Me to Caroline*: "What does she mean by nice?" *Caroline*: "Well, titled, of course." I couldn't do anything about it. That gives you an idea of what she was like. Then she had my parents followed. It was really horrible because she knew so many

important people – MPs and so forth – that she thought she could have my family exiled from England. Well, we happened to have been naturalised British subjects.'

GG: 'Was this all a mask for anti-Semitism on Maureen's part?'

LF: 'Perhaps that came into it. But I had never really seen myself as a Jew in any absolute identifying way, although of course I was and am.'

Caroline was equally resolute; she felt it was a matter of her survival, mentally as well as physically, that she should leave him, and much later she confessed to her daughter Evgenia, and also to her oldest friend Lady Anne Glenconner, that her body had somehow mysteriously and intuitively changed to prevent her having his children long before she had consciously calculated in her mind that Lucian was not good for her mental well-being. She was a subject to which he returned in our conversations, as it was a central relationship in his life, and she was the last person he married.

GG: 'Have you ever been obsessed by anybody?'

LF: 'Yes, long ago. I remember the obsession more than the person.'

GG: 'How driven was the obsession?'

LF: 'I couldn't think about anything else.'

GG: 'Did you get her in the end?'

LF: 'I had married her by that time.'

GG: 'Oh, this was Caroline.'

LF: 'Yes.'

GG: 'You were very obsessed by her, you crossed continents to find her.'

LF: 'Yes, all the time, but on the other hand, I can't pretend if I'd met someone very exciting on the train I wasn't led astray.'

GG: 'How did the obsession make you feel?'

LF: 'Demoralised. Because I always thought, whatever happened with the obsession, I could work and when I got terribly obsessed I couldn't really work.'

GG: 'That's interesting. That brings us back to the sexual urge.'

LF: 'Yes, but if it was just a sexual urge you could have a sexual wank and get on with your life. But if it's the person, if you

would rather have a horrible time with someone you are obsessed with, rather than an exciting time with someone you've just met, that makes you realise how different you feel, doesn't it?'

GG: 'I suppose that's being in love.'

LF: 'Quite.'

GG: 'Caroline was incredibly beguiling?'

LF: 'If there is such a thing, I suppose so, yes. The timing was always so bad. When Caroline was looking for me I was gone, or away, or ill and when I looked for her she had disappeared. And her mother was monstrous and paid some people to have me killed.'

GG: 'How did you find out?'

LF: 'Because I knew the people. You know where I lived in Paddington. It was full of villains. She asked some people who were linked to the people who knew me. She said, "I don't especially want to know how you do it. I just want to read that it has been done."'

GG: 'Did you ever challenge her about this?'

LF: 'It was very difficult because she had bodyguards and crooked servants. I mean, it sounds like a really bad book.'

GG: 'You never had any children with Caroline.'

LF: 'No.'

GG: 'Would you not have liked to have had some?'

LF: 'I think anyone you like very much you want any kind of link with them, and in a way a child is an obvious one, isn't it? I've never been concerned with babies or anything.'

GG: 'Why is that?'

LF: 'Must be my upbringing. You know how lots of people say how lovely a baby is and I think, "Can't you put it down and we can have a dance together?"'

GG: 'And so it ended.'

LF: 'If there's such a thing as fault, putting it mildly it was completely my fault.'

They divorced in 1959 and rarely saw each other again. At the start of their break-up, Lucian was devastated. His young Paddington

neighbour, Charlie Lumley, recalled how Francis Bacon was worried that Lucian might attempt suicide after having been dumped by Caroline. 'He was a right mess and Francis told me to make sure he did not top himself,' Lumley remembered.[83]

The relationship left other difficulties in its wake. Anne Glenconner, who had been at school with Caroline, remembers appalling conversations that Lucian had with Caroline. 'He behaved very badly towards her and said things which were cruel and it physically affected her. It was mental pain; he was very unpleasant the way he talked to her. As a result I decided I would not see him,' she said.[84]

Born Lady Anne Coke, daughter of the Earl of Leicester, she had been a Maid of Honour at the Queen's Coronation alongside Jane Willoughby. Anne's husband, Colin Tennant, who became the Baron Glenconner and was later famous for buying the West Indies island Mustique and turning it into a playboy resort, was completely swept up by Lucian's charm and sat for him and bought many of his pictures. (They fell out later when Colin sold them.) One consequence of their friendship was that he met yet another of Lucian's lovers and muses, Henrietta Moraes, whom he painted three times, notably in *Girl in a Blanket* (1953). She was also famously a model for Francis Bacon, who painted her at least sixteen times and whose 1963 *Portrait of Henrietta Moraes* sold for £21.3 million in February 2012. Colin and she started an affair and more than forty years later he had to confess to his wife that he was the father of Henrietta's child. 'It was not exactly what I had hoped Colin's friendship with Lucian would bring,' said Anne Glenconner.

Being with Lucian in the early 1950s was a tangibly sensual experience, according to Vassilakis Takis, the Greek kinetic sculptor, who first met him at the Hotel Louisiana in Paris in 1954 when Lucian was painting Caroline's portrait. 'He had invited me for a cup of tea early one morning, but was tremendously awkward and dropped his brushes on the floor, then quickly picked them up in a darting movement. I had arrived early, surprising him. The whole atmosphere was sensually and electrically charged. We didn't speak for a few moments. The shock for me and for him and Caroline didn't pass quickly; there was a long silence. Thinking of

Epicurus, I can only describe the meeting as intensely sensual,' he said.[85]

Takis was three years younger than Lucian and also working his way up in the art world. He had been a member of the Greek resistance and spent six months in prison. Charismatic, handsome and forceful, he was in Paris to further his artistic career. He later lived in London where he and Lucian shared a friendship with Francis Bacon, but more importantly, according to Takis, they shared several girlfriends. Like Lucian, Takis was a serial seducer. 'I have had at least 500 women as lovers; that would not be an exaggeration, probably the same as Lucian,' he told me from his ninth-floor suite in the Athens Hilton almost sixty years after he first met Lucian. With a white beard, dressed in baggy pink-red jeans, Prada sandals, smoking Rocket '24' cigarettes and drinking tumblers of Johnnie Walker on the rocks, his memory was sharp, still struck by the physical potency of Lucian. As well as being a legendary womaniser, Takis also had various homosexual experiences. His sculpture of St Sebastian, made in 1974, shows a naked man with a very prominent erection, taken, he explained, by putting a plaster cast on a well-endowed peasant boy from the island of Samos, where Pythagoras had lived. 'One of my assistants turned pages from pornographic magazines to keep him ready. It is the most erotic sculpture of the twentieth century,' stated Takis. The Russian dancer Rudolph Nureyev, a friend of Takis, fell for the twenty-two-year-old model.

Openly candid about his own sexuality, he describes a tangible frisson between him and Lucian:

> When he saw me I was very attracted. He understands men. He was very erotic with me in one way or the other. It was an Epicurean connection, a sensual one, but not physical. You can be very erotic without having sex. I have been attracted to men and women. All is very similar, one sexuality. Lucian had this penetrating dynamism in an erotic way. I was the opposite to him. He was so quick; I was more silent. He had a beautiful physique and face with a small frame. Why didn't we have an affair? I don't know. I have no reason to tell lies, but we didn't. We had been very close. Same clubs, same

girls, but he was more expressive than me in his behaviour. I have had male sexual experiences so why not him, he was so erotic. He could not discard that part of him. Lucian closely scrutinised me while Caroline appeared in a world of her own. His grey eyes sharply focused on me before they both asked me to go with them to a gay club for women called Feneo. Caroline complimented me on my jacket before we went out and I told her it had been lent to me by a friend. They both then again stayed silent. I waited for my whisky, looking at some of his pictures.

The portrait of Caroline appeared to Takis to be 'somewhere between nice and creepy at the same time'.

Key to their relationship in London was Bacon, but also the Cumbrian painter Sheila Fell, who had a child by Takis, and who Takis believes also had an affair with Lucian. She had been a protégée of L. S. Lowry and was also a close friend of Frank Auerbach, who greatly admired her and her paintings of landscapes.

'I remember Francis always wanted to find out what Lucian was doing. I remember Lucian was very happy that I said I liked Lucas Cranach. He was smiling and happy about it. We never talked about girls we had been seeing. David Sylvester [art critic and friend of Francis Bacon] was also in love with Sheila. She was very beautiful. He hated me.'[86]

<center>⁂</center>

In 1992, forty years after Lucian painted *Girl in Bed*, I found myself standing with Caroline looking at the picture, which she still owned, in the dining room of her house in Sag Harbor, Long Island, east of New York. I was there because her daughter Ivana, aged twenty-six, was my girlfriend. She was strikingly beautiful, exactly as Caroline had been, with the same luminous eyes, quirky wit and hesitant shyness. Caroline was then aged sixty-one, thin and grey-haired, her face ravaged by too little care and too much drinking, the skin no longer pale, unblemished and marble-like.

I had first met Ivana at a dinner party on the Upper East Side of New York City in 1989, after I had been dumped by a girlfriend

in London and had flown to America for ten days to forget her. On my last night in Manhattan I had sat next to Ivana and was enchanted. She was funny and very beautiful, but I also sensed something fragile. I did not realise she was vulnerable and somewhat damaged by her own dysfunctional family life. She told her story with great candour in her own memoir, *Why Not Say What Happened?* Like Caroline she was shy and drink made her loquacious and witty, sometimes corrosively so. Her upbringing had been chaotic and unstable, its greatest tragedy the death of her eldest sister, Natalya, from a drugs overdose aged seventeen.

She was left confused as to whether her biological father actually was Israel Citkowitz, a Polish composer whom Caroline had married after her divorce from Lucian. Her mother mischievously suggested it might be Robert Silvers, the editor of the *New York Review of Books*, with whom she had had an affair. An added confusion was that Ivana then changed her surname to Lowell, after Caroline's third and final husband, the American poet Robert Lowell. When Lowell died in 1977 in the back of a taxi in New York, he was clutching Lucian's portrait of Caroline which he had bought for £28,000 from Lord Gowrie, one of his close friends and an art dealer who later became Mrs Thatcher's arts minister.

Only after her mother's death did Ivana discover, with the help of DNA tests, that her father was in fact Ivan Moffat, an English film producer (*Giant* with James Dean was amongst his credits) who coincidentally had been at Dartington Hall school in Devon with Lucian. 'It was so obvious that Ivan was her father. Just look at what he's called and what she's called,' Lucian told me, perplexed by the fact that Caroline had never revealed the identity of Ivana's real father to her.

When we first met at that dinner in 1989, Ivana and I chatted and laughed continuously, and at the end of the night I took her telephone number before flying back to London the next day. I kept the piece of paper with her name and number in my wallet for two years until 1991, when I moved to live in New York as the American correspondent for the *Sunday Times*, and then I called her. We started an affair, which was to last two years. And with Ivana came Caroline, with whom we spent most weekends at her house in Sag Harbor.

So Caroline became part of my life in her declining years. Drink emphasised her warped waspishness, her aperçus piquantly observant. Lucian's picture *Girl in Bed* was above the mantelpiece. Well, sort of there, because it was a copy. The original was considered too valuable to leave in a seaside holiday house with virtually no security. Many a flatterer would coo to Caroline about the tiny, subtle brushstrokes of a genius, barely visible to the eye. She laughed at their folly.

Caroline had a dark side, emphasised by the tragedy in her life; her brother Sheridan Dufferin, the 5th marquess, was a victim of AIDS in May 1988, ten years after her teenage daughter Natalya died. She battled in court over money with her own mother, her three marriages failed and as a mother herself she had mixed success. Where she triumphed was as a writer, producing some sharp and brilliant books such as *Great Granny Webster*, shortlisted for the Booker Prize in 1977. It was a gothic comedy seen through the eyes of an orphaned girl and her relationship with her great-grandmother, and was interpreted by some people as a *roman-à-clef* about her monstrously bullying mother and her own dead daughter.

Never dull, she could indeed be unsettling. I remember hearing how she once found some baby blackbirds in her wellington boot and crushed them with her foot. 'It was too awful, really awful, but I just did it,' she told the biographer Victoria Glendinning.

Caroline's use of language was quirky. 'Shall we go to the cunt?' she would ask Ivana or myself when she wanted to leave Manhattan, abbreviating the word 'country', relishing the impropriety; or 'Shall we have some shamp?' as she eyed a bottle of Bollinger, in a similar vein to Francis Bacon's famous line 'Champagne for my real friends, real pain for my sham friends.' (Although, as Lucian would point out, real pain was part of Francis's sexual kicks, and so actually for his real friends too.) In her last years Caroline's smoky, throaty rasp could be heard in many a Manhattan bar ordering a vodka, 'with tonic on the side', the emphasis on the word 'side' as that was where it remained, usually untouched. Armed with her conversational tic of eyeing a detail, isolating, repeating, exaggerating and then playing with it over and over, she was at times outrageous. Someone would be so, *so* fat, or have *such* a bad sense of humour, or write *so* terribly.

A smoke-tarred laugh would follow, the light side which followed the dark. It was *School for Scandal* gossip from a steely, untrained mind. Like Lucian, she was mainly self-taught. She instinctively knew that her strongest suit was candour and ruthlessly pursued her version of the truth in her writing. Her final unfinished book was about transvestites, and she conducted her research in strange bars and clubs downtown.

Her daughter Natalya also crossed Lucian's life. As if he was trying to retrieve some strange echo of his relationship with Caroline, he met her after she had left Dartington, which she had also attended, and he had asked to see her. Caroline was alarmed but was too neglectful as a mother to do much about it. Natalya had her own flat and was spiralling down a path of addiction. It was a tragedy waiting to unfold on many levels. Evgenia at one time complained to Lucian when he was seeing her sister that she feared that Natalya had a serious drugs problem. Lucian dismissed this as nonsense. Evgenia could never understand why a seventeen-year-old would be allowed to have her own flat and live apart from the family and yet be so transparently unable to look after herself.

Neither Caroline nor Lucian showed Natalya wisdom, kindness, responsibility or much decency. It was a shameful episode. Natalya confessed to her sister that she had slept with Lucian. She was seventeen; he was fifty-five. It was almost incestuous in spirit, sleeping with his ex-wife's daughter. Shortly afterwards, she was found dead. It added a strange and unsettling coda to Caroline and Lucian's story which left them all very uncomfortable.

Lucian took an instinctive and unwarranted dislike to Caroline's surviving daughters. It was something that Evgenia accepted with generosity. 'I first met him when I was fifteen. I had dinner with him and his daughter Bella, and saw him from time to time over the years. He would never look at you directly, but sideways and he'd quickly look away when you turned to face him. This gave him the appearance of being slightly furtive, but I believe it was because he was only interested in the truth of the unguarded moment, when a person hasn't had a chance to put up a front, or rearrange their face. That didn't interest him as much as emotional and physical candour.'

Caroline often expressed a harsh view of Lucian and would provocatively tell friends that Lucian should have foreseen her abandonment of him. She had a theory that all his paintings were in some way prophetic, outlining her views in an article called 'Portraits by Freud', commissioned by Robert Silvers for the *New York Review of Books*. It was ostensibly a review of 'Recent Works' at the Metropolitan Museum of Art in New York, but it was also psychological payback. She seemed strangely mystified and hurt as to why he had aged her unnecessarily in her portraits. The involvement with her daughter left her disgusted, but this was clearly just the surface of her resentment.

Caroline wrote: 'His portraits have always been prophecies rather than snapshots of the sitter as physically captured in a precise historical moment. In the past this was not so obvious because his prophecies had not yet become so dire and grim. When I used to sit for him nearly forty years ago the portraits he did of me in that period were received with an admiration that was tinged with bafflement. I myself was dismayed, others were mystified why he needed to paint a girl, who at that point still looked childish, so distressingly old.'

She pulled no punches as she turned the tables on her former husband, and castigated his portrait of himself naked, aged seventy, with a crushing analysis, describing him as a 'naked and paranoid Mephistopheles, crazily smashing around, evilly waving his palette knife as if he sees it as a wand or sword or sceptre. In this powerful self-dissection, Lucian Freud allows himself to be seen as wearing nothing but a pair of embarrassing unlaced boots.'

At that time, according to Caroline, at her most crushing towards Lucian, many people saw his paintings of men and women as cruel: 'The eyes of Lucian Freud's sitters, as they stare out from his pictures, suggest that, like the blind Tiresias, "they have suffered all". As selected specimens of humanity, magnified by the cruel accuracy of a microscope, they have also been seen by all.'[87]

Caroline and Ivana were both referred to as heiresses by newspapers, and while financial security gave them the freedom from having to rely on men and the ability to bolt in times of trouble, it also made them struggle to find happiness. A desire to settle down

conflicted with an unreliability. Just as Caroline fled Lucian, so Ivana left me just as abruptly for the film producer Bob Weinstein (shortly after he and his brother Harvey sold their company Miramax to Disney), although we remain very good friends.

The final contact between Lucian and Caroline came when she lay dying from cancer in New York in 1996. He telephoned from London to her deathbed and they talked sweetly for an hour as she lay calm, touched by his affection and charm. In a morphine-induced state, Caroline saw a mosaic of colours as Lucian spoke. She was once again in a hotel room, not the cramped one in Paris as half a century before, but a grand suite at the Mayfair on 65th and Park with wood fires in the room. It was their last conversation.

Lord Gowrie was there to give his farewell, but left Caroline to have her last words with the man who had made her immortal with paint. 'We could hear her laughing through the door of her room, and she suddenly sounded young and girlish,' said Gowrie. Caroline kept her dark humour to the end, telling Lucian how a friend had come to visit her with some holy water from Lourdes, which she had accidentally spilled. 'I might have caught my death,' she said.

As her son Sheridan stood in the hotel room, with light coming in through the window from the Manhattan street, although woozy with morphine Caroline somehow in her mind drifted back to the final portrait of her, *Hotel Bedroom*, where Lucian had stood by the window in Paris all those years ago, and for a few seconds she muddled Sheridan with Lucian, and said he was just like Lucian, as art and truth and the people she had loved all merged in her final moments.

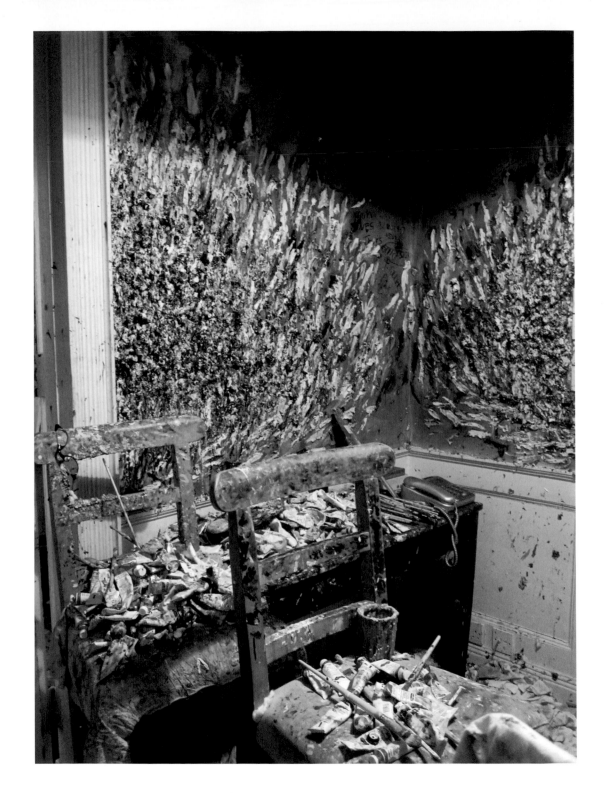

CHAPTER EIGHT # Paint

Lucian always had several paintings on the go at the same time. The work dictated every minute of his schedule, and nothing interrupted it. He was dictatorial to his models about being on time and would make some go through almost tantric feats of endurance, asking them to take up exhausting positions for hours at a time, and for weeks and often months on end. It defined his life and it was the only subject about which he ever wrote publicly.

'God, it seems cheap now,' said Lucian as he picked up my faded, yellowing copy of *Encounter*, the literary magazine edited by Stephen Spender. It cost just 2s 6d (12½p) and the 1954 July issue had included his essay 'Some Thoughts on Painting'. On the front cover he was billed above W. H. Auden but below Dylan Thomas and Bertrand Russell. It was his only published article, and in 2004 I was on a mission to get a follow-up piece fifty years after Spender had commissioned him to write about how and why he painted.

It was my second attempt to try to persuade Lucian to do something in *Tatler* magazine, having had him photographed at breakfast with Frank Auerbach. He liked the unexpected, and *Tatler*, the oldest magazine in the world, founded in 1709 with Jonathan Swift as its first correspondent, appealed to his sense of history and quirkiness. Would he write some more thoughts on painting? He said he would think about it as he flicked through my copy of *Encounter*, knowledgeably explaining Auden's take on the Old Testament story of Balaam and his donkey which had divine powers that meant it could hear the voice of an angel. He

Opposite: Paint-smeared walls in his Notting Hill studio

momentarily cursed Spender, who he insisted had stolen some drawings from him.

Lucian had not seen a copy of *Encounter* for decades, and enjoyed seeing reproductions of his pictures of Christian Bérard, Caroline Blackwood, John Minton and Francis Bacon printed over four pages, and two more pages carrying his text. He warmed to the notion of a sequel as long as he could think of something new to write. As we sat in Clarke's I read aloud part of his 1954 essay while he and David Dawson listened: 'My object in painting pictures is to try and move the senses by giving an intensification of reality. Whether this can be achieved depends on how intensely the painter understands and feels for the person or object of his choice.'

His views had barely altered, he said. It was the powerful combination of intellect and emotion – how he 'understands' and 'feels'. 'I have not changed my mind at all. I still feel the same. Isn't that right, David?' he said. It was almost a tic in his last years for him to seek confirmation from David, who had observed his pictures develop every day for twenty years. The original words, Lucian said, had been hard-wrought, chosen with the same perfectionist zeal with which he applied paint, almost chiselled from his mind. He had expressed disdain for abstract art, arguing vigorously the case for the superiority of figurative art: 'Painters who deny themselves the representation of life and limit their language to purely abstract forms are depriving themselves of the possibility of provoking more than an aesthetic emotion.'

He believed the human body was the most profound subject and he pursued a ruthless process of observation, using the forensic exactitude of a scientist dissecting an animal in a laboratory. His paintings were always more analytical than psychoanalytical; he never intended them to have a narrative. They merely showed what he saw and if the oddity of a zebra, rat or protruding leg gave rise to psychological interpretation, he would insist that he had merely painted what was before him.

I carried on reading: 'The subject must be kept under closest observation: if this is done, day and night, the subject – he, she, or it – will eventually reveal the all without which selection itself is not

possible; they will reveal it, through some and every facet of their lives or lack of life, through movements and attitudes, through every variation from one moment to another.'

The essay was a justification of his way of life. 'A painter must think of everything he sees as being there entirely for his own use and pleasure. The artist who tries to serve nature is only an executive artist.'[88]

Lucian listened and nodded. 'It is very straightforward as very simply all I ever really want to do is to paint. I am very selfish about it. I say it not as a boast but a fact. I have never tried to hide that,' he said.

His ambition, he had written in *Encounter*, was to give 'art complete independence from life, an independence that is necessary because the picture in order to move us must never remind us of life, but must acquire a life of its own, precisely in order to reflect life.'

One week later I was back in Clarke's and Lucian brought a piece of paper with several crossings-out in his genius-child handwriting, along with a few clear sentences. His thought process seemed jagged, reluctantly released into the world. He had shared his anxieties about finding the right words with his friend the art critic Martin Gayford, whom he painted in *Man with a Blue Scarf* (2004). 'I've written three new sentences. I thought of another one today, in a taxi. Writing is so enormously hard that I can't understand how anyone can be a writer,' he said.[89] 'I can't quite believe it, but I left out of my original article the most important thing.'

His new, very short manifesto contained his final published words. 'On re-reading it ['Some Thoughts on Painting'] I find that I left out the vital ingredient without which painting can't exist: PAINT. Paint in relation to a painter's nature. One thing more important than the person in the picture is the picture.'

In July 2004, it was published in *Tatler* alongside his original 1954 article. He judged the fifty-year gap between the two pieces to have been perfect timing. 'No hurry,' he said. Lucian had emphasised how painting was everything to him, and the way art was made obsessed him. On the walls of his studio were scribbled three words: 'urgent', 'subtle' and 'concise'. He explained how those words defined his purposes:

LF: 'By "urgent" I don't mean SOS urgent. It is like a memo; I was trying to put into words the qualities that I was trying to achieve. I think art is not called art for nothing; it is a deliberately wrought thing. What is on your paper or canvas is what you actually leave.'

GG: 'Is it important to try to achieve sensuality in a painting?'

LF: 'Yes: feeling and touch. With the painting of a horse it can be

rather like writing a love letter. It is to do with the forms themselves having a feeling that affects you. Doing it is private and individual.'

GG: 'How do pictures evolve?'

LF: 'If a painting's going well you work on it all over. You don't say, "Oh I won't touch that bit again." You suddenly find something you do changes another bit. That is the art element. That is what you feel or you wouldn't do it. The picture sort of paints itself out in the end. It doesn't want you to do any more; you have done enough. But sometimes you go on, wrongly, and think, "I have done this bit and so I will do some more over there," and then you think, "What a mistake!"'

GG: 'Can you remedy it?'

LF: 'Yes, you can do anything. Sometimes through urgency, strong decisions get things done on the canvas in a way that if you did it again it would not go down in the same way. Chance comes into what happens. Luck can be linked to pace or speed but also time. Scale affects everything. Doing everything on different scales is something that keeps you alive; it makes you aware. My *Self-Portrait with a Black Eye* that sold recently is tiny. I know this sounds presumptuous and rather selfish but it doesn't look tiny.'

GG: 'So what makes you paint?'

LF: 'It is what I like doing best and I am completely selfish.'

GG: 'Can anger come into it?'

LF: 'More like franticness or desperation.'

GG: 'What do you like about it?'

LF: 'Everything. I always have three or four things on the

go. It's the actual project. In my case it is always entirely autobiographical. I work always with people I like being with and who interest me.'

GG: 'Ambition is a major spur for you?'

LF: 'The one thing I don't want to do is just another picture.'

GG: 'And the sitter is essential at all times, even when you are painting the floorboards?'

LF: 'I need the person in front of me to achieve that because it's a portrait rather than a naked still life of a person on the floor.'

GG: 'And with the portraits of Caroline [Blackwood], were her enormous luminous eyes what was important?'

LF: 'I never really think of features by themselves. It is about the presence.'

GG: 'There are some painters you have told me you do not admire, like Raphael.'

LF: 'I am not saying he's not good. It's just not evocative. He's impossible not to admire.'

GG: 'Who then do you admire?'

LF: 'Ingres as much as anyone.'

GG: 'Do you think about time?'

LF: 'Yes, the older you get the more you do.'

GG: 'And do you remain ambitious?'

LF: 'Yes very. That's the only point. What is the motive otherwise? There cannot be a harder way of earning money. I work every day. I don't do anything else. I used to get caught up in manic activities like being in a casino for eight hours. No longer.'

The Notting Hill house where he painted in his final years was a cross between a rough and-ready carpenter's workshop and an eighteenth-century salon. As you entered there were two large, early, thickly encrusted Frank Auerbach paintings. In his kitchen was a Rodin sculpture of Balzac, bellied, bulky and imposing. 'It was his face but the body of a local butcher,' said Lucian as he put the kettle on his old gas stove to make a cup of tea.

Hundreds of paintbrushes were stuffed into large tins, baskets, pots, many of them stiff, old and covered in dust with paint-smeared

Brushes piled up

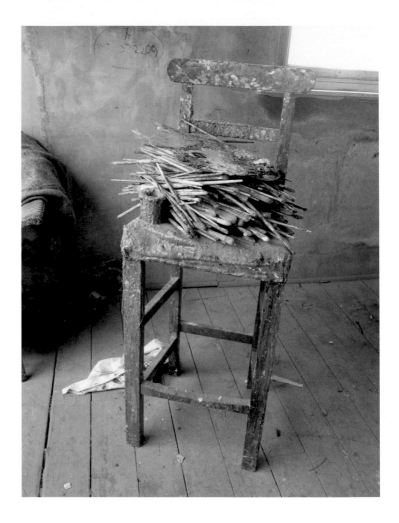

handles. The walls were in some parts crusted thick with paint, from where he flicked it from his brush or palette knife, building up and congealing over the years like 3-D Jackson Pollocks. (Lucian allowed only three pieces to be cut from the abandoned Holland Park studio wall to be preserved: one for Jane Willoughby, one for David Dawson and one for me. Six months after his death his studio was dismantled.)

Ripped pieces of white sheet on which he wiped his brushes were discarded on to the floor like giant pieces of tissue. Telephone numbers and names were scrawled on the wall. An old iron bedstead, leather armchairs with their stuffing spooling out, a tall bar stool, easels and tables of paint and brushes, were all arranged as if time had stopped. A trestle table in his studio bent under the

weight of unopened and half-full tubes of paint. The furniture and mattress covers were slowly fading, disintegrating, the room devoid of any electronic devices. It was like the set for Samuel Beckett's *Breath*, chaotically littered with miscellaneous rubbish, but somehow stylishly ragged. Michael Saunders, a bookie who worked for Victor Chandler, remembers turning up to try to recover money from Lucian to repay his gambling debts. He was met with a decadent scene: 'He had a tin of Beluga with a silver spoon in one hand and a paintbrush in the other, standing by the easel wearing what looked like pyjama bottoms,' he recalled. On the wooden table stood a half-bottle of Salon champagne, open, flat and warm. A slab of calf's liver pâté from Sally Clarke's delicatessen had been half eaten, its edges dark from being left out unwrapped. A tap could be heard dripping in the kitchen. He loved fine tablecloths. He was very happy neatly to sweep up crumbs. He had beautiful knives, forks and eighteenth-century wine glasses. He was so pleased, for instance to be given by his daughter Annie four simple egg cups. But next to the Irish linen tablecloth there might easily be rotting peaches, grey with decay. Lucian liked domesticity on his terms.

Although the physical material of paint was so present in Lucian's life – his clothes were often speckled with it – his hands were scrupulously clean. 'Sometimes I will have three baths a day; it calms me down,' he told me. He was snapped naked in his bath by the East End photographer Harry Diamond in 1966, and later by Jacquetta Eliot at her home in Notting Hill with her young son. He was rather addicted to time in the tub. He was always elegant, a raggedy silhouette sitting in the back of Clarke's, his grey hair cropped short by his daughter Bella, a day or two's stubble often visible. He slid across the kitchen linoleum in his socks as if on skates. Neil MacGregor remembered that 'He was always with no shoes on, scampering up and down the stairs in that long athletic way. The speed of movement was astonishing for a man of his age and the suppleness and deftness. There was something elfin about the features, the sharpness and brightness of the eyes and their constant movement.'[90]

Lucian needed to be fit, standing up for hours on end when working, at any time of day or night. If 3 a.m. suited him and

Lucian working on his final painting, *Portrait of the Hound*, March 2011

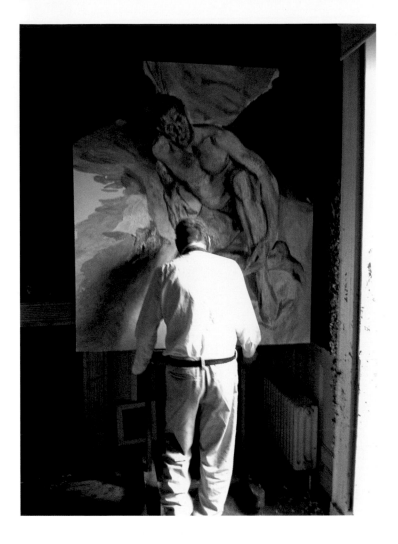

his model, he would paint then. Although his hours became less antisocial as he grew older and he found it harder to rise very early, the intensity of his relationship with paint did not fade. It folded into his life in every way: he even used a paintbrush as a shaving brush. 'Bristle While You Work' was the headline in *Tatler* beside a photograph by David Dawson of Lucian lathering up his face with a paintbrush in one hand, a razor in the other.

'It was not just a need to paint. It was the need for perfection,' said Victor Chandler. 'Sometimes he bought back pictures which he felt were not good enough and should not have left the studio. It was the anger, real anger at himself when he did something wrong. And

it was quite frightening because he'd jump backwards and swear. You got "Fuck, fuck, fuck."[91]

Success or failure rested on a knife-edge. 'I think of Lucian's attention to his subject. If the concentrated interest were to falter he would come off the tightrope. He had no safety net of manner,' said Frank Auerbach.[92]

He painted whoever was in his life, sometimes those intimately connected with him, like his children or lovers, sometimes strangers with whom he became intimate through the very process of painting them. Mark Fisch, the New York property developer and Old Master collector, whose portrait Lucian painted, said to me, 'I can remember him telling me once how a girl he had never met knocked on his door, he opened it, she enters, he fucks her against the wall and then he paints her.' This was recounted to Fisch when Lucian was eighty-four. 'Countless husbands and boyfriends could have put a sword through him. In so many ways he should not have lived till the age of eighty-eight,' said Fisch.[93]

Sometimes his friendships splintered, as did the one with Tim Behrens, who for nine years saw Lucian almost every day. They had met in 1955 when Tim was a 17-year-old student at the Slade School of Art, and Lucian was his one-morning-a-week teacher, at 33 almost twice his age. For a time they were inseparable. 'Everyone assumed we were having a homosexual relationship which was very far from the truth. For a time we lived together, sharing a house at 357 Liverpool Road, Islington,' he remembered, fifty years after he first sat for Lucian.

The older and younger painter grew very close and as a sign of his affection Lucian gave his protégé an early self-portrait and a drawing of Caroline Blackwood. But sweetly as their friendship started, it was to end sourly.

One reason was the cross-over of women in their lives, remarkable, even by Lucian's priapic standards. Three of Tim's girlfriends became lovers of Lucian: Suzy Boyt, Susanna Chancellor and Janey Longman. Lucian also had an affair with Tim's daughter Kate.

When they first met in 1955 Tim was the rebellious son of a prosperous banker. He had left Eton early to go to art school where he met Lucian, who immediately asked him to sit for a portrait (he

painted him four times). He also encouraged Tim with his own painting and bought some of his pictures. It was as much a friendship of equals as a quasi father–son relationship. They partied hard, often very late, as well as hitting the pubs around Paddington, not that Lucian drank much. 'We used to play pinball a lot, Lucian never won,' recalled Tim.

Gambling debts sometimes caused the odd social hiccup. 'I remember when a guy comes up and says "Hello Lou, how funny seeing you." Lucian head-butts him and says, "Run." We get away and then I say, 'What on earth was that about?' Lucian says, "I think I owe him fourteen." I say, "Fourteen pounds? That's not much." "No," he says, "£14,000". It had been a gangster trying to get money owed to him.' Lucian and Tim were famously photographed together by John Deakin in Wheeler's at a table with Francis Bacon, Frank Auerbach and Michael Andrews.

'When we lived in Liverpool Road, Lucian was with Suzy Boyt and I with Anne Montague,' explained Tim, who had introduced Lucian to Suzy Boyt, the eventual mother of four of his children. 'I first saw Suzy at a party, glued to a guy who I did not think was worthy of her. I was at least as good looking! Their mouths were locked together as well as their thighs. I waited to make my move,' he recalled. 'Lucian later asked for an introduction to Suzy, describing her to me as "that marvellous girl with green hair". I had gone out with her before, not very satisfactorily, and I was happy to pass her on to Lucian,' he recalled.

Tim next met Susanna Chancellor, or Debenham as she was then called, when she was the girlfriend of Jane Willoughby's brother Tim. Behrens regarded him as too rakish, someone from whom she needed rescuing. And according to Behrens, he accompanied Lucian to Nice to lure Susanna away, but after she left Tim Willoughby for him, Susanna subsequently turned to Lucian. One positive repercussion for Tim Behrens was that he met his second wife as a result of Lucian luring Susanna away from him. On finding the front door of his flat locked he went to bed in a small room on the mezzanine, taking off all his clothes, only unexpectedly finding another girl in that bed. She became his second wife.

The falling out with Lucian occurred soon after Tim's first

wife unexpectedly died. She had an allergy to bee and wasp stings and, after they had separated, she had gone on holiday with her Turkish boyfriend without her serum and had been fatally stung. A few months later, Lucian became livid with Tim for immediately and, in his eyes, inappropriately, falling for a girl who looked just like his dead wife. Lucian thought this extremely bad taste so soon after her death and they rowed angrily. When Tim went round to try to talk it over, Lucian said he was too busy painting and slammed the door shut. It was one of the last times they ever spoke. Their intense nine-year friendship was over. 'I was devastated. I could not believe anyone could be so cold. I had seen him as a substitute for my father who had been a complete bastard. I truly loved him and that was what made it so painful when we had our bust-up,' he said from his home in Spain, where aged seventy-five, a black patch over his right eye, his hair still sandy red, he is a celebrated poet and painter.

A no less conventional introduction took place in 2002 when Kate Moss was brought to Lucian's attention by his daughter Bella. It went against all his instincts to use a professional model, but with her he was intrigued. She was wild and unpredictable and had caused a global media storm when she had been caught in a tabloid drugs sting. He always liked rebels.

LF: 'I was told there had been an interview in a magazine in which Kate said she wanted to be painted by me. I asked Bella if this was true. I had had a dance once with her and so when I heard that she had said she wanted to be painted by me I told Bella to send her round.'

GG: 'Was lateness a problem?'

LF: 'I used to get very cross sometimes. I get tense when working and the worst thing is if anyone is late. She was late only in the way that girls are, sort of eighteen minutes late. I was cross but tried to ignore it. I used other means to get her on time like sending someone to fetch her.'

GG: 'Are you glad you painted her?'

LF: 'I liked her company. She was interesting company and full of surprising behaviour. I used to mind someone waiting outside for her while she was with me. I think it was someone

she had been with since she was very young. I have always hated being watched. Not that it happens much.'

GG: 'And the end result?'

LF: 'The picture didn't really work.'

GG: 'Why didn't it?'

LF: 'That is like asking a footballer after the match why he didn't score. The picture is now with a South American collector.'

GG: 'And is it awkward when a painting is finished and you don't want to see the person again?'

LF: 'That was not the case with Kate but not really. I've never gone in for any lying, apart from just ludicrous ones. I so like that saying of William Blake: "The truth that's told with bad intent beats all the lies you can invent." I think that's terribly good, but I've never gone in for it.'

GG: 'When I had dinner with her she told me you gave her a tattoo.'

LF: 'I think it was done in a taxi. She said I keep on hearing you give people tattoos. What do you do? I said, "Come on," and gave her a tattoo in the taxi.'

GG: 'She said you used an engraving stick. I asked her to show me her tattoo but she said not in the restaurant where we were.'

LF: 'It was a little bird.'

GG: 'Who else have you given tattoos to?'

LF: 'Not many.'

GG: 'How do you cut?'

LF: 'You draw and rub in Indian ink until the blood comes up. Then it's what's called the scab which you pin in some of the ink and when the scab goes there's a drawing, the tattoo. It's very primitive. They did it on the merchant navy ship I was on during the war.'

GG: 'They gave you a tattoo?'

LF: 'No I gave them tattoos. "Oh, yeah," they'd say, "you're a fucking artist, give us a tattoo." They'd say, "My girlfriend says if there's an artist on the ship get him to tattoo my name." Sometimes I did animals, mostly horses.'

GG: 'Some of your earliest work!'

LF: 'I wouldn't like a tattoo myself. I think I could stand the

pain but when the police arrest somebody they strip them to see any identifying marks. I wouldn't want such a clear identity. I prefer to be able to slip away unnoticed.'

Another person he tattooed was Jacquetta Eliot, who allowed him to mark her bottom. 'If you are in love you do crazy things, it just happened,' she explained.[94] During his tempestuous affair with her, his landlord put a note on the front door of the building in Paddington where Lucian had his studio, asking everyone to keep it shut to prevent rats entering from the basement. Thinking of her lover, Jacquetta wrote a reply on the note: 'Too late. There's already one on the second floor.'

* * *

Painting and the act of sex were not unconnected. According to John Richardson, for Lucian they were interchangeable. 'He turns sex into art and art into sex, the physical manifestation of his life expressed through paint. His creativeness was very akin to fucking. The sex act and the intellectual act – or creativeness, or whatever you call it – of painting, were in some ways interchangeable. He had no difficulty transforming sexual notions into paint and paint into sexual notions. There was no differentiation; the two aspects of his senses came together in the act of painting.'[95]

But nakedness does not necessarily mean openness. The identity of the sitters often stayed secret, which was at odds with the way they were revealed in truly explicit poses. For instance, Penny Cuthbertson, who married Desmond Guinness (Caroline Blackwood's cousin and the son of Diana Mitford, whose sister Debo became Duchess of Devonshire and one of Lucian's oldest friends), obsessed Lucian for years in the 1960s. In *Naked Girl*, painted in 1966, her genitalia appear raw and pink. She lies back with a sense of acceptance of being dominated, not only by the angle of the picture as we look down on her, but also by her sweet expression of acquiescence and adoration. Her feet being cut off by the bottom of the canvas draws her even closer as if she cannot escape scrutiny.

For all his dramatic impact as a great painter of nudes, in

spite of his overt subject matter, his pictures were themselves not without a degree of caution, according to Richardson. There was rigid control and formality in his composition, however bizarre it might seem, with girls contorted on the floor or in cupboards, or Leigh Bowery with his legs askew on the sofa. 'There are these people lying around, male and female, sexual parts exposed, painted with a great deal of love and care but at the same time there was a reticence,' said Richardson. 'With Picasso you know he has fucked this girl, is thinking of another and so he adds blonde hair to the brunette. It is the reverse of reticence. Picasso is thinking what more can he bring in. He might have seen a Man Ray book of bondage photographs and so a little bit of bondage comes in. It all comes at this heterosexual dynamism which you never get in Lucian's work. You get this double take, a very sexual subject but, in a way, presented in a very reticent manner. There is this double thing of reticence and overtness.'[96]

One work of intrigue and ambivalence features the artist Celia Paul, who was taught by Freud at the Slade, and who was the mother of their son Frank, born in 1984. In *Painter and Model* (1986–7) she stands fully clothed while a naked man called Angus Cook, unrelated to her, lies on a cracked brown leather sofa. It is another scene of tangible tension. Lucian paints her bare foot squeezing green paint out of a tube. Having previously been painted as Lucian's naked lover, helpless before his gaze, Celia sees herself with newly emerging power in this picture: 'I'm holding this very definitely angled brush and I'm standing on a tube of paint which is oozing. The brush and the oozing paint tube, I feel, are kind of sexual symbols and I think suddenly me becoming a mother and a seriously ambitious painter put me in a different position and I was no longer the kind of voluptuous figure lying on the bed. I remember at one point we had some quarrel and I said I'm leaving and he pleaded with me not to because he said we're just in the middle, and it made me conscious that there was going to be an end and that it wasn't going to be a relationship for life.' It was not something that Lucian ever denied.

Life with Lucian was very tricky for the mothers of his children, and for Celia, there was the ever-present dilemma of how

Painter and Model, 1986-87

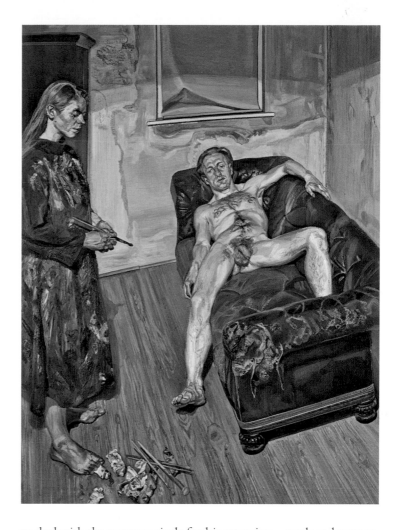

to deal with the constant rivals for his attention – work and women. He always wanted them to sit for him. Celia said, 'I found it an excruciating experience to be scrutinised so pitilessly. I cried most of the time. After that I think the paintings of me became more tender. He started the painting of me called *Girl in a Striped Night-Shirt* in 1983 and finished it in 1985. I sat regularly from 1980 to 1987. The first painting was *Naked Girl with Egg*. The last painting was *Painter and Model* which shows my independence, me literally standing on my own two feet as the strong, clothed painter compared to the weary, vulnerable, naked man [Cook] on the sofa in front of me.'

For young painters like Celia Paul, it was absorbing to see him at work. In one painting, *Double Portrait* (1985-86), she is the subject as

well as being able to observe the other model. 'When he painted he stood quite close and it was always possible to see the slow progress of the painting. He would start from one point and then work out from there. In *Painter and Model* he started with Angus Cook's balls and for a long while that was what he focused on.'

Wanting someone meant wanting to show in paint what they were like, who they were when put under scrutiny and how they interacted with him. The experience affected the psyche of all his most intimate sitters, like Celia. 'He didn't start painting me for two years until after I started going out with him. I was a very, very self-conscious young woman and it did feel very exposing to lie there and he stood very close to me and kind of scrutinised me in a way that made me feel very undesirable. It felt quite clinical, almost as though I was on a surgical bed.'[97]

Encountering Lucian himself naked in his studio was not uncommon. His art dealer Anthony d'Offay would conduct conversations with Lucian in the bath, catching up and exchanging news. 'He would get out of the bath and be completely at ease, almost purposefully so, clearly not shy about his body,' he said.

Lucian was quite nonchalant about how new models and lovers entered his life, whether they were random encounters in restaurants or letters from admirers, and he was always on the lookout — even in St James's Palace, where he asked a young woman who worked for the Keeper of the Queen's Pictures to pose for him. Henrietta Edwards had sat in for the Queen to wear the diadem on her head for some extra sittings when Lucian was painting the monarch in St James's Palace.[98] He was always on the look-out. When his specialist art movers came for a meeting at his Notting Hill house in 2006 he invited Verity Brown, an engaging 29-year-old executive, upstairs to see his pictures. She ended up naked as a sitter a few weeks later, and although she was not a lover, she became very attached to him. Whenever he found someone he liked, he folded them into his extraordinary schedule, painting day and night. 'My subject matter is entirely autobiographical: using the people I like and who interest me to make my pictures,' he explained to me.

The final stage in the creation of his pictures was often the appearance of Frank Auerbach. 'I dreaded the arrival of Frank as

it most likely meant that the painting was finished,' said Verity Brown.[99]

'I would always ask Frank what he thought. Above anyone else he would have a view which I would want to hear and which could be useful,' said Lucian.

It was never easy. Paint for Lucian was 'pain' with a 't' on the end, as one of his sitters noted, a view echoed by his son Alex Boyt (known as Ali), who also sat for several pictures: 'It appeared to me that the painting process had an element of masochism. When a series of brushstrokes went down well there was often a silence, but when the paint didn't do as he wanted, there were startling jumps, shouts and stabbing himself or slashing at the easel with a paintbrush.' Progress could be slow. 'Sometimes he would work on a part of a painting for a week, only to decide it wasn't good enough, soak a rag in turpentine and gently wipe the whole lot away. When I was young, after I had put so much effort into sitting as still as I could, my heart sank when it appeared to have been for nothing,' Ali said. 'Dad told me once that if he lived to be 300 he might become good at painting.'[100]

Modelling for Lucian always went far beyond sitting still in one spot as he folded sitters into his social life too. Lucian also liked to escape the entrapment of his studio. 'In my teenage years, the sitting started to take on a glamorous edge. There were the visits to the Playboy Club after work where Dad raised the stakes at the blackjack table until all other gamblers left, save sometimes one stubborn Arab who couldn't be shaken off. There were letters from the Vatican cajoling Dad to paint the Pope.' Lucian took it all in his stride.

But finding models or muses was not always straightforward. When Lucian cast an eye towards Hannah Rothschild, the protective instincts of her mother Lady Rothschild came out. 'My mother apparently said if you lay a finger on my daughter I will break both your kneecaps. He was so upset that he left the house immediately,' recalled Hannah. She never sat for him. The next morning a poison postcard from Lucian to Lady Rothschild landed on the mat.

The raw, naked portraits are the most recognisable of Lucian's paintings, but he also often brought narrative intrigue to his work.

Sunny Morning — Eight Legs is a painting in which David Dawson sprawls naked across a bed, his arm around Lucian's whippet Pluto. The room seems abandoned, its dirty plaster walls more suggestive of a police cell than a living room. The picture seems to tilt, making David and the whippet in his arms appear as though about to slide unnervingly towards the viewer. Two of the legs referred to in the title belong to David, four to Pluto, and then there are two further anonymous male legs emerging from under the bed. Do they belong to a corpse? To someone hiding?

At Clarke's, David explained to me that all the human legs in the picture are his, and that during the sitting, as well as lying on top of the bed, he had also lain underneath it for weeks with his legs poking out, the rest of him wrapped in a duvet on a mattress of cushions. 'I am not a naturist! I was allowed to wear pants under the bed,' he laughed.

'Even I am not that demanding,' added Lucian.

The extra legs were added to give a sense of hidden space under the bed; but it is also simply what was there: his loyal assistant and dog stripped bare in his unadorned studio. Lucian was averse to the idea of any symbolism being seen his pictures, yet embraced the idea of narrative interpretation. 'The reason I used David's legs rather than somebody else's was precisely because I didn't want mystification. I thought, by using his legs, it would be rather like a hiccup or a stutter or a nervous repetition and therefore the legs would refer back to David.'[101]

Another quirkily composed picture, *After Cézanne* (1999–2000), is in part a homage to the post-Impressionist painter's two different versions of *L'Après-midi à Naples* (1872–5 and 1876–7), with Lucian's variation using a stockily built naked woman awkwardly carrying cups of tea on a round tray towards the two other naked figures. Lucian used his son Freddy, and a blonde-haired woman introduced to him by Sue Tilley, to sit on a white makeshift bed on the wooden floor. A chair nearby lies upended. The upper right-hand corner of the canvas is completely missing, as if the painter has cut it out, playing games with the viewer's expectations. Or was an extra panel added on the left side to give the woman with the tray more space? It is playful, but like so much of what he painted, it does not

make the viewer feel comfortable. The man is leaning awkwardly on wooden steps. The woman with the tray seems to be steadying herself to avoid tripping. The blonde woman looks as if she has been rejected in some way by the man. The fallen chair adds to the nerviness, the jittery lack of calm. One of the women had worried that it was unflattering to paint her without her nightdress. Freud disagreed and said he always made his models seem ugly. To make her feel better he told her he was worried that he had made her look beautiful. It was a typical Lucian conceit that he should worry that he had failed by flattering.

Large Interior, W9 (1973) is one of the most remarkable of his portraits, with his elderly mother, buttoned up in tweed suit and sensible shoes, sitting in a leather armchair while his naked lover Jacquetta Eliot lies on a low iron bed, half-covered under a brown blanket, her naked breast exposed, her arms locked behind her head. Neither woman interacts, they appear in separate worlds and that is really the point. It is as if he has created a scene between a psychoanalyst and a patient. For years Lucian had felt harassed by his mother seeking personal information about him; the intimate details that she would have so desired were now flung in her face with the image of Jacquetta lying exposed on a mattress.

There is a sense of the hospital or asylum about this painting. A mortar and pestle lie on the floorboards, suggestive of a chamber pot beneath the old woman's chair, but also a reminder that they are both in a painter's room (or patient's room), where pigments are ground. Both cry out for psychological interpretation. But it is also not quite as it seems. The two women never posed together. Lucian kept them separate, joining them only on the canvas, which gave a bizarre psychological twist to the strange three-way dynamic of the artist, his widowed mother and his lover. Again, this is a milestone painting in Freud's oeuvre with its more adventurous use of space and the experimental composition. Perhaps more is learned about Freud himself in the end, rather than about the lover and forlorn mother. The woman with her arms locked behind her head on the bed exposing her armpit hair, her knees bent under the woollen blanket, and the bare mattress echo an earlier portrait of Kitty. His mother is gripping the chair with her gnarled hands, her

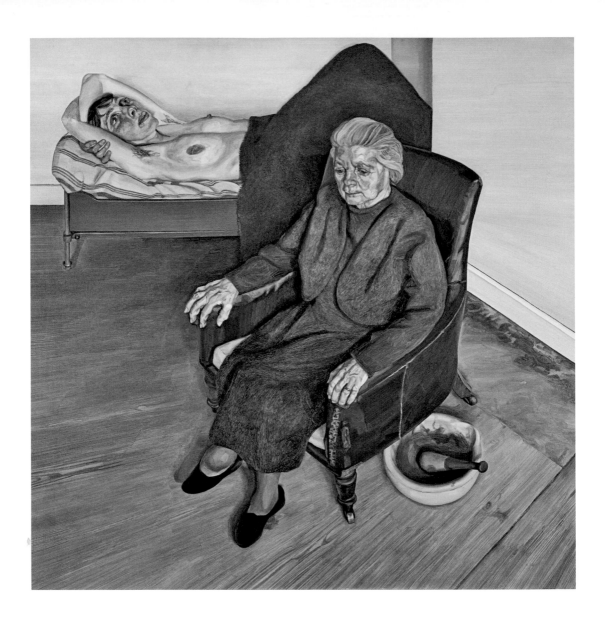

Large Interior, w9, 1973

wedding ring in contrast to the illicit affair between Lucian and his married lover. The colours are brown and muddy with only the pink of the nipples and the gold wedding band showing lightness, and the empty space between the two figures and their gazing in diametrically opposed directions increases the sense of alienation. The bare simplicity is stark, and the fact that no clue as to the relationship between the two women is given in the title, gives the picture an edge of tension.

All his life Lucian captured moments to which he brings a sense of drama: Kitty appearing to be about to strangle a kitten or tensely gripping a rose; the gangster masculinity in *Guy and Speck*, in which the massive right hand of Guy the bookie is all that stops his terrier Speck from falling off his lap on to the floor. So often he makes the viewer feel discomfort. It often simply reflected surreal aspects of his life, or how he was perceived to live; for instance, when he and Kitty set up home their household was rumoured to include a condor with a six-foot wingspan. (Not true, but he did have a large, fierce kestrel, about which Kitty gave him the ultimatum 'either me or it'. In a rare retreat, he took it back to Palmer's, the pet shop.)

A mystical connection to animals was integral to his art and life. He had a particular passion for birds of prey, and in the late 1940s he kept a pair of sparrowhawks in his house. To feed them, he would shoot rats with his gun on the canal bank at Regent's Park. He once brought home a pair of buzzards. His whippets Eli and Pluto were part of his entourage and he drew, painted and engraved them. At an auction in 2012, an etching of Eli fetched a record price for a Freud etching of £147,000.

'I am a sort of biologist. My interest in humans as a subject is as an observer, examiner and watcher of people. I worked a lot from horses in this way,' he told me.

'I don't know if he could break a horse but if anyone could it was him,' said John Richardson. 'He adored animals and they him. It was like some psychic power. Just as Picasso could put his hand into a cage of wild birds and one would quietly allow itself to be taken, so too did Lucian have a gift.' At the close of his career, he painted *Grey Gelding* (2003) and *Skewbald Mare* (2004), portraits of horses he rode outside Wormwood Scrubs prison where he had transformed the stables, run by a nun called Sister Mary-Joy, into a temporary studio. He liked the juxtaposition of a nun and a jail. He would sometimes turn up at Clarke's for a late breakfast after riding Sioux, the skewbald cob mare. He knew how to make horses do exactly what he wanted (except win a race). 'He was like a shaman with horses. They knew him as if he had magic powers,' said Sister Mary-Joy.[102] The shamanic side to him can be seen in a 1948 Clifford Coffin photographic portrait of Lucian with a kestrel.

It was a feisty quality in Kate Moss that he liked, her particular wildness, an aversion to conformity and domesticity. 'He talked about foxes in the same way that he talked about her,' said restaurateur Jeremy King. 'He liked the free spirit. He liked the bite of danger.'

Sometimes this sense of danger, mixed with intrigue and mischief, hovered over the breakfast table as he sat in Clarke's, incongruously slicing slivers of nougat. 'I don't think I ever killed anyone,' Lucian told me. We had been talking about gangsters with guns turning up at Delamere Terrace, which had led Lucian to query whether he had killed anybody. 'I like conflict and tension,' he said.

When he left his house or a restaurant in his later years he would often pull his grey coat over his head and hide his face with a scarf to shield himself from the attention of the paparazzi. It made him seem like a prisoner on the run rather than the Grand Old Man of British art.

Did he ever get into trouble with the law? 'Only occasionally being locked up overnight: something to do with fighting. Shaftesbury Avenue in the 1950s was a bad place for me. I had a house in Dean Street but I couldn't paint there. Too many people on the run from the police knew I was there and would ask if they could stay a couple of nights.'

Was he ever jailed?

'Only in a police cell but I visited people in prison. The man who lived underneath me was a car dealer and the police said he killed somebody. I got involved because the night he was supposed to have done it, he was with me. I went to see the chief of the West London police and they were cajoling and blackmailing: "You are well known around here and if you want to go on living in this district ..." It was really squalid. I did not realise how crooked the police were and then something happened, like in a really bad novel: I went out with Princess Margaret and the Queen and this was reported in the press and all the trouble stopped.'

Lucian instinctively distrusted those outside his immediate circle. When the art dealer Robin Hurlstone bought at auction some of Lucian's love letters to Caroline Blackwood, he furiously demanded them back because they were, in his opinion, stolen. They were, in

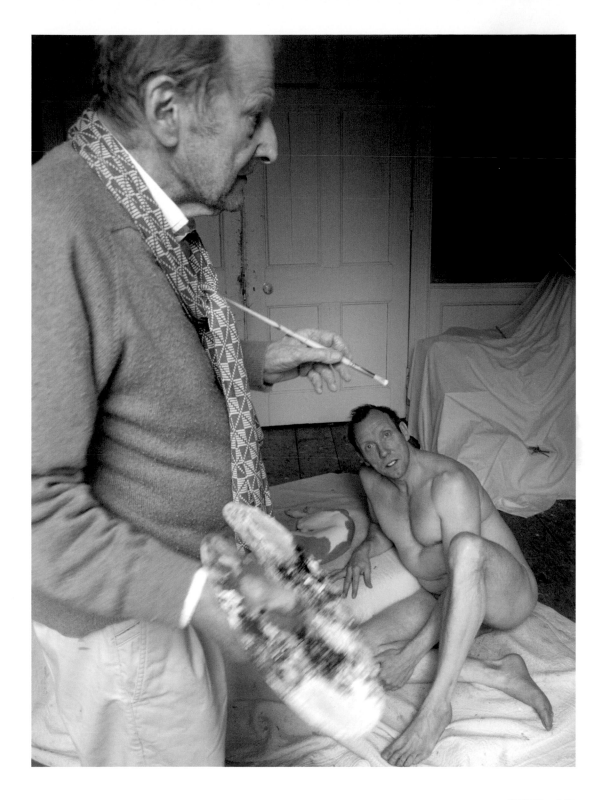

fact, sold legitimately and he eventually conceded that Hurlstone was an acceptable owner of his love missives, which included some drawings. But he had been viciously vocal on the matter. He never apologised and seldom explained. Lucian did only what he wanted and never what others asked. When also asked by the National Gallery trustee Simon Sainsbury if he would lend the painting *Two Figures (1953)* by Francis Bacon which hung in his bedroom, Lucian refused – even though it was for a big show at the Pompidou in Paris. Lucian declined with poetic brevity: 'How dispiriting to look at a nail.'[103]

Lucian was by reputation litigious, and quick to ring his lawyer Lord Goodman, the consummate legal fixer of the time (whom he drew in 1987 wearing a pair of yellow pyjamas). Just as Lucian liked to have his suits made at Huntsman, the grandest and most expensive tailor on Savile Row, so he sought the best legal advice. Arnold Goodman was not a strong-arm tactician and more often than not would make a problem go away with a quiet word. But Freud rarely sued and certainly never commented in the press. I interviewed Goodman in 1989 for the *Sunday Times* and the editor decided not to use the article. I rang Goodman to apologise for wasting his time and he could not have been more charming, assuring me that he would sort it out and that it would most definitely be published. And it was. This was exactly the sort of ally Lucian loved to have on his side: discreet and influential.

In Lucian's latter years Goodman's successor Diana Rawstron was equally effective. He was well protected by her, a soft-spoken Yorkshirewoman, and they talked almost every day. His dentist bills, tailor's invoices, bank statements and fan mail all went to her. Occasionally a letter from a stranger intrigued him – the painting *Naked Solicitor (2003)* was the result of Marilyn Gurland, a Ghanaian-born solicitor from Brighton, writing to him to enquire why he had never painted a black woman.

Very few details of him as a father or indeed as a husband emerged. At least one lover was banished from his life as soon as she had apparently given birth, the child never meeting Lucian. Some of his children gave interviews to the press, quite guarded and careful and usually with his permission, but some of them infuriated him

with their public complaints about his absenteeism. Sitters who were bold enough to divulge what happened in the artist's studio were given the cold shoulder. When the endless rumours about lovers and children threatened to make it into print, swift action was often taken to maintain his privacy. One newspaper was forced by Rawstron to apologise and pay damages when it muddled a daughter with a lover. A protective silence was built up around him, which is how he preferred it.

Sometimes he was not averse to less orthodox means of persuasion, such as calling in a few gangland favours. Once over breakfast, Lucian asked me if I needed any help from his 'friends in Paddington' when I was involved in a quarrel with someone. I declined, but it was a part of his armoury. He would also occasionally resort to unconventional means of self-protection. Delivering a copy of the *Evening Standard* to his front door one evening, I rang the bell and after the clunking of several locks the door opened a few inches and a voice menacingly asked, 'What do you want?' A ten-inch knife with a serrated edge was pointed at me. 'Lucian. It's me, Geordie. Put the knife down,' I urged. And then I laughed, and when he saw I was laughing, he laughed too. '"Lunatic Artist Stabs Editor of *Evening Standard*" is not a good way to be remembered,' I said.

'I can think of worse ways,' he answered, letting me in and offering me a cup of tea.

Woman in a Fur Coat, 1967-68

CHAPTER NINE # Lovers

In his later years two women stood out, of more significance than all of the younger ones who were to sit for him. Jane Willoughby and Susanna Chancellor ran on parallel tracks, seeing him separately, almost never meeting each other but both very important to him in different ways. They were essentially the women to whom he turned for true companionship and unconditional love. They were only too aware of the difficulties of falling in love with Lucian. His restlessness as an artist and inability to be tied down defined him.

No one loved Lucian longer than Jane Willoughby. They were introduced in the late 1950s and for the next sixty years their lives were threaded together. Jane helped him all his life and forgave him everything. 'She understood he was an artist and would do whatever he needed to fulfil that role,' said Anthony d'Offay. They met at a ball where Lucian emerged from under the skirts of another girl's ball gown. Both had the same bohemian impulses and, crucially, Jane had a love of art and an understanding of why it mattered more than anything else. Tim Behrens remembered Lucian at his most anguished over Jane. 'He was terribly upset, rolling on the ground in complete misery. I don't know what it was about. Maybe because she would not go to bed with him or because she did not love him as much as he did her. It was very un-Lucian-like, I was impressed by this sign of human weakness and heartache. Before that I had always thought he was invulnerable in that way.'[104]

Over time she came to accept his refusal or inability to be tied down. Two failed marriages were enough for Lucian to know that

it was better that he lived alone. 'Through not being married they remained in love with each other, if you see what I mean,' added d'Offay. 'If they had married it would have been untenable because Lucian would never abide by anyone else's rules. By being separate and sort of understanding each other they managed to love each other all their lives. His relationship with Jane was a big anchor for Lucian. It made him feel safe or something like that.' Not that it was easy for Jane. She would sometimes write to him saying it was too painful to go on seeing him; but it always did go on. Lucian told Jane there were only two women with whom he had fallen in love: her and Caroline.

Jane is depicted in the 1967–8 painting *Woman in a Fur Coat* (also the title of a great portrait by Titian painted *c.* 1537). It is a picture of tenderness and affection. Clothes were always important and they interested him, but he wanted the picture to make people ask 'Who's that?' rather than 'Who's that in a fur coat?' He felt strongly that they were two distinct reactions. There is no known picture of her naked and this surviving portrait tells little of their long relationship. Lucian used to stay with her at her baronial home in Perthshire and supported her plans to build up an astonishing collection of work by modern British artists who were essentially his friends: Frank Auerbach, Michael Andrews and Francis Bacon were the most significant. She owned the Holland Park flat where Lucian lived. She bought his first ever sculpture, the three-legged horse. Jane was kind to his children and his parents. When part of her house in Belgravia was altered she used Ernst Freud as the architect. She was generous not only with her money but also with her time and thoughtfulness. She was crucial to his life and continues to be crucial to his legacy, accruing the greatest collection of his works. There are plans to use part of her house as an extraordinary museum for the work of Freud and his circle.

Born Nancy Jane Marie Heathcote-Drummond-Willoughby on 1 December 1934, she was the daughter of Earl Ancaster and Nancy Astor; Jane's grandmother was the more famous 'other' Nancy Astor, the first woman member of the House of Commons. On her father's death in 1983 she became the 28th Baroness Willoughby de Eresby.

When Lucian met her she was free-spirited, beautiful and clever, a modern girl with an ancient pedigree. Lucian particularly

liked the fact that she had served as a train bearer and Maid of Honour to the Queen during the Coronation. She seemed set for a charmed life, until her brother Timothy, heir to the earldom, went missing at sea off Corsica in 1963. Suddenly she was the heir, and from that moment her life was defined by her family's possessions. She was to inherit 75,000 acres in Lincolnshire and Perthshire, and become a joint hereditary Lord Great Chamberlain to the Queen. She has never married or had any children, and it was Lucian who played perhaps the most significant part in her life, together with Eric de Rothschild, who also became an important collector of Freud's pictures much influenced by Jane. She was one of the few people with whom Lucian remained close over a long period.

He talked to me about her with deep affection and admiration. Often on a Sunday she came to have breakfast to see his latest paintings. She also was part of an inner circle invited on his rare trips abroad. In some ways, she had seen all the other women off. She knew they would not last as long with Lucian as she had and would continue to do so. Perhaps it was the fact that she had never had a child with him that gave her a sense of independence and also availability. But if Lucian had married her, as his friends often thought he might, he would have also married into the responsibilities of owning two great stately homes — an impossible task for a man dedicated solely to his own life and work.

She showed him great love and was loved back in kind. If any woman got the most of Lucian's capacity to commit in his own peculiar way, it was her.

Also important for many years was Susanna Chancellor, who like so many of the women who stayed in Lucian's life he met when she was very young, still a teenager. Born Susanna Debenham, she was a schoolgirl at Cranbourne Chase when they met. Her father Martin was a left-wing politician and worked for the Coal Board. The family name was famous because of the eponymous Oxford Street department store. The Lucian links were almost claustrophobically close, as Susanna's boyfriend for about two years at that time was Timothy Willoughby, Jane's brother, shortly before his death at sea. Susanna sat for several portraits, but not until the 1980s. She remained a constant thread in his life, especially in his later years. When he

gave her etchings, and there were many, he always autographed them using her maiden-name initials 'SD'. She introduced whippets into his life and his art. They were the only constant in his domestic life. In *Double Portrait 1985-1986* Susanna's arm shields her eyes as she lies entangled with a whippet called Joshua, an intimate image combining his obsession with animals and women.

Their relationship started with tremendous passion. Ffion Morgan, daughter of Ann Fleming, who had introduced Lucian to Caroline, recalls 'a dinner party where he had her sitting on his lap ignoring every other guest – especially me, as I had made it clear that I did not want to have an affair with him'.[105] They were introduced when Susanna was seventeen and the relationship lasted until his death, when she was in her mid-sixties. Throughout all this she remained married to Alexander Chancellor, the convivial and clever journalist who had edited the *Spectator* magazine in the late 1970s and early 80s. Their families were close: Alexander's aunt Paget was married to Susanna's uncle Piers Debenham, and their grandfathers had also been friends.

Susanna's link to Lucian had a new layer of complexity added around 2000, when Lucian painted and started an affair with a young writer called Emily Bearn, who had also had an affair with Alexander. Born in 1974 and educated at Westminster and Cambridge, she was a talented features writer for *The Times* and the *Sunday Telegraph* when she first met Lucian in 1998, at which time she was in her mid-twenties while he was in his late seventies. She later quit journalism to become a successful writer of children's stories. She was intelligent, articulate and attractive. In all she sat for seven paintings, one of which, *After Breakfast* (2001), shows her lying on white sheets placed directly on the floorboards of the Holland Park studio. The perspective is disorienting as the floorboards seem to be tipping towards the viewer. Emily looks almost wounded, lying in a state of seeming anxiety, accentuated by the games played with odd angles and perspective, her right hand grabbing her own hair.

What was unusual was that Emily actually moved into his Notting Hill house, which ran counter to his anti-domesticity agenda. He was completely smitten and asked that she give up her staff job at the *Sunday Telegraph* to go freelance. As always he

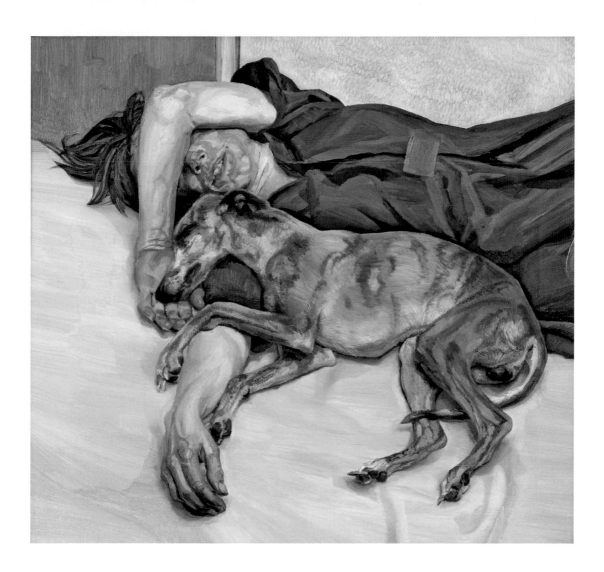

Double Portrait 1985-1986

wanted to pursue every aspect of his lover, and with her this involved making a double portrait with her father, the anatomist, Dr Joseph Bearn, almost a contemporary of Lucian, born in 1923, who lived in a chaotic house in St Luke's Street, Chelsea. Lucian painted him there, separately painting his daughter for the same picture, *Daughter and Father* (2002). It was an extraordinary circle of sitters which covered his time with Emily. The rota included two sons of his Irish bookie, Kate Moss, David Hockney, the Queen, Henrietta Edwards (from the Queen's Picture Gallery) and his son Freddy Eliot, as well as self-portraits and the perpetual sittings by David Dawson.

The end to his time with Emily was wrought with pain when she moved out of his house at the end of 2002. She continued to sit for him until they finally split for good in the spring of 2003. It was sad and difficult. As Lucian often told friends, 'the death of a friendship is sadder than the death of a friend'.

It was one of Lucian's most tangled webs: in living with Emily, he had become deeply involved with a young woman who had had an affair with the husband of Susanna Chancellor, who was herself a perpetual thread in his life; and after Lucian and Emily broke up, Emily went *back* to Alexander Chancellor in 2004, and they had a child together the following year. Lucian told her he was glad to hear the news that she was pregnant. For Emily to go back to Alexander Chancellor was not exactly completing a circle, but was more like a figure of eight, as always Lucian's lucky number.

Susanna and Alexander stayed married to each other, spending Christmas and some holidays together with their children but also living independently. Lucian and Susanna remained close right until his death, often being seen together in Clarke's, and their relationship was as near as he got to having family outside of his children and their mothers. But, as was always the case, Lucian in part remained unattached, straying, seeking new conquests.

* * *

Although there were many lovers, work remained his main mistress. It often dictated the timing and length of his relationships. But when a relationship started, it lit up his life. It rejuvenated him. In 1977, Harriet Vyner was a young, impetuous girl from a landed Yorkshire family, who was exactly what he liked: spirited, wild and attracted to the danger and risk which he exuded. It was instinctive whom he chose, as Harriet discovered as a seventeen-year-old schoolgirl. She was talking to the painter Craigie Aitchison when she was targeted by Lucian. 'He immediately zeroed in on me and made it quite clear that he was interested in me. It was the opposite of that English thing when you never quite know are they just friends or are they wanting more. He wanted more,' she said.[106] Harriet was doing A-levels at Queen's Gate School. Lucian was fifty-four and at the

height of his powers and at his most determined to do exactly what he wanted. 'There was a sort of intimidation but not because he was trying to create it, but just because it just felt like that. I didn't really have any sort of reference of dealing with someone that different.

'I remember I didn't really think he was that keen on me at first, but when I said I was going on holiday to Italy he said, "Well, don't get too sunburnt because I'd like to paint you," and I remember being so thrilled. I thought not only that I'd love to be painted by him but also I thought that meant he actually liked me quite a lot. Remember I was very young and I don't think I have ever grown up out of that thing completely of thinking "Do they like me?" There's always that element.'

His portrait of her, *Sleeping Head* (1979–80), reflected their rather chaotic time together. 'I'd left school by then and used to fall asleep partly because I was already starting to take some drugs. I'd take a sleeping pill or something, which was always my favourite thing and sleep in the day and then he'd paint me.' Lucian disapproved of drugs. 'I did turn into a bit of nightmare for him because if anything disturbed his painting it made him very, very agitated and when I was behaving waywardly and spoiltly he would really mind. I remember him anguished,' she said.

While painting came first, Lucian's other desires and instincts took up much of his energy too. It was a life of hidden people, canvases turned to the wall, telephone calls made but not taken by him, and car journeys to destinations about which only he knew. Sometimes the divisions in his life broke down. 'I think once we went out to dinner with somebody who he knew and this person kept mentioning another girl and then looking at me. Lucian was a bit upset because he liked to keep things private,' said Harriet. They danced at Annabel's, visited gangsters' houses in Essex, swam, listened to Bob Dylan and read Byron. They laughed a lot but also fought; painting was more important than anything they did together. They also gambled, or rather Lucian did, and while her role as muse, model and lover was intense, Harriet always felt he was pushing her to her limits, even with his jokey asides. 'One thing he did say to me, when we were discussing whether he'd find any man attractive, he did say the one man he would really like to go

to bed with was [the jockey] Lester Piggott! He completely hero-worshipped him.' Lucian's conversation and conduct were never predictable or conventional for long.

His gestures of affection were startling. He gave her two rats, and offered her a wolf. She got jealous when she learnt that another girlfriend, Katie McEwen, had been given a monkey. He took Harriet shopping at Yves St Laurent, unnerving the staff as he entered the New Bond Street store in his splattered garments. It was then famously run by a redoubtable grand dame called Lady Rendlesham, a former *Vogue* diva, who glowered in disapproval at the older man and his teenage lover. 'He used to come in looking very scruffy and, of course, she knew who he was and he used to buy me this, this, this, this, this and this! She didn't quite know how to deal with him because he'd ignore her as he did with people he didn't like. He could be very rude, but all the same it was quite gratifying to watch him with this rather bullying woman.'

Time with Lucian was never ordinary. 'It is very rare for someone never to worry what other people thought but just doing what he wanted to do.' For Harriet it was a rollercoaster romance. He was initially besotted. But she had gradually become addicted to drugs during their time together, which for Lucian made her erratic yet also enticing. Harriet certainly found sustenance in sitting for him but did go through a very difficult time, eventually being jailed for ten months for drug offences. Harriet remembers the slow breakdown between them before her imprisonment as dramatic and difficult. 'He got low during this period and as I came in to his studio he was ranting on about something or other and there he was lying on the floor and he just couldn't move. He was in despair because he couldn't paint. By being such a nightmare, I was affecting him so much.' It finished because in the end Lucian protected himself. 'He did ring me to say, "I think we can't go on. I find it too difficult seeing you." I admired that he'd actually thought "no", rather than just putting up with it,' she said.

There was rarely a pause. Others filled the gap, some familiar but also always someone new. A year after meeting Harriet, he first saw Celia Paul, in the downstairs life room at the Slade in October 1978. It was another teenage crush.[107] 'I was eighteen and Lucian was

fifty-five. He walked into the room dressed in a beautiful grey suit and white silk shirt with a white silk scarf round his neck. He was very, very pale and smoking a Gauloise. He stared pointedly at the naked model on the mattress. I went up to him and asked him if he was busy and he gave a half-laugh in reply, as if to say that the only real way to be busy is to paint.'

He invited her to his studio where he was finishing a picture called *Two Plants*. 'He was working on it obsessively, leaf by leaf, almost as if they were growing at the plants' own rate. He said that the important thing in painting is concentration; he stressed this as if it were a revelation.'

Celia found a creative but challenging tension in being with Lucian, while also being mesmerised when she sat for him. Six years later she would have his child, Frank, eventually leading to too much tension for her to continue sitting. Domesticity always threatened him. 'He liked to have a conversation while he was working. He wanted to observe his sitter's face in motion, catching them off-guard to capture the uncanny likeness he was after. I would have preferred to be silent so that I could go into my own world but Lucian would have none of that. He would very often go out of the room to make telephone calls and I would hear him in the next room talking into the receiver in a very conspiratorial stage-whisper. I was always very aware that I was certainly not the only fish in his sea.'

As someone else discovered, it was a wide, open sea.

* * *

Sophie de Stempel opened the studio door in Holland Park to see Lucian laughing and dancing naked to Blondie's pop anthem, 'Sunday Girl'. She had arrived to sit for a night portrait. It was the summer of 1982 and this was the last thing she had expected to find.

Here was an unexpected side to Lucian, the *homme sérieux* who would read his beloved Flaubert's letters to her, explain the merits of Henry James's short stories, or talk of more obscure figures like Adolph Menzel, the nineteenth-century court painter to the German emperor Wilhelm I, who did formulaic portraits but exquisite drawings. 'For whatever reason Blondie got under his skin,' said Sophie.[108] He had been introduced to the band by both Harriet

Vyner and his daughter Bella. While driving around London he would listen to Blondie cassettes. Another musical fad was Johnny Cash, whom he had seen play live, and Ray Charles, of whom he said, 'That man knows how to wear a suit.'

Sophie had met Lucian at the French House pub in Soho in July 1980, when he was out for a night in the West End with his daughters Bella and Rose. She was then a nineteen-year-old art student, the daughter of Baron Michael de Stempel and a direct descendant of the anti-slavery campaigner William Wilberforce. Aristocratic, articulate and ambitious, she too had a troubled time; after a sensational court case her father was jailed for his part in defrauding an elderly aunt. Sophie had spotted Lucian in the pub and introduced herself. He invited her to join them at Wheeler's, where Lucian ordered oysters for everyone, paying with his usual roll of banknotes. That evening Sophie gave Rose her telephone number; one month later after she had returned from a holiday in Greece, Lucian called her and she found herself posing for him.

'We had established at dinner that I would sit for him,' she said, 'but I still had an anxiousness and, to put it bluntly, I was stage-struck. He used to say that I was a bad model who became a good model. I am not sure that is true, but the first time I felt so nervous I thought I would have a heart attack.' It was the start of a tempestuous decade as his muse, model and lover.

In the early days Sophie was nervous and eager to please. 'I could not tell him "I'm freezing," because he was so anxious when starting a painting. Part of the room was so hot under the lights but a little bit away from them was so cold. He never really understood that – he was so intent on getting what he did in the painting right.'

He could be erratic, even melodramatic. 'I saw him stab himself with a paintbrush, wounding his thigh so that it bled,' she said. 'It was, he explained to me, like being the jockey and the racehorse, urging on with a manic compulsion, pushing to the limit, finding urgency. Lying beneath his feet where I sometimes was positioned, on that hard wooden floor, when he stomped about in his mountaineer's boots, was unnerving,' she said. In the middle of painting her, Lucian would jump up and, in mid-air, curse.

One of his other subjects in these years was Baron Heinrich

'Heini' Thyssen-Bornemisza, then the richest man in the world. Daylesford, his magnificent house in Gloucestershire, had once been owned by Viscount Rothermere, whose wife Ann (later married to Ian Fleming) had introduced Lucian to his second wife, Caroline. 'Lucian said he tried not to jump up in a mid-tension tantrum when Thyssen was around, so as not to make him jolt, but he would often only remember too late when he was mid-air. It was painful for him starting a picture, to make something from nothing. He would pile the pressure on himself, saying, "I would rather lose all my hair than not do a good painting,"' she recalled. This was at a time when his gambling debts were threatening to bury him, and he had rushed out in the middle of the night to persuade Thyssen to commission a portrait. It was a financial lifeline.

Although Sophie had met Lucian in a chance encounter, she had always been intrigued by his reputation as a rake. 'I remember hearing a friend of mine had been having an affair with him and the inference was always: "Isn't it shocking?"' she said. 'In the 1970s his paintings were widely considered absolutely hideous, the most ugly things you could have, but they were unarguably powerful.' His reputation as a man without boundaries – artistically, physically and sexually – was by this time fully secure and widely known.

Lucian aimed for a higher truth through intense observation, as Sir Nicholas Serota, director of the Tate, pointed out at Lucian's memorial service at the National Portrait Gallery. 'Lucian saw the world more differently than most. There was an acuity and a penetration in his scrutiny of your face and in his search for the smallest details of appearance as a clue to character.' It was echoed by what Lucian himself asserted. 'I hoped that if I concentrated enough, the intensity of scrutiny alone would force life into the pictures,' he said.[109]

Sophie experienced this when she sat for him. 'I just assumed I was going to be a nude for the first picture. He started a drawing in the afternoon (I was pretty nervous) he was very patient and by the evening I was calmer,' she said. It was exhilarating, and what impressed her most was his complete dedication to his art. 'It was very exciting to know that someone was really marvellous at something and to be part of helping bring that about.'

She was mesmerised by his focused intent, the combination of a strict work ethic with an unstructured moral code. While his subject was before him, they were all-important. 'The aura given out by a person or an object is as much a part of them as their flesh,' he once wrote. 'The effect they make in space is as bound up with them as might be their colour or smell. The effect in space of two different individuals can be as different as the effect of a candle and a light bulb.'[110]

Once Sophie had started an affair with Lucian, she too quickly realised that he was incapable of sticking to one sexual partner. 'I was intensely involved but aware that other people were involved too. You don't know things and just have to work them out. You're not quite sure what's going on. When Lucian was out of the room I would look at the paintings turned against the wall and see a bit more of someone's breast. It would make me terribly jealous. He gave a lot of attention when you were there with him, but when you weren't then you knew there was a whole other life happening. That was tough,' she said.

What was also tough was the physical element of sitting for Lucian. 'Like all his sitters it was hard as the hours were long, sometimes seven or eight at a time. In the beginning he would be in agony and torture, thinking he couldn't do it. He would get in a terrible state. It was all about making it work,' she explained.

Sophie committed herself to her relationship with Lucian until 1984 when she took a break, exhausted by the sittings and the complications of being one of his lovers. The dates of his paintings provide crucial statistical evidence but give no hint of the emotional upheavals he caused. A picture dated '1980–5' suggests continuity but masks a painful hiatus in their relationship. Sophie returned, though, because she found his brightness and energy addictive. Few women wanted to let him go completely, even when they knew it damaged them.

Always there were others around, and awareness of this sometimes came from the art itself. 'There was a long period when I remember seeing some woman materialise [in a painting]. I remember thinking, "Well well, there's Janey Longman." So things dawn on you; you have to work them out. He had compartments

for all of the different people in his life. There were people he was painting and then some he'd painted before and probably others he was going to paint. They were all in play. I don't really know who was around but when the books on his art came out I would see the paintings and the dates and think, "Oh, was that when so and so was around," but I never knew anything for fact,' she said.

GG: 'Did you mind Lucian having a relationship with other women?'

s de s: 'Yes. I think so but by then I was really working as a model and so had sort of disengaged which was quite good as I could be more detached.'

GG: 'So you stopped having a sexual relationship?'

s de s: 'That was a good thing, actually, because it brought fewer complications. It was much easier to work just as a model, emotionally for me and also for him. It's hard to work when people are fighting, when emotions are high. He had to balance between his addictions: love of women and gambling. He also had to be very focused as he worked such long hours. All the wild things he was doing were really on the fringe. Painting was always his centre.'

There were day paintings and the more sexually charged night sittings. There were pictures of members of his family – in 1982 his daughter Bella sat naked for a day painting – and there were paintings with male sitters: 1980–1 was when Lucian's bookie Guy sat with his terrier Speck. Also at that time Angus Cook first modelled for him, standing in for Guy when Lucian concentrated on Speck. (Cook later sat properly for Lucian in his own right.)

Once Sophie told him about an Indian waiter at a restaurant in Victoria who had attempted suicide but couldn't tell his family back home about it. Lucian was fascinated. 'He wanted to go to the restaurant and thought about painting him. He would get obsessed. In his mind he had created a character but if they then did something that disappointed him he could really turn against them. He could never forgive betrayal. He wrote outrageous letters to people. I remember someone asking him to host some grand function and he wrote back saying he would rather have a wank. But there were also

sweet notes. "I'm sending this via a Bella-shaped messenger because I'm rather weary of late. Can you please come at six tomorrow for a dance. Love Lucian." He knew how to enchant.'

It was a heady and hedonistic time. Lucian and Sophie would have dinner at Annabel's and breakfast at the working men's cafés in Smithfield he loved, sometimes at six in the morning. He got a sudden obsession with a Johnny Cash song about swapping his brain with a chicken when the chicken was robbing banks. In his Bentley on his way to dinner he was always the most selfish and reckless of drivers as Cash's music boomed out.

With Sophie, it was a long affair which totally consumed her and bewildered her parents. Their initial introduction came when they witnessed him reverse his Bentley at breakneck speed down the street in Belgravia where she was living with them. When it came to an end, it was like the curtain coming down on a melodrama.

'There was a time when I was leaving Lucian that felt as if I was giving up drugs. I saw it a bit like being an addict. I could give up for two years and then everything would start again. That can make someone quite bipolar. It went on most of my grown-up life. From the age of nineteen onwards, I was involved with Lucian in some shape or form, which changed with time. He would talk about love. He used to fall madly in love with people and do absolutely anything for them. He did some unbelievably kind and generous things for me, but he always had to pull himself back to work.

'There are paintings in the 1970s that have so much sex in them you practically know what people smell like. He did a lot of mad chasing of women, climbing up drainpipes and climbing in high windows of women's houses he wanted to see, hanging from balconies by his fingertips. By the 1980s when he was in his sixties he was saving his strength. His paintings were better, bigger and made more quickly. What was the same was the mattress, beds and rags,' she said.

Blond Girl, Night Portrait (1980–5), *Standing by the Rags* (1988–9) and *Lying by the Rags* (1989–90) are three portraits of Sophie as a prisoner in his studio, but one who chose to be there because of his commanding presence. The last of these three was the triumphal

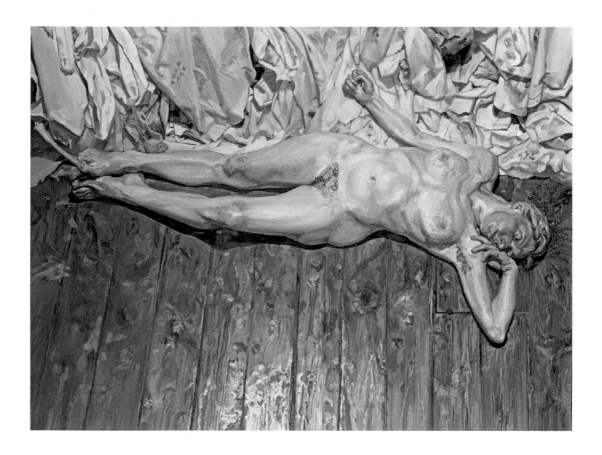

Lying by the Rags, 1989-90

conclusion of his relationship with her, and one of his most powerful nude portraits. Sophie lies uncomfortably and incongruously next to the rags he used to wipe his brushes. Just as Samuel Beckett buried actors in dustbins or made them stare ahead without blinking, their words going round and round in echoes and rhythms, all to express a greater truth about the human condition, so Lucian manipulated his sitters to stretch the tiny studio stage into a wider world of understanding. *Lying by the Rags* is a portrait in which half the painting is of wooden floorboards. The top area is of discarded sheets and Sophie is sandwiched in the middle, lying exposed, vulnerable and seemingly abandoned, certainly uncomfortable. It is a tough act of collaboration. The hard polished floorboards, rumpled sheets and soft flesh all contrast and jar. Lucian owns and controls this figure, who seems willing to submit to whatever is necessary. He is pushing abandon and willingness to the edge. In the end he sacrifices

everything for paint. As does his model; it was the last time she sat for him.

'I got to mind someone else sitting. I minded too much to go back again. We somehow did stay good friends until he died. He is the person outside my family that I have known longest and best, and been involved with for what seems for ever. But our affair was finished,' she said.

'Our rows were not physical but they felt physical, they felt violent. I tried to avoid them as much as I could. He was always testing you in some way and there were times when it was right to be passive and others when you had to stand up for yourself. There would then be a confrontation, an explosion. And that would mean often not speaking for a few years.'

All this unfolded in a sealed vacuum; she could not reveal to others what was happening. His privacy remained sacrosanct. 'He was fiercely, fiercely private. He had to protect himself entirely for his work. He did not want anyone to know where he lived. It's like being a spy being with Lucian. He did not want people to know you worked for him. He was clever and would explain that he couldn't work unless things were as he wanted them. I am quite secretive anyway but became even more so, partly because I wanted to be loyal.'

Sophie eventually walked out for good because she could no longer tolerate the unsettling pressure of other women in his life. 'There was someone who found out that I was sitting and they were so upset. She had been hospitalised and was almost suicidal. There were some ugly scenes where I really thought you could be killed. They were dangerous moments. Some of the people were quite violent,' she said.

Again, Lucian allowed chaos to exist around him but managed to keep a bit of himself at the still calm centre in order to stay focused on his work. Around him swirled hysteria, rows, falling-outs, new affairs, old affairs rekindled, debts and wild nights out. The only constant was the application of a paintbrush to canvas and the continued competing in his own mind with the greatest artists that had ever painted.

※ ※ ※

Unusual circumstances often played a part in producing new lovers. Alexi Williams-Wynn, a mature art student, met Lucian after she was almost knocked down by a speeding car in which he was a passenger. She caught a glimpse of his face, like a smudged Francis Bacon portrait, just before she was nearly hit. The next day, as a shot in the dark, she wrote asking to meet him. She became his lover and model for two years, moving in with him. 'I only meet people through letters,' he would quip. She was thirty-one at the time and had been a friend of the photographer and writer Bruce Bernard. Lucian was more than fifty years older than her but she found him irresistible. 'I was transfixed by his energy, his manner, his physicality; he felt quite wild, even feral.'[111] Straightaway he asked her to sit for a night painting. A day painting followed. Soon Alexi was sitting continuously. This required her to put her MA in art on hold. 'It felt as if we were doing something constructive and amazing together, living, eating, sleeping. Painting, the central element of our life together, felt important and impactful. Sometimes we would get up at four in the morning having got to bed at midnight. I was the one who was exhausted half the time, not him. Occasionally, you could see a fragility,' she said.

It was a romance with much pleasure: trips to the ballet, weekends at Badminton staying with the Duke of Beaufort. It was odd meeting his children, Alexi felt, as she was younger than most of them. 'There were some tense moments,' she said, 'but also they were often generous and welcoming, especially Bella and Esther.'

The Painter Surprised by a Naked Admirer (2005) was the main legacy of their relationship. It is a portrait of Alexi crouched on the wooden floor, one arm caressing Lucian's thigh, in a pose of submission and adoration, but with a suggestion of captivity. 'I was quite keen for him to have other sitters to keep my life as normal as possible but he wasn't having any of that. Lucian is quite greedy and he wants all of you. If you were five minutes late he would make it seem as if you didn't want to be there at all, getting upset and cross.' Lucian felt the threat of lost time keenly.

'He would work outwards from a starting point. He was very concentrated, every brushstroke mixed separately in a long, laborious

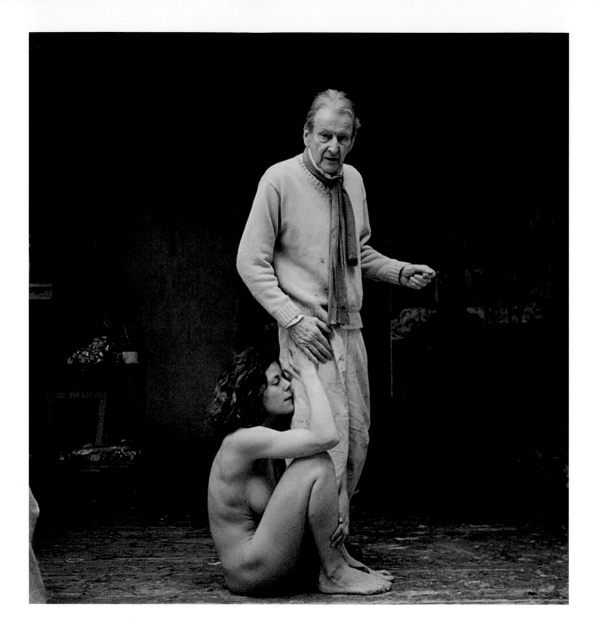

The Painter Surprised, a portrait of Lucian and Alexi Williams-Wynn, by David Dawson

Opposite: The Painter Surprised by a Naked Admirer, 2004-05

process. It was exhausting, as the four o'clock in the morning sessions meant leaving his Notting Hill house in darkness and getting a taxi to his Holland Park studio,' she recalled. Her life was on hold while she was with Lucian. 'I even gave up my mobile phone. He found any contact I had with the outside world intrusive,' she said. He was the maestro and wanted no competition or distractions. 'He would give you a hundred per cent concentration – nothing else existed. It

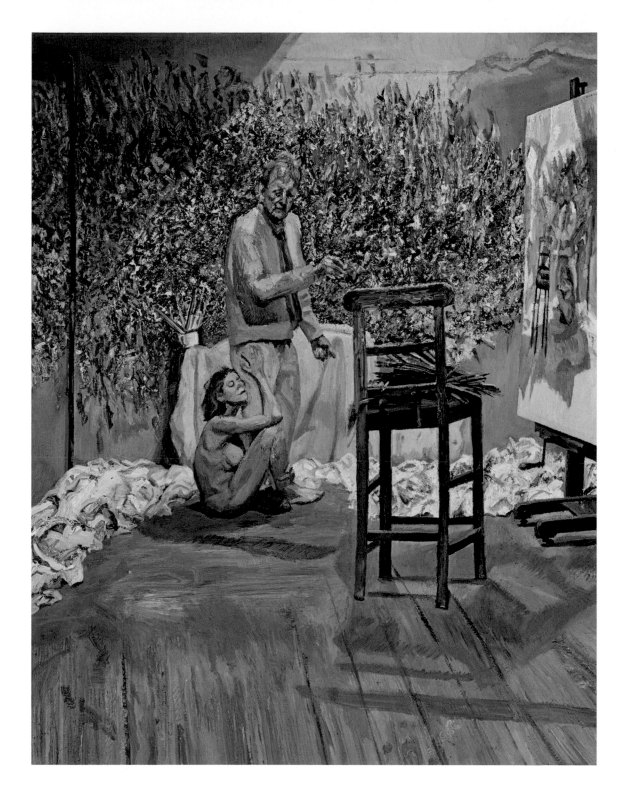

was always generous. He shared so much knowledge, poetry, songs, he was entertaining.'

She also noted odd things he did, like never saying goodbye. 'He would just slam the phone down, not meaning anything except that the conversation was over,' she said. He was not a hugger but he was very physical. 'Everything interested him. It was part of finding out about the person,' she said. He had a book about the sex lives of, among other creatures, dragonflies, as well as a copy of Remy de Gourmont's *The Natural Philosophy of Love*. And, as ever, he loved to share Flaubert's letters, lying back in an armchair wearing his tortoiseshell spectacles, reading aloud. He would tell Alexi how he was by nature contrary, preferring reverse gear if urged to go forward. 'I remember him telling me when he was told at school how to tie his shoelaces that he was never going to tie them like that again. And of course he never did. I didn't really anticipate falling in love with him. You don't really have a choice. These things happen. I was quite shocked when I realised I was totally involved in his world. It wasn't a case of just being his model, it was much more complete. It felt totally at ease. We were lovers; it was very intimate. There was a huge sexual charge. You were there, involved in his life, which was around painting.' There were new tastes, sounds and sensations; breakfasts of freshly squeezed carrot juice and sausages, his gentle voice reading aloud, his ability to turn heads, and to somehow turn the ordinary into magic, in art and life.

The time that she could not control was the end of their affair. As usual it coincided with the completion of a picture: another portrait of Alexi, naked on a bed. She had not seen him for a couple of days and he was cross because he needed her in order to finish the picture. The power dynamic shifted. Press interest in Lucian and his young lover was increasing, the legendary Lothario and his young girlfriends fascinating the middle-market news-papers like the *Daily Mail*, who had placed a reporter outside Alexi's flat for a week.

When they did part, Alexi felt physically pained but understood. His power to change lives, as well as portray them, never seemed to dim. 'He had a very acute sensitivity or receptivity to physical or emotional experience,' she said. 'I saw him as very

independent and self-contained, but we possibly became too close.'
An illness Lucian had in 2005 also affected their relationship. 'It
wasn't that I just didn't go back to him. It was time for change,
something I hadn't anticipated nor took well. I was devastated.' They
stayed in touch after he moved on. Not a lot, but the connection was
never severed. Her final farewell was at his deathbed.

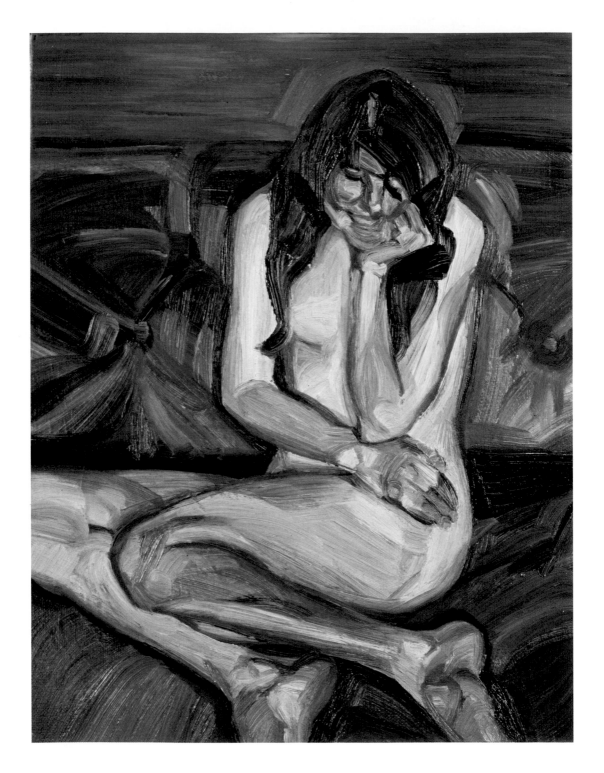

A Daughter's Tale

The public was fascinated by Lucian's portraits of his sons and daughters, some of which were naked portraits. Journalists had a field day trying to explain the Freudian significance of children in their teens or early adulthood stripping bare for their father. His fourteen offspring included a novelist, a biro artist, a fashion designer, a journalist, a drugs advisor, a poet, and a sculptor. They rarely mixed, however. His four children by Suzy Boyt, a student he met at the Slade in the 1950s, and two by the writer, bohemian traveller and gardener Bernardine Coverley, were the main exception to this rule. Some were only vaguely aware of each other's existence even after Lucian died. Some still do not know of at least one of their half-siblings.

Over the years there were splits and spats, tight alliances and silent stand-offs, shared intimacies and dramatic events. His charm was magical, even hypnotic, and they all fell under his spell. He had a playfulness alongside the steel core of ambition. He always lived well. He may have at times been buried by debt, but he was never tight.

He was the central focus of his family's attention, deciding when he saw his children or not. Few had his telephone number. With the exception of the four children by Katherine McAdam, he did, however, paint all his acknowledged children. He painted their faces, in family groups, lying in bed with friends, holding their own children and, most controversially of all, in the case of six daughters and one son, naked.

The first of these was in 1963, when Lucian asked Annie Freud, his eldest daughter, aged fourteen, to remove all her clothes and

Opposite: Naked Child Laughing, 1963

teenage inhibitions for a nude portrait. It was certainly risqué to use as a naked model a somewhat innocent and naive teenager. This was a momentous and controversial event in Annie's life. Many felt it was reprehensible, if not downright immoral. Lucian did not care. The question of whether it would damage his daughter simply did not occur to him.

On a worn sofa in his studio in Clarendon Crescent in Paddington, Annie perched with her leg jack-knifed into a position of protective modesty. In *Naked Child Laughing* she displays hints of emerging sexuality combined with gleeful innocence. It is a study in vulnerability and teenage allure, with her wild grin of spontaneous mirth. A good subject for any artist, but one with psychological edge, questioning the line between appropriate and inappropriate behaviour by a father towards his pubescent daughter.

It was the first full-body nude that Lucian ever painted, and it caught a moment of intimacy and trust between them. 'We actually had a wonderful time; it is the picture of me by Dad that I most admire,' Annie said to me.[112] He knew that nudity changed everything, bringing new levels of revelation and exposure. Or as he once put it, 'I paint people, not because of what they are like, not exactly in spite of what they are like, but how they happen to be.'

At the time, Annie could not articulate very clearly how she felt, but later said that she could feel the collective prudish culture of Britain breathing down her neck, as well as being embarrassed since her boyfriend and her mother, both not unreasonably, felt that it was not right for her to pose naked. Analysis of what had occurred seemed beyond a fourteen-year-old's emotional grasp and understanding.

'I knew that some people felt what I did with my father was dangerous and inappropriate. But my dad felt it was all right and whatever he did at that time I felt was a hundred per cent OK. It was somehow forbidden and experimental, but there was nothing sexual or inappropriate in what happened. There was some hurt done, not intentionally, and it was nothing to do with sex — perhaps it was more an intrusion into innocence. Being naked in front of your father certainly went against the tide of opinion at the time. It was all very well for Dad to say it was all right. No one else felt it was,' she said.

Annie's mother Kitty Garman, by then divorced from Lucian,

was alarmed. 'When I was sitting a letter arrived from Mum which he opened and then howled with laughter. In it she said that her father would have felt that it wasn't right for Dad to paint nudes of me, and how it might make me unhappy. Dad thought that was terribly, terribly funny,' said Annie.

Lucian said that 'Ep [Kitty's father Jacob Epstein] would turn in his grave if he knew about Kitty's letter,' as Epstein had himself aroused hostility many years earlier by also challenging taboos surrounding the depiction of sexuality. Lucian argued that nakedness was simply a way to get to a more truthful portrait, scoffing at any suggestion that to paint his own children was in any way taboo – and of course he liked risk, and never cared what others thought. Opposition always made him dig his heels in.

It was of little comfort to Kitty to have Lucian sneer that her own father would have swept aside any of her protective maternal instincts concerning their child's exposure. 'Lucian just thought that my grandfather would regard Mum as ridiculous over all that. He howled with laughter, which was difficult for me to handle,' said Annie. 'It is awful when any parents say unpleasant or disparaging things about each other,' she added.

Lucian simply did not engage with Annie or her mother about how the painting affected them. He was interested only in what worked for him as an artist; those around him, the people in his life, were who he wanted to paint. He had an artist's objective view of nudity, having often painted naked models in life classes. He saw objections as bourgeois, the fruit of people's own twisted minds. He was simply pursuing an artist's licence to portray people in a way that mattered. That the subject happened to be his own teenage daughter and that she was naked was no one else's business.

The picture was the starting point for a career defined by his naked portraits. He created his own language with paint through prolonged observation of people. 'I'm really interested in them as animals. Part of liking to work from them naked is for that reason. Because I can see more: see the forms repeating right through the body and often in the head as well. One of the most exciting things is seeing through the skin, to the blood and veins and markings,' he explained.[113]

In his picture of Annie, Lucian used paint with a new confidence; he used expressive, looser brushstrokes to paint Annie's arm, wrist, knuckle and breast, conjuring up her gamine essence and most memorably her slightly expressive out-of-control rip of laughter. He used a shorthand of marks in paint, daubs and strokes, and so became freed from his previous rigid sense of control. Risk was implicit in the style, subject matter and context. His skill had deepened to make his images more pliable and responsive. He told Francis Bacon his paintings had not previously reflected feelings through the way he painted, which was why he welcomed this more expansive, bolder and looser style.

Although Annie said that on the one hand that they had a wonderful time, other memories of sitting for her father tell a more complex story, and sometimes 'it was not easy. I remember having long hair and wanting my hair to cover my nipples and Dad would lean forward and move my hair away with his paintbrush.'

GG: 'To expose the nipples?'
AF: 'Yes, and not because of any sexual impropriety or forbidden eroticism . . . This is something I have talked about with my sisters. You would think it would have a bad effect on your feelings, your sexual feelings or your body feelings but it didn't. There wasn't any question in my mind of a lack of trust of Dad. It did involve me requiring a particular strength: it was full exposure. The issue was about someone having dominion over you. It was all quite shocking.'

The morality of family life was a subject about which Kitty minded a great deal. Annie remembers Kitty looking down on people with illegitimate children, despite the fact (or perhaps because of it) that she was illegitimate herself. She tried to keep Annie's childhood going for as long as possible, and monitored what books her daughter read.

In 1955, after Lucian and Kitty had divorced, Kitty married Wynne Godley, the younger son of Lord Kilbracken, a much-loved stepfather to Annie and Annabel. He was an oboist whose chronic stage fright forced him to change careers. He turned to economics,

becoming a professor of applied economics at Cambridge. Kitty and Wynne had a daughter called Eve, and with Annie and Annabel they all lived at 128 Kensington Church Street, just a few doors down from where Lucian eventually lived and died. It was comfortable, secure and tidy, the opposite of Delamere Terrace. Kitty created an Arcadian calm in her home, in contrast to her own brittle disposition. Friends remember buttercups in old jars, William Morris wallpaper, tapestries, seashells and her love of the Italian Renaissance painter Carlo Crivelli, one of whose Madonnas she resembled. And always she maintained a love of Proust.

There was inevitable fallout in the wake of Kitty and Lucian's divorce and the children suffered from their unpredictable upbringing. 'I was sent to boarding school to free me a bit from Annabel's illness at home and Dad,' she recalled.[114] Most stressful was having her father in the same room as her mother and stepfather. 'The two men I adored appeared to me to be in competition and conflict when together. Lucian would come to the house in Kensington Church Street and have these surreal games of table tennis with my stepfather Wynne. The tension in the room was palpable. Dad would have a fag in his mouth and he would often serve the ball under the table and lose spectacularly. I did not want them to be together. They had a different set of beliefs, languages, preoccupations.

'The only good thing I discovered through psychoanalysis much later on was that my stepfather and father were both in different ways committed to see that I would actually grow up one day. I still find that enormously useful because their contempt, fear and loathing of each other was so completely felt.'

In the evening Kitty would sometimes sit between these two men in her kimono, 'silent, beautiful, tense and consumed with rage, rage against the world, artists, husbands, the past, the future,' said Annie.

There was also luxury and an extravagance in her childhood, at the homes of Lucian's long-term girlfriend Lady Lambton, the wife of the former Tory Cabinet minister. Life became exotic for the Freud sisters during the Lambton romance. Bindy Lambton was rich and characterful, and Lucian's portraits such as *Figure with Bare Arms* (1961) show a large-boned and angular beauty. 'God, it was a

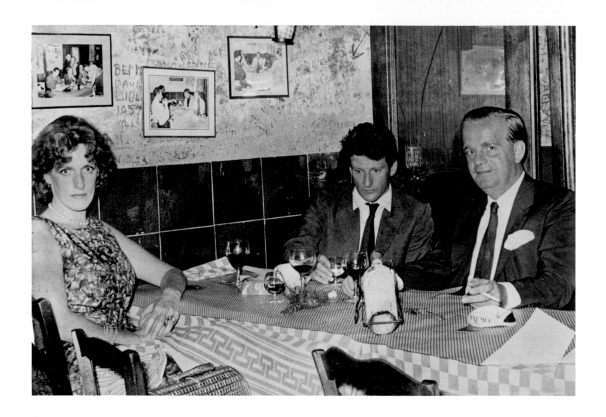

Bindy Lambton, Lucian Freud and John Wilton in Nice, *c.*1960

funny household. We would be on her bed with Dad, who would be picking horses, grabbing the phone, talking to the bookie and also watching the races. Then we would watch the wrestling and *Top of the Pops* and have marvellous tea and cakes. All this while we all lay in bed.' Bindy had been abandoned by her mother and brought up by her aunt Mrs Freda Dudley Ward, a famous mistress of the Prince of Wales, later Edward VIII. Bindy was wild and unpredictable. She had been expelled from eleven schools. Through her marriage she was rich, and able to pursue her idiosyncrasies at will. Her last words, when she died aged eighty-one in 2003, had been the lyrics of a 1940s song, just exactly the sort of thing that Lucian liked and recited:

> Cocaine Bill and Morphine Sue
> Strolling down the avenue two by two
> O honey
> Won't you have a little sniff on me
> Have a sniff on me.

While they were together Lucian lived in palatial splendour with Bindy in her haunted Georgian house in South Audley Street in Mayfair while keeping his independence (and feeding his fondness for high–low contrasts) with his pied à-terre and studio in Delamere Terrace. 'They were so damned rich; Bindy had floor-length mink coats. If she asked you to get a pair of gloves for her there were hundreds, each on a sort of cardboard hand to keep them glove-shaped,' said Annie. When she wasn't in London Bindy lived at Biddick Hall in County Durham where young lions and leopards roamed the garden, occasionally being seen in the bedrooms too.

Freud's double life created inevitable tension with Annie's mother. 'Lucian and Kitty together just brings memories of anxiety, Kitty desperately anxious when the little girls were dangerously whisked off by Lucian in a car,' revealed their friend the painter Janetta Woolley. Hedonistic holidays were deeply disapproved of by Kitty. Annie revelled in the 'great tribe of Lambton children, Beatrix, Rose, Anne and Isabella and the nanny and maid, all eating our way across France, driving from hotel to hotel ending up in the Ritz in Paris'.

'My stepfather Wynne, egged on by my mother, took Lucian to court saying that my relationship with the Lambtons was corrupting me,' she said. 'Often when I got home I used to lie to Mum about where Dad and Annabel and I had been because I feared her envy. She and my stepfather thought the high life was going to bring me the worst kind of false expectations of what my life was going to be like. I remember being severely punished for saying something about us not having servants and I was very much taken to task about behaving disrespectfully about our way of life compared to Dad's way of life. Anyway, they took Dad to court to try to prevent my relationship with the Lambtons.'

It was a childhood beset by many emotional explosions. Annie would find hate letters lying around his studio that Lucian was about to send, 'saying the most critical things he could think of to say about somebody he had been in love with, intricate things about their dishonesty, vileness or beastliness'. Annie was aware throughout her childhood of unresolved conflict. Her mother had become pregnant with Annabel 'to bring dad to his senses, not a nice thing to do'. It was to no avail.

Lucian's ever-roving eye had an upsetting effect on Annie. 'There were many experiences of meeting his girlfriends, becoming besotted with them, and then I would never see them again,' she remembered. To her delight, from the 1960s onwards the beautiful and loyal Jane Willoughby would float back and forth into Lucian's life. 'Above all the other women, Jane had a huge basic sanity, perhaps to do with her class. She is different from most people and more sanguine. She was not like, "Oh, he's hurt me and then he went and met someone else." Nothing could stop his great feelings of respect for her.'

Lucian stained not only others' memories with his moods, voice, opinions but also the rooms where he lived and worked. 'The bedroom was knee-deep in dirty clothes, letters, bills, cheques, books, paint, personal objects, works of art. Dad was a manic buyer. He shopped and he shopped and he shopped. Boer War bedspreads, for instance, made by English prisoners of war using old pieces of their uniform. They were often in poor condition, with threads unravelling, but he piled them up. The stairway had no steps visible – the newspapers were like a kind of river, piled up deep,' Annie recalled.

She wrote a poem called 'The Ballad of Dirty Del' which described his scruffy bohemian existence in Delamere Terrace. It seemed to be simply part of his nature; part of him needed a sense of decay, and of course he was dealing with flesh, its immediacy and how it was fleeting and temporal. 'It was simply a fact of my life, all the chaos: food, pans of oil in which chips had been fried. I accepted it because it was part of my dad who I loved absolutely and completely. I adored him. My mother was worried my poem showed a lack of respect, but yet she used to tell me harsh things about him. It was all confusing.'

Her father's relentless work schedule and his way of life affected his health. 'He would complain about awful boils on his bum. Work, relentlessly pursued, took a terrible toll on top of endless love affairs going wrong, lack of money, terrifying gambling debts, conflicts with galleries and the odd fight,' said Annie. Despite this, he insisted that his daughters should have beautiful manners. 'We used to go to see his friends for lunch, often in very grand houses or amazing restaurants, and he wanted me to hold out my hand to our hosts and say, "Thank you for a lovely lunch, that was delicious." He wanted

Large Interior, WII
(after Watteau), 1981-83

me to be the politest English girl, not muttering "Thanks" but clearly saying, "Thank you, that was really lovely." He used to stand behind me jabbing me with his fingers to make sure I did it properly.'

When Lucian caught Annie smoking outside he was cross. 'He told me that prostitutes smoked in the street and wanted me to know that if I did it again I could be regarded as a prostitute.' He asked if she knew why he was being so adamant. 'I replied, "Because you are my father," and he said, "That's completely irrelevant. It is because I care about you." I found that statement of objectivity incredibly hard to bear. I wanted his love because of the nature of our relationship,

not because of his feelings. I probably cried, certainly inwardly. I found that so hard because he is my father, that is what he meant to me. Everything he said, did, the way he looked, the way he behaved, his friendships and his paintings, everything was the fact that I came from him. I was of his blood. That is what mattered.'

Annie identified with him, almost obsessively. 'We looked alike. We even sounded alike in the way he slightly rolled his Rs in words like "free" or "restaurant". And I loved his assertions . . . how he would say, "I take bribes but they never influence my judgement: that's true incorruptibility." I was one hundred per cent part of him.'

That closeness was to be shattered in 1975, when Annie was twenty-seven years old, and she discovered that Lucian had fathered other children. It had never crossed her mind that she and her younger sister Annabel might have other siblings. At Wheeler's in Old Compton Street in Soho where Annie had gone to meet Lucian, a young man stretched his hand across the table and said: 'I am your long lost baby brother, Ali.' He was one of four children Lucian had fathered with Suzy Boyt. At lunch nothing further was discussed. She had no idea that her father had at that time at least seven other children. He had hidden this from her, which left her feeling betrayed, depressed and astounded. 'I simply didn't know about Ali, Rose, Susie, Ib, Bella or Esther at all – none of them. I had no idea that they existed. Or who their mothers were. Not the slightest idea. At the time, I hadn't understood that you can be, indeed that you have the right to be, angry with your parents, so I felt that I couldn't be angry either. I had been brought up to think that whatever Dad did was perfect,' Annie said.

The discovery of secret siblings was disturbing enough, but even more so was the fact that they all appeared to know about each other and about her and Annabel. 'I then started to assume that almost anybody I met was a child of Dad's. Even if I met someone with an Australian accent I wondered if it was some brother or sister of mine,' she said. It provided the key to the door of his many secret lives. 'I had no way of acknowledging my feelings of betrayal until later on when I had a nervous breakdown.'

His children were hungry for his attention. Sitting for him was really the only guarantee of seeing him. During her pregnancy

in 1975 Annie returned to England and Lucian painted her with Alice Weldon, a young American artist. He was as addictive and mesmerising to his children as he was to others, and Annie also confirmed the physical conflict on which he claimed to thrive: 'Dad used to hit taxi drivers and punched people in the street if he didn't like the look of them. Sometimes he had cut marks on his face. He might have made a pass at someone's girlfriend or something. When he was restless he would go round cursing and somebody would take a swipe at him. He was very odd,' said Annie.

For a while she changed her name to Robinson, much to Lucian's consternation. Her mother insisted she change it back, which she did, and Annie is proud of her reputation as a successful poet and scriptwriter under the name Freud.

While Annie and Annabel, Lucian's only children born in wedlock, may have inherited an extraordinary pedigree, any empowering sense of identity diminished as they faced their father's parallel private lives. Highly unpredictable parenting took a heavy emotional toll. Annie sometimes funnelled her anxieties into her poetry, often humorously. In her collection *The Mirabelles* there is a poem about being with Lucian, called 'Sting's Wife's Jam has Done you Good':

> You pass me some nougat
> on the point of your knife
>
> that looks like the one I used to have
> that I bought in France, that never went blunt
>
> and was lost in the debris of a moules marinières.
> Was that the bell? I hear you inquire
>
> No, I reply. I think it's a bird
> You are painting a restaurateur
>
> More nougat is cut
> What was that noise?
>
> It's a bird in the garden
> Having a squawk.
>
> The model's upstairs.
> We kiss and we part.

Although he had never been a predictable father, Annie was jolted when Lucian was no longer the father figure solely for her and Annabel. He was suddenly someone who cared for other children besides them, or, even worse, simply didn't take his paternal responsibilities as seriously.

'Somehow the person I thought I had as my dad was no longer the person I had known. I was anchorless. Dad had brought me up to be fantastically correct and polite, but then in the 1970s he was suddenly buying into punk where you had to be as rude as possible. What was all that bloody well about?' said Annie.

'Bella and Esther knew all of these dangerous heavy-duty people who would tell you to fuck off as soon as they looked at you. My marriage broke up and I became a ferocious feminist and Dad took a dim view of my unhappiness. He didn't want to know.'

Although he carried on calling her Hunnington, a long nickname for Honey (or sometimes an even longer more whimsical term of endearment, Hunnington Herbert), something fundamental had altered. Hers had always been a childhood full of bewildering contrasts. 'To break one's addiction for continuity was an essential way of dealing with him,' she concluded.

Annie's eventual independence and courage to pursue her career as a poet, writer and mother forced her to stand up to Lucian with dramatic repercussions. They clashed in 1981 just before he started *Large Interior, London W11 (After Watteau)*, the hugely ambitious painting based on the eighteenth-century rococo painter's picture of four figures in an imagined garden playfully listening to music. Lucian asked Annie if her daughter May would sit as one of the figures. Annie was nervous of the idea, as she knew that Lucian's sittings were long and arduous. The day before the painting was due to be started, Annie and May were harassed by some youths on the Tube. 'I was angry but Dad told me not to talk about it in front of May because I might frighten her. And I thought right, right. That's it. This is too much.' The next day Annie told her father she had changed her mind and that May would not be in the picture. He was furious and immediately told her to leave. 'It was the worst mistake of my life because we for ever lost our intimacy. I did try with a huge amount of effort to rebuild our closeness, but it could

never be remade.' (The picture shows Celia Paul, Bella Freud, Kai Boyt, Suzy Boyt and a child called Star, the daughter of a girlfriend of Ali Boyt.)

Annie wrote letters asking forgiveness. 'I was very frightened of him after that. I had lost my way with him. If I told him I was writing poems he wouldn't say anything. It was just terrible.' For five years they did not see each other. 'It was like suffering an assault for being a mother,' she said. She survived as a poorly paid secretary and started a relationship with another woman who helped her to bring up May. When she did meet Lucian again it was at awkward, stiff lunches where hardly anything was said. 'He would write to me saying I mustn't go on about being so sorry about the past and that everything was fine. I stopped writing eventually as everything got back to an even enough keel, but at a huge cost.'

But it was not the same. For instance, Annie was never given her father's telephone number although some of his other children had it. 'It was very upsetting. It really screwed me up for a long time,' she said. Annie is candid and courageous. She has been through a lot of therapy to process her upbringing and writes witty, bold poems. At her father's funeral, she read 'The Most Beautiful Bottom in the World', about a photograph in his house. It ends:

> You kissed me. I drove away.
> And all that's left is what you said about the photograph,
>
> And me going through a red light
> on the Bayswater Road
>
> and the shiny touts on Queensway
> trying to get you to eat
>
> in their Lebanese restaurants.

Two Late Sitters

Hockney

David Hockney calculated that he sat for Lucian for more than a hundred hours over four months in the summer of 2002, amid dozens of Lucian's torn white rags flecked with paint. Dressed in a spattered white 'apron' over his trousers, Freud looked like a worker in an abattoir, next to the dandyish younger artist. Hockney was sixty-five, Freud was seventy-nine. The sitting was the high point of a long, episodic friendship that had started forty years before.

The portrait shows a close-up of a face in thoughtful repose. It is unsentimental but reveals Hockney's warmth and curiosity. Lord Rothschild told Hockney it showed him very much as a Yorkshireman. He wears a jaunty red and black checked jacket and blue shirt. The professional observer is minutely scrutinised and recognises the process with a combination of fascination and impatience, as any poacher-turned-gamekeeper might. 'With Lucian being slow, taking such a long time over painting a picture, it means you can talk. If you do a picture in just an hour you can't, there's no time. He got to really know and watch the face do a lot of things, and that is what he did. He came close to my face to see the subtle differences. He was looking and looking and coming closer and closer. He has a startling energy, almost electric, which comes across. No way are you going to fall asleep with him,' Hockney said.

The same was not the case when Freud sat for Hockney a few weeks later. 'I got two afternoons, that was all,' said Hockney.

Opposite: David Hockney, 2002

'During one he fell asleep but I carried on drawing him. I said, "It's OK, I can draw you asleep," but no, he didn't want that. So he woke up.' He disliked any prospect of being seen as less than vigorous. He fidgeted like a child, his head twitching round as if fearful that some enemy was about to appear, like a mountain eagle in a cage. He appeared apprehensive in someone else's space, even Hockney's airy Kensington studio.

Hockney's sittings started with a cup of tea brewed by Freud on a grease-covered gas stove. 'I liked the old-fashioned bohemia of it all. The plates with old beans on them from last night, or even last week, it was like student days, very appealing after all those very clean New York lofts. I told him you can't have a smoke-free bohemia by definition. He let me smoke – "Don't tell Kate Moss" was his request.' (Lucian was also painting the supermodel in his Notting Hill house at the same time, and he forbade her to smoke.) Every day, Hockney would walk through the delightful public park to reach Lucian's flat, past the bronze statue of Lord Holland. 'Sometimes I was early, and he would leap up the stairs two at a time. No slouch at eighty. He never wanted to be seen as inactive.'

It was as visually arresting as a scene from *Sweeney Todd*: Freud's grip on the paintbrush was sabre-like and his concentration unswervingly focused. 'I was fascinated with his technique,' said Hockney. 'At times, I thought he might have pre-mixed colours to speed it up for me, but I quickly realised he wouldn't do that as he wanted as much time as possible. Because of this we could talk. Lucian's talk was always fascinating. Sometimes it was just gossip about people we both knew, very amusing, very good put-downs that made me laugh. But we talked about drawing a lot, Rembrandt, Picasso, Ingres, Tiepolo, I remember he didn't like Morandi. We talked a lot about Rembrandt drawings and how everything he did is a portrait, no hand or face is generic.'

Hockney's fleshy face dominates Freud's canvas, peering over round-framed spectacles. Freud's take on Hockney had a historic frisson of two great contemporary talents locked in the observation of each other in a silent room, frozen in time. One sitting was brilliantly captured in a photograph by David Dawson, with the enjoyment they shared for each other's company being almost

tangible. Of Lucian's famous paint-encrusted wall, Hockney observed that 'He squeezes the tubes so the paint cakes up on them and he flicks this off on the wall with a swipe. He has been doing this on the studio wall for the last forty years so it is thick with many years' layers – like a wall in the life rooms at the art schools of the 1950s that I knew, but this was all done by the same hand, a rare and beautiful thing in itself.'

They first met in 1962 through the Guinness family. 'Lucian was very famous even at the time while I was still a student. He was always social; he was Jewish aristocracy and through Caroline Blackwood he had married into the Anglo-Irish aristocracy,' said Hockney. Caroline's brother Sheridan, the 5th Marquess of Dufferin and Ava, was a roué who was rich, charming, clever, married and gay. Dufferin became the financial backer of Hockney's first dealer, John Kasmin. He had married his Guinness cousin Lindy but had led a not very discreet gay life, especially on visits to New York, before he died of AIDS in 1988. Both artists had liked Sheridan but had diametrically opposed views on his widow Lindy. Lucian liked to have a pet hate or feud and said he loathed her in his final years, even though he had previously felt no such animosity. He loved to use the phrase 'really ghastly', rolling the Rs, his German intonation seeming more apparent, delightfully so on the word 'corrupt'. She was everything he might have liked but it all somehow worked against her: an amateur painter, organic farmer, yoghurt maker at Clandeboyes, the 6,000-acre estate in Ireland she inherited from her husband. She was very tactile, enthusiastic, sometimes intrusive of other's space but for no particular reason he found her beyond the pale. 'Lucian could not bear enthusiasm,' explained Lucinda Lambton. Hockney, however, was a big fan. 'You had to take his diatribes with a pinch of salt. They were often funny and I am not sure how seriously even he took them.'

'How is Hock?' Lucian would ask me at Clarke's when David was at one time away in Norway painting the fjords. He enjoyed hearing of Hockney's powerful tirades against anti-smoking legislation or the 'puritan pygmy politicians' Brown and Blair. Lucian admired Hockney's experimentation, drawing with a camera obscura, learning to paint watercolours, and later on iPhone or iPad 'paintings'. It was the opposite of what Freud was doing, confined to one of two cell-

like studios, intense watching of one person equipped with the same brushes and palettes that he used decade after decade.

Hockney liked Freud's portrait so much that he offered to buy it, but Freud's dealer Bill Acquavella declined to sell it to him. His wife said she wanted it. Lucian and David remained close friends.

Donegal Man

Breakfast with Lucian was expensive for Pat Doherty. The Irish builder sat for Lucian on 220 mornings between 2006 and 2008, usually starting with a cup of tea at Clarke's, before sitting for his portrait. He paid £4.5 million for two paintings of himself.

Pat Doherty's house is five minutes' walk from Clarke's. 'You are only the seventeenth person ever to have come into my house,' Lucian told him, and although that was possibly a slight exaggeration, his house was indeed a very private space.

Doherty has no pretensions. He is a property developer who came to London in 1961 to seek his fortune. His face is wide, his teeth project crookedly from his smile. Born in 1942, he did well in business and now has homes in New York, London and Ireland. This modest man whose portraits were simply titled *Donegal Man* often entered Lucian's house just as I was leaving. We would nod and say hello, but nothing more, as Lucian kept each bit of his life separate.

It was by chance he became a Freud subject, but there were always links. Andrew Parker Bowles, another of Lucian's sitters, was chairman of one of Doherty's building companies. They had been in business together since the late 1960s. Doherty had also built David Hockney's studio in Kensington, and collected his prints. 'Back then to reduce my bill I was offered a portrait of [John] Kasmin for £5,000 but I had not started collecting and I told them I would not take it even if it was free. Five grand then was quite a lot of money.' (It was not an error he would make with Freud, although the number of noughts in the price of the pictures he acquired doubled.)

There were moments when Doherty feared that sitting for his portrait would never be finished. 'He was looking intently at my tie and then he said "Lots of life in that tie." I thought the whole process could last years. I might be sitting for the tie on its

Donegal Man, 2006-08

own for weeks more.' Doherty settled into the routine, sustained by the conversation. 'He vividly remembered the merchant navy in the 1940s, telling me, "I thought I was a hard man till I joined them. For fun they would stub a cigarette out on your neck if they found you sleeping." Lucian told me he cried with relief on the train back to London when leaving the boat for the last time.'

He sat a hundred times for the first painting, *Donegal Man*, thirty-five more for an etching and then eighty-five further sessions for another oil portrait *Donegal Man, Profile*. But his first instinct when Freud asked to paint him was to turn him down. 'I initially said no, but then Andrew Parker Bowles said I would be mad to refuse.' Sometimes Brigadier Parker Bowles, the builder and the painter would have dinner at Clarke's or the Wolseley.

The first sittings did not work and the sessions stopped. A half-sketched head was never finished. Some months later Lucian requested Parker Bowles to ask his Irish friend to come back. 'I had expected it to last just a couple of sittings but I saw he was slow, very slow. I had started counting how many strokes he was doing in an hour. But somehow it was not right the first time. He was trying to fathom me out, and me him.'

Through the marathon sessions they got to know each other well. 'His hobby was reading people. Some people wondered why he would sit with a young girl, a model or one of his grandchildren and not speak much. It was because his eyes were swivelling round reading people's movements and looks. It was what he did professionally,' said Doherty.

'His life was like a dramatic film, always in fights, never uttering a dull word, making art that would last for ever, always there were great women and characters in his life, always so many children. Even the bad times sounded good. He told me about the time that he fell out with Francis Bacon after Lucian had hammered into a boyfriend who had attacked Francis. Francis then fell out with Lucian for giving him a hand.'

He mulled over his extraordinary times with Lucian.

'It was a grand life.'

Dealers and Gambling

Gambling was inherently linked to Lucian's painting. Whenever he made money from selling his pictures in the earlier part of his career, he gambled wildly, often losing the lot; yet when he began to make vast sums, he gave up gambling almost entirely. Risk fed his enjoyment of more risk, so when a financial safety net appeared as the price of his pictures soared, the relishing of gambling disappeared. When he had run up mountainous debts, death threats were made by unsavoury lenders. He would pay what was owed, when he could.

Sitting in Clarke's in the autumn of 2009, Lucian explained that he was neither glad nor sad that his gambling days were behind him.

GG: 'Did you gamble to make money?'

LF: 'No. Gambling is only exciting if you don't have any money.'

GG: 'Did that get you into trouble?'

LF: 'Very much. I tried to pay back the sums I owed but they were so big that there was no chance. I laid very low after I got involved with the Krays who gave me credit. They forced money on me.'

GG: 'More than £10,000?'

LF: 'More like half a million.'

GG: 'So you were in deep trouble?'

LF: 'Yes I was. Nothing to be proud of. When I occasionally won money I repaid them, but there was a dodgy moment

when I had to put off a show. If they had read about an exhibition of mine they would have said, "Do you see how much it made and he only fucking owes us this much."'

GG: 'Scary?'

LF: 'I was nervous.'

GG: 'Did they threaten you?'

LF: 'No. You see I can't be threatened. Even if it is something I want to do – if someone threatens me I will never do it. I can't function like that.'

GG: 'Did the Krays get heavy?'

LF: 'They were clear and polite. It was all honour-bound. No swearing. Their reputation was such that if people said, "I will call the Krays," people were afraid. If anyone said or was even rumoured to have said one of them was queer, which one of them was, their life was in danger. The funny thing was I wanted to paint one of the twins and the other said no. I quite enjoyed people treating me in a very delicate and careful way because of my association [with them]. But it got rather out of hand and the police warned me.'

GG: 'And no regrets now that your gambling days are over?'

LF: 'It just no longer interests me as I have enough money to lose without it ever hurting me. The only point of gambling is to have the fear of losing and when I say losing I mean losing everything. It has to hurt.'

Lucian's art dealers grew used to him making agitated demands for cash. It was a constant cat-and-mouse game, with Lucian wanting more money and earlier, hopefully before a picture was finished, but at the latest on the day that the final brushstroke was applied. That said, it never made him rush to finish, as he kept a steely focus on achieving the best. Money mattered because as well as gambling, he needed it for his ex-girlfriends and children. He had their school fees to pay and would also get letters from some of his children at university about their monthly allowance. He was randomly generous when he could be, although some of the children found it embarrassing to being given a wedge of banknotes. And while his studio might have had a touch of squalor, he would offer

guests the finest burgundy, and from there he ventured out to the best restaurants.

It was a combination of feast and famine. Jacquetta Eliot recalled going with him in his Bentley to drop off an envelope of cash for Bernardine Coverley, his ex-girlfriend and mother of his daughters, Bella and Esther. Sometimes it was as little as £25, and she remembers him remarking that Bernardine did not seem very pleased with it and had barely looked up as he dashed in to drop it off. But, as she pointed out, he had just popped in, he had not given her much time. He and Jacquetta would then head off to some expensive restaurant.

Like a financial Houdini, he believed that somehow he would always find an escape route, postponing, delaying, avoiding or at the last resort finding the wherewithal from others to pay. He had often lived off other people's money, his grandfather's legacy, odd cheques from his father, Peter Watson's generosity as a patron when he was a young man, also borrowing from Jane Willoughby, and when really in dire straits selling paintings to her which he owned, such as Francis Bacon's *Two Figures*. Although they became her property, they remained in his house. There was always a way out. But it was not always easy – twice Jane had to rescue the Bacon picture from pawnbrokers. It was amusing for her to look back on his recklessness with money, or rather her picture, but it was not so at the time.

One night in the 1970s when he lost £20,000 at John Aspinall's casino in Mayfair, pressure was immediately applied for him to pay the debt. In desperation, Lucian offered to paint a baby gorilla which Aspinall kept at his wildlife sanctuary in Kent. Laughing, Lucian recounted how John's mother-in-law, Dorothy Hastings, had brought a baby gorilla to his studio in the back of a black taxi, but not before it had urinated on her and ripped her dress. 'My daughter Jane is on the cover of *Tatler* and here am I in the back of this cab with a wild animal out of control,' she lamented.[115] The animal portrait has never been seen.

Although betting at the racetrack was deleterious to his finances, he loved everything about the sport: the horses, the risk, the speed, the chase and the endeavour, as well as the company of

jockeys, punters and bookies. He was addicted. 'I always went all out. The idea of it being a sport seemed to me insane. The thing I liked was risking everything.' He never let his debts, which were often burdensome, unduly upset him, or affect his work. Gambling provided tension, which he loved. 'There is nothing quite like gambling, the chance throw of the dice, as it were, that can leave you without a roof, or bring the thrill of winning,' Lucian once said as a way of explaining his gambling habit. 'It is like galloping or jumping through fire, sort of beyond what is sensible but it makes you feel alive.'

Bookies inevitably became part of his life. He painted them, talked to them often, borrowed off them, sold them pictures and sometimes got blind drunk with them. Lucian's favourite bookmaker was Victor Chandler, who was debonair, mischievous and enjoyed a night out on the town and was besotted with Lucian. 'I really did love him and would have done anything for him.' He arranged for a daily to clean Lucian's flat, bought him shirts, had his clothes laundered, and even ordered special silk scarves from Sulka in New York that Lucian wanted. It was only over money that things became tricky. Collecting money from Lucian was a regular task for Chandler's associate, Michael Saunders. 'Victor would say to me, "He owes £50,000," and we would say, "Let's do a deal for £30,000." There was no question of him not wanting to pay and somehow everything was settled in the end, but it was never easy getting the cash,' Saunders said.

Saunders would walk up the fifty-four steps to the top floor of Lucian's studio before giving a coded secret knock on the outer front door to gain entry. There were often gifts brought to try to sweeten negotiations, and also because Chandler was naturally very generous. He arranged for a man called Jimmy the Cigar to fly to Warsaw to buy for Lucian the entire stock of Cuban cigars and Beluga caviar in the duty-free shop and then fly back the same day.

While Chandler, dapper, charming and amusing, was a public school boy, Saunders had started in the gambling industry at the age of twelve, first as a street bet-taker. Both lived and breathed horses' form. 'Lucian was a bookmaker's joy and nightmare. He never had

no cash but that did not stop him from betting,' Saunders said. 'I loved him like a brother, and had many of the funniest times in my life with him,' said Victor. In 1983 Lucian was banned from most racetracks as a bad debtor but he was undeterred and used disguises to enter race meetings. 'I remember laughing till I cried getting Lucian into one meet wearing a beanie hat, sunglasses and his grey cashmere coat. Somehow it worked,' said Chandler.

A chit from Chandler shows Lucian placing £400 on Man in the Middle and £80 on Grand Unit to win the 3.20 p.m. The sums were always multiples of eight, Lucian's lucky number. Chandler took the bet on tick and, as so often happened, Lucian lost. Chandler believes Lucian liked the edge of losing as much as the delight of winning.

Over the years Lucian probably paid somewhere between £3 million and £4 million to the Millfield-educated bookie. 'I'm going to have my betting shoes on today,' Lucian would boast as he rang to back a horse, but they seldom brought him luck. Lucian did have some significant wins, but ultimately his addiction to risk meant he lost more than he won. Saunders would be sent to Clarke's for a 'debt breakfast' with Lucian. 'I would know if he would pay on the day simply by what he did. If he put his glasses on, he would read the bill and that was hopeful. But if they stayed firmly on the table, Victor and I knew that he would take the bill home to read later. No money then,' he said. Victor would sometimes try to make him more likely to pay by saying, 'Lucian, please put your glasses on.'

Chandler felt gambling was an intrinsic part of Lucian's character. 'My impression is that he wasn't one for great self-analysis; he was almost animal. He went with his feelings, took what he wanted. That was his strength. You could also physically see it in his actions, eating with his fingers, tearing birds to pieces on his plate. When we cooked pheasant or partridge he wouldn't use a knife or fork. I don't think he ever articulated it, but the usual social rules that we apply to ourselves I don't think he ever thought they applied to him. There were no rules really.'

In gambling and in painting (as well as in kick-starting endless new affairs) Lucian found an adrenalin rush. Both occupations, he thought, relied on a degree of chance with a tiny margin of error

between success and failure. 'I would see Lucian put his boot through a canvas when he felt it had gone wrong, when only the day before he had been convinced that it was going to work. It mirrored the hope of winning before a bet turns sour, the difference between winning and losing can be the head of a horse, and with a painting one fucked up brushstroke,' Chandler said.

It became a rite of passage for Lucian's bookies to sit for their portraits. It was the most practical way of reducing his debts, as they could buy his pictures at a discounted rate. Chandler liked sitting for Lucian as it gave him many hours of quiet time away from his hectic office. It immersed him in Lucian's world completely. Sometimes at midnight they would visit the National Gallery using Lucian's special 24-hour access. And they talked incessantly, and often provocatively.

GG: 'What was Lucian afraid of?'

VC: 'I think he had a fear of being poor. Underneath all that bravado it meant something to have security. It was as if by gambling he could sort of play with his biggest fear.'

GG: 'And women?'

VC: 'The conversation we had about that was that he needed sex to stay alive. It was his attitude to living, to need the release. I think he needed to dominate women in certain ways. He talked about everything. One night we had a long conversation about anal sex. He said unless you've had anal sex with a girl she hasn't really submitted to you.'

GG: 'And as to the number of women he had in his life?'

VC: 'It was extraordinary. You never knew what the situation was. It was like a farce with girls coming in and out. He bought that house in Kensington Church Street so that he had somewhere to go with women. I went with him to buy the house.'

His interest in horses brought pleasure and pain. Andrew Parker Bowles played a significant role in attempting to salvage Lucian's reputation as a bad debtor. This was after Ladbrokes, the largest betting company in England, had placed Lucian on a 'forfeit list'

in February 1983. It effectively prevented him from placing any bets with the bookmakers.

Parker Bowles's well-meaning, chivalrous aim was to prevent Lucian from dying with his reputation tarnished by having his name on racing's black list. So on 27 February 1999, sixteen years after the ban had first been imposed, he sent, in confidence, a typed letter to Peter Grange, a senior executive at Ladbrokes Racing Ltd pleading for leniency and a pardon. 'I write to you not as a director of the BHB [British Horseracing Board] or as a member of the Jockey Club but as a friend of Freud who believes he should not die while on the forfeit list.' The dispute was over £19,045, which Lucian insisted he did not owe. Parker Bowles argued that it was a misunderstanding rather than any intentional dishonesty. 'Freud is Britain's greatest artist and his pictures average around £1 million. I was surprised to find that he owed this comparatively small amount. He told me that back in 1982 when he went to the local Ladbrokes he had offered Northern Irish pounds which the Ladbrokes clerk had refused to take, although, of course, it was legal tender. The horse he chose then won so he deducted the money he would have won from what he owed Ladbrokes. He is stubborn,' warned Parker Bowles, who explained that Lucian would never simply hand over money to Ladbrokes he felt he did not owe. He suggested that Lucian write a cheque for £4,000 to a jockeys' charity to end the dispute. The cheque was duly written and he was taken off the list.

Parker Bowles had first got to know Lucian in 1982 by finding him horses to ride and draw in London. As commander of the Household Cavalry Regiment in Knightsbridge he had dozens at his disposal. 'Lucian wanted to gallop or canter and would never wear any protective headgear. I was terrified I would be blamed for the death of our foremost painter when he landed on his head,' he said.

Lucian asked Parker Bowles to sit for a portrait in 2003. It was another vertical journey. He fitted into the same category as the Devonshires, Birleys, Rothschilds and other grandees in his aristocratic circle. The traditional genre of the 'gentleman-soldier portrait' can be seen in many country houses. Lucian wanted to take this classic genre and give it a twist. The inspiration for his picture of Parker Bowles came from James Jacques Tissot's portrait

of Fredrick Gustavus Burnaby (1842–85) painted in 1870 and hanging in the National Portrait Gallery. It showed a dashing cavalry officer relaxing on a chaise longue and was an archetypal but characterful, flamboyant Victorian portrait.

However, it lacked the drama of Freud's picture. Parker Bowles had not worn his ceremonial uniform for many years and because it was too hot and uncomfortable to wear buttoned up, he undid it. The painting grew bigger with extra pieces of canvas being attached, and so took longer. *The Brigadier* (2003–4) shows him sprawled in his uniform, as if somewhat gone to seed. Red-faced, waxy, paunchy, stomach billowing under his white shirt, the red stripe of the uniform hints at a sense of the dashing. But somehow the formality of the uniform is undone by the vulnerability of a man who has grown beyond the smartness of his military garb. The arm raised has a suggestion of pomp but the worn leather armchair reminds the viewer that not only the sitter but the setting and the furnishing have seen better days. This is no romantic take on a nineteenth-century portrait tradition. Lucian let the first viewing of the brigadier and his portrait be seen in *Tatler* after David Dawson photographed the painter and sitter in the studio.

Lucian told Parker Bowles how a few years earlier Prince Charles — well known to be an 'amateur' artist, who had received tuition from Edward Seago, John Ward, Bryan Organ and Derek Hill — had sent a handwritten letter to him suggesting that he and Lucian exchange paintings. 'It was such a cheek. It was almost like theft,' said Lucian. 'I never replied. What was there to say? It was embarrassing.' Lucian was outraged, and when he crossly recounted this incident to the brigadier, Parker Bowles laughed. He saw the amusing side of a £3 million work being swapped for one worth perhaps £5,000, painted by the man to whom he had lost his wife.

The portrait took its time. 'The Brig, as yet mouthless, is slowly coming to life,' Lucian wrote to Parker Bowles's wife Rose on 9 December 2003. Six months earlier he had written a birthday greeting to her, adding 'The bemedalling [*sic*] Brig is giving me invaluable help.' The finished portrait prompted a clerihew from the satirist Craig Brown:

Andrew Parker Bowles
Is the most benevolent of souls.
He was even overjoyed
To be done by Lucian Freud.[116]

* * *

The end of Lucian's gambling days coincided with gaining a new dealer. William Acquavella was ambitious, and transformed Lucian's reputation and prices. His New York gallery was the ultimate blue-chip modern art dealership, presenting exhibitions by Monet, Degas, Cézanne, Picasso and Léger. It was established by his father in 1921, first selling Renaissance paintings, and is based in an elegant, five- storey, French neoclassical town house on East 79th Street between Madison Avenue and Fifth Avenue. It is a grand setting, and produced grand deals.

Acquavella had once upset Lucian by wearing the wrong shirt. He had flown to London from his home in New York for ten days to sit for his portrait. Assuming all his blue shirts were identical (he usually bought six or eight at a time), he had not realised that he had worn one with a minutely different shade of blue for his second sitting. Lucian minded because this imperceptibly different blue would alter his picture.

Such subtleties were crucial to Lucian, and it was also why he never tolerated lateness. It changed everything: mood, light, routine, and thus the end result. In 1997 he had erased the Texan model Jerry Hall from a portrait of her breastfeeding her and Mick Jagger's son Gabriel because she was late once too often. Lucian's revenge was comic and cruel, but also pragmatic.

Acquavella had some difficulty explaining this to Jagger, who called him to try to buy the painting. 'I said, "It's not even finished." We negotiate, I sell him the [uncompleted] picture. Then one day, Lucian calls and says, "I want you to be the first to know: the painting's had a sex change." I said, "What are you talking about?" He said, "Well, Jerry didn't show up for two sittings so I changed her into a man. I've got [his assistant] David's head on her body." I said, "You've got to be crazy." But I knew immediately there was

nothing I could do. Mick calls me up and says, "Hey, Bill, what the hell is going on? My wife sits with him for four months and . . ." Then I thought: how am I ever going to sell this picture? But the first person who saw it when I brought it back to America bought the picture.'[117]

Lucian's arrangement with his New York dealer was simple: Lucian named his price, Acquavella paid it. They never negotiated. It was probably an advantage that they lived on different continents in different time zones. It gave them space and it made Lucian less reliant than he had been on his former London dealers. When Acquavella took him on, he said bluntly: 'Lucian look. I'm an art dealer. I'm not an accountant. I'm not a nursemaid and if you need any of those things you've got the wrong guy. But you paint them and I'll sell them.'

Lucian had fallen out with and left six dealers prior to joining Acquavella's stable in 1992. Most of his dealers had been run ragged, especially by the untidier ends of his personal life: late-night calls, demands for cash to sort gambling debts, and so on. When the shutters came down, he rarely made peace, especially when he was not at fault. Anthony d'Offay, his dealer in the 1970s, discovered this too late when he closed Lucian's show at his gallery a day or two earlier than scheduled to open a show by the then fashionable German painter Georg Baselitz. It infuriated Lucian, who effectively fired d'Offay. Salt was rubbed in the wound by Lucian being supplanted by an artist who represented everything that Lucian opposed. Baselitz's neo-expressionist, postmodern pictures were antithetical to Lucian's work.

D'Offay regretted his decision. 'In the end I did behave badly and that was that. And so Lucian went. We didn't see each other for fifteen years or so. When we changed the dates of our show and knocked off those days at the end of his show he was super-livid and had a right to be. By changing the date without discussing it, it led to a breach of trust between us. The minute that happened it felt impossible to repair,' he said.[118]

In the 1960s and 70s Lucian had been in danger of being left behind by the international art market. The collectors of his work were mainly English aristocrats like the Devonshires or Colin

Tennant, who were willing to pay between £5,000 and £25,000 per painting. 'It doesn't seem a great deal now but it was then,' said d'Offay. There were one or two early purchases by the Tate and other public collections in the 1950s, but that petered out. Certainly compared to Bacon he seemed an artist in the second division. On top of that, dealers considered Lucian difficult as he would sell works on the side, or slip them off quietly to bookmakers to settle a debt.

D'Offay's relationship with Freud had started in the 1960s through an introduction by a bright young art expert called James Kirkman, the son of a general, who worked for Marlborough Fine Art and looked after Lucian there. Marlborough, part-owned by the Duke of Beaufort, was the most prestigious British contemporary gallery, representing Francis Bacon, Henry Moore and Graham Sutherland, as well as Lucian. But Lucian felt ignored and sidelined compared to his friend Bacon, who in 1962 had a show at the Tate Gallery and was rapidly gaining a global reputation. 'Lucian was by no means a star then. He was actually thought to be something of a has-been,' said Kirkman. 'No one was really interested in figurative art, especially what he did. Pop art and kinetic art was what modern art collectors desired. All that passed Lucian by, making him seem traditional, even old-fashioned, but still with an ability to shock with his raw nudes. He was doing pictures that were considered less attractive, that were not really appealing to anyone. It sounds strange now but that was the reality and how he was received and perceived.'[119]

Kirkman, however, did set in place many of the coordinates that would help to make Lucian successful. Lucian got a toehold in America after an early portrait was given to the Museum of Modern Art in New York. Kirkman was an astute and dedicated dealer who adored Lucian and protected and looked after his interests assiduously. He worked with the British Council promoting Lucian's works, but it was not easy, given that outside Britain his paintings were met largely with indifference.

Kirkman remembers him as a painter whose star was not on the rise. 'His shows were non-events. The press cuttings about them were thin on the ground, but there he was plugging away. Lucian

knew his works were not much liked, but he did not care. Others at the Marlborough were fairly dismissive and thought he was only there because he was a friend of David [Somerset, the Duke of Beaufort]. Marlborough did not do anything for him. He was seen as a bit of a bore, always wanting advances. It was a thankless task.'

In 1972 Kirkman left Marlborough to set up on his own and Lucian anxiously asked what would happen to him, as Kirkman had been his main point of contact. No one had any helpful answers. 'Lucian then said to me, "I'm not staying with those bastards,"' said Kirkman. Lucian joined him and another young dealer – Anthony d'Offay. It was the start of a twenty-year relationship. Doff, as Lucian liked to call him, was an enigmatic half-French aesthete from Sheffield with a brilliant eye and prescient taste. He was stylish and funny and his gallery in Dering Street was far more influential than its bijou size suggested. In 1972, he and Kirkman put on a stunning show of Lucian's pictures (at that time the top prices for a Freud work were about £1,000).

James Kirkman was eventually to fall out with Lucian over the portraits of Leigh Bowery from the early 1990s. Whatever his own feelings about the works from a critical and purely artistic perspective, when Kirkman saw the first picture of the naked, obese, shaven-headed, preposterously coquettish performance artist, his first thought was, 'Who on earth will buy it?' The flesh was pink and blubbery, almost waxen, and verged towards the grotesque. Kirkman was just not sure he knew a buyer who would pay huge sums for pictures of this freaky Australian extrovert so indelicately exposed. 'His penis was like a slug,' helpfully suggested Lucian's ex-wife Caroline. What was more worrying for him was that Freud always insisted his dealers buy his pictures up front, and then sell them on for whatever price they could achieve. For years Kirkman had successfully sold Freud's paintings, many of them neither picturesque nor easy on the eye: the words 'cruel', 'disturbed' or 'distressed' were used by some critics of his treatment of women. Many portraits stretched the sensibility and taste of traditionally minded art collectors. But with the Leigh Bowery portraits, it was as if Lucian were deliberately testing Kirkman on a new level.

Bowery was an unlikely cause of the break-up between Lucian

And the Bridegroom, 1993

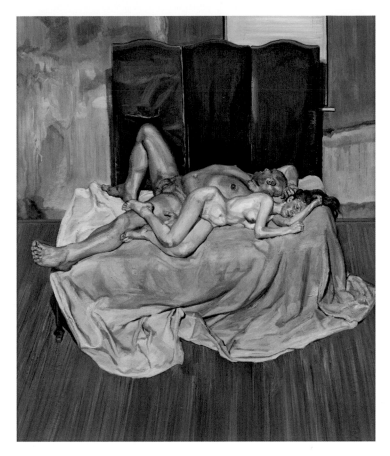

and the sophisticated Mayfair dealer who had done so much for him. 'An unusually big heifer carting around sixteen or seventeen stone,' is how Bowery described himself. By profession he was an exhibitionist dancer who transformed himself into strange versions of human sculpture. It was often fetishistic or transvestite in style or he was naked. His entire head and body were shaved to facilitate what he called 'body modifications'. The pictures by Lucian were sensational in every sense, with a tributary echo to Velázquez as he transformed a freakish performer into serious art. Hard core as well as high art: there was the rub. Were there buyers for paintings like these?

The Bowery portraits were a step too far in scale and subject matter, but most of all price. With Lucian demanding ever higher figures while producing more and more paintings, it meant that Kirkman simply could not afford to keep buying them. They were

not easy to sell and Kirkman felt he had come to the end of the road. 'Lucian wrongly thought I was being neurotic or even homophobic because it was when he was doing Bowery's portrait. But I wasn't. I bought everything I could and always thought the Leigh Bowery paintings were some of his greatest works. Lucian had to make a row. It was like a divorce.'

Kirkman appealed to Lord Goodman to arbitrate to prevent the split and saw him twice, but even England's greatest fixer could not mend the relationship. Victor Chandler also tried to broker a peace deal, but to no avail. Kirkman said, 'I didn't want to go on. I had another life and other artists. Lucian was very demanding. I never went away for more than ten days and he would phone within five minutes of my coming back home. Even on Christmas Eve he would call and ask for some photographs of a work to be sent to someone. It never occurred to Lucian that he could be wrong, however monstrously he behaved to his children, wives or even his dealers.'

Two years before their break-up, Kirkman had scented change and suggested that Lucian should find a new dealer. 'Moving dealer is like moving house – you want to avoid it,' Lucian had told him.

'I said it would be better if, like every other artist, you come to me and I sell it and take a commission. But he always wanted the money up front,' said Kirkman. Essentially he needed a dealer with cash flow. After going without a dealer for two years, Lucian found one.

Acquavella was on a different scale. He travelled by private jet. He never queried a price. He had a palace of a gallery in Manhattan. He was rich and patrician and already dealt in major pictures by Picasso and Matisse. Kirkman had always been unable to find anyone who wanted to give Lucian a commercial show in New York. That changed in 1992 when Acquavella put his muscle and money behind Lucian to propel him into the big time.

Ironically, Acquavella had not initially wanted Lucian as a client. He had met him socially in London through the Duke of Beaufort, but after Lucian had left Kirkman, Acquavella had heard every good reason not to take him on. But overtures had been made and a lunch was set up at Wilton's, the grand restaurant on Jermyn Street in St James's famous for its lobsters and Dover sole. 'I had no

intention of really taking on Lucian because every English dealer told me he was doing these totally unsaleable pictures: huge, full-front male nudes, impossible to sell and he's such a difficult person. My wife came along for lunch and I said to her, "How we gonna get out of this gracefully if he wants us to go back to the studio?"

'Well, we had a very nice lunch and sure enough he invited us back. The first thing he pulled out was a Leigh Bowery painting and I went, "Man, this is different from what I had in mind, and from what you have done in the past." The first was the one with his leg raised. Then one of Leigh's monumental back, before finally he pulled out the big picture of Leigh in the red chair. I saw those three paintings and said, "Let's make a deal."'

They shook hands. "'If it works we will keep doing it and if it doesn't we'll stop," I told him and he just said, "Fine."' Lucian had a new dealer, his seventh. His first had been the Lefevre Gallery which exhibited his work in November 1944, and then the London Gallery and the Hanover Gallery in 1950 before he joined Marlborough in 1958. Anthony d'Offay and James Kirkman then followed. The new deal remained how it had always been. The moment the final brushstroke was applied to a painting Lucian wanted a cheque. Whatever profit was made by his dealer never bothered Lucian. He wanted cash fast.

There was one slight hitch. Lucian owed money to a Northern Irish bookie, and asked Acquavella to sort it out. He had often asked his dealers to sort out similar financial headaches in his life. Lucian said that the bookie's name was Alfie McLean, and that he had bought many of his paintings. Acquavella duly arranged lunch with McLean, whom he recognised at once as 'the Big Man' in Lucian's portrait of that name from the 1970s. 'When I sat down with Alfie McLean at the end of the meal I asked what Lucian owed him. I was thinking of some preposterous figure like £100,000. When he spurted out £2.7 million I was blown away.' Acquavella, however, kept to his word and the debt vanished. It was the ultimate act of confidence in his new artist. 'I made Alfie buy a picture at a better price, and so on. We worked it out,' he said. 'I don't know if you have ever met Alfie – a very big man, I mean really big … hands and head, a big character. Well, it was a big debt too.'

It was the start of Freud's international career, moving from a niche British artist onto the global stage. Acquavella offered the picture of Bowery called *Nude with Leg Up* (1992) to the Hirshhorn Museum in Washington DC for $800,000. To sweeten the deal he gave them two years to pay. Lucian got his cash immediately. Acquavella next persuaded the Metropolitan Museum of Art to buy the second Leigh Bowery. Twenty years later, of course, those pictures have an estimated value of $30 million each.

The advantage for Acquavella was that because Lucian had had no dealer for almost two years, he had a lot of pictures to sell. 'Once I took his work to New York and I started living with it I realised that he was an unbelievably special artist who had found his time. When Francis Bacon died, Lucian exploded on the market,' he said. Freud's pictures had grown in size and scale. They were more imposing and more monumental. Lucian had joined the top table.

In December 1993, the Metropolitan Museum staged a Freud exhibition and at the same time Acquavella showed new works in his gallery. It was all so different from the first major American show at the Hirshhorn in 1987, when no New York gallery or museum wanted his work. This time everything sold. Big-shot collectors like the financial titans Henry Kravis and Joe Lewis bought paintings, as well as corporate players like the Chicago Institute of Art.

Acquavella was delighted to hear young American artists say they had felt they could not be considered cutting edge or truly contemporary by doing figurative painting, but Freud changed all that with his ability to create surprise and tension. 'They could stand up and compete with anything that was being done in the contemporary world here, a Jeff Koons or any other artist in America. You put a Leigh Bowery there and you're not going to walk by without taking a look. Lucian needed to be established in this country as he was basically unknown. Our gallery has been here a long time and he fitted into our programme. I also just liked the pictures and if no one had bought the Bowery pictures I would have been very happy to have owned them myself,' he said.

The transformation into a global phenomenon reached its peak with a painting of Sue Tilley, or Big Sue, introduced to Lucian by Bowery. Like him she was enormous. She worked at the Islington

Job Centre by day and posed for Lucian by night. The art market was electrified when *Benefits Supervisor Sleeping* sold for £17.2 million in May 2008 to Roman Abramovich. The painting was not sold by Acquavella, but his preparatory work for Lucian had set the pattern. Lucian was by then an international star.

Anthony d'Offay could not have been more gracious on seeing the man whose work he had supported early on in his career do so well. He said: 'It was thrilling that Lucian went from a little artist at the Marlborough into a great world master. In his last fifteen years he conquered the world.'

Lucian was always a rogue trader, in that he never had a signed contract and liked to be able to sell his work on the side. Jay Jopling – the most powerful contemporary art dealer in Britain as the owner of White Cube, the gallery which represents most of the once so-called YBAs (Young British Artists), such as Damien Hurst, Tracey Emin and Marc Quinn as well as older artists like Gilbert and George – met Lucian in odd circumstances. A dapper Old Etonian with signature 'Joe 90' glasses, Jopling had been having a quiet drink in Green Street, a dining club in Mayfair, when Lucian entered the room and attacked him. 'He kicked me on the shins, grabbed the girl I was talking to and walked out with her,' he said. Their only other connection had been when Jopling had written to him when he had been a student at Edinburgh University, to ask him if he would help with an arts project to raise money for Save the Children. Jay followed up by going round to his house and ringing his doorbell. He was bellowed at with a simple message: 'GO AWAY.'

When Jay set up his first gallery on Duke Street in 1993, he invited Lucian to visit. 'Dear Lucian, It has been a long time since you kicked me . . .' began his letter. The charm offensive worked and Lucian paid a two-minute visit, afterwards driving Jopling back (in typically hair-raising fashion) to see new paintings at his studio.

Seven years later Jopling bought *Naked Portrait* (1999), a hard-core Freud nude, and subsequently sold it to the Museum of Western Australia. He was then sent a close-up of Leigh Bowery's cock and balls, and sold that. Lucian befriended him, calling him 'Jop', and would ring for lengthy chats and occasional ventures into the outside world. Jopling accompanied him to see his daughter Annie on one

of his rare visits to her flat in south-east London. Lucian partly used him as some sort of emotional buffer to dilute any difficult conversations. On the professional side, Jopling encouraged him to paint another self-portrait in the style of Rembrandt, and they flew over to Holland to the Rijksmuseum and spent a wonderful day looking at pictures. On the way back, Lucian had a slight memory lapse and said, 'Jop, where are we?'

'We are in Schiphol in Amsterdam, Holland,' he reassured him.

Lucian clicked back into top form 'Ah Holland, Dutch-fucking . . .' He was convinced that it was when two people have sex with another at the same time. Jay explained that an alternative meaning was when someone gives you a cigarette from which to light your own. 'It was brilliant,' he said, 'he just flashed back.' Doing deals with Lucian was never grey.

The biggest winner among everyone who ever did business for him, though, was Alfie McLean, the bookie. He had taken the biggest gamble of his life by swapping Lucian's gambling debts for pictures that eventually became worth tens of millions of pounds. He ended up owning twenty-five paintings, possibly the largest collection of Lucian's work in private hands.

The Big Man (1976–7) is an archetypal Freud work, mesmerising, brooding and remarkable for a portrait of what is essentially just a ruddy-faced man in a suit. It could have looked like every corporation's commissioned portrait of their company chairman, but this picture is scarily hypnotic. McLean's fingers are entwined in his lap, the stuffing in the arm of the black leather armchairs bursts out, a mirror behind him creates a reflection of the back of his head with a quirky, unsettling perspective. He stares ahead, his enormous physical presence almost squeezed out of the frame, a brute force suggested by the sheer bulk of his body, his legs apart, thighs thick, fingers like fleshy truncheons. Every fold of his tight-fitting suit adds to the tension of this very bulky man trapped in this space, lost in his thoughts as he is scrutinised. A sense of physical threat hovers; this is not someone to fall out with over bad debts, and luckily they never did.

This portrait was one of the pictures in the first Freud show that I had also seen at the Anthony d'Offay Gallery in 1978 when

I knew nothing about Freud or his life. There was a secondary portrait of him in the show titled *Head of the Big Man*. Back then there was no knowledge or hint about who he was. He was dressed in a gangsterish manner, a sort of muscular Sunday best. Questions hovered, but I had no answers, and the gallery said simply that the subjects were people the artist knew. It was another Lucian secret, his private life, his hinterland, all his troubles sealed beneath the painted surface.

The Big Man was part of Lucian's life for more than thirty years, and they became close friends after trusting each other over large sums of money. McLean was the most unlikely modern art collector. In September 2003, Lucian, the Duke of Beaufort and Andrew Parker Bowles travelled in a small private plane to view the bookie's bounty in McLean's modest family house in Northern Ireland, the ordinariness of the dwelling belying its extraordinarily valuable contents, which any national gallery would have liked to own.

McLean was something of a legend in Ulster, born in Randalstown, growing up in Ballymena and staying loyal to the County Antrim town where he died and was buried in May 2006. When Northern Ireland legalised betting shops long before the rest of the United Kingdom, he became one of the pioneers of the betting industry.

Painting remained an activity for Lucian that was equally bound up in risk. Surprise motivated him. 'I am doing what I find most interesting, what amuses and entertains me. If I knew exactly what I was going to paint in the next minute why would I ever want to do that? It would be so pointless,' he said, repeating his view that 'gambling is only exciting if you don't have any money. I used to get given very good credit because I went about with very rich people.'

Lord Rothschild was one of those rich people and remembered a Pinteresque encounter when Lucian told him: 'I'm in trouble with pressing debts to the Kray brothers. If I do not give them £1,000 they will cut my hand off.' Rothschild recalled: 'I said I would loan him the money on two conditions. First, that he never ask me for a loan again and second, that he did not pay me back the money. He accepted the conditions but ten days later a large envelope came

through my letter box with £1,000 in cash and a note saying thanks. And he never asked me again.'[120]

This was no solitary request. The Duke of Beaufort, one of Lucian's oldest friends, was also tapped up. 'He rang me at about four in the morning and said "David, can I come round? I've got something to ask," and I said, "Well, yes, but you'd better hurry up because I have to go to the airport to catch a plane." So he came round and said he needed fifteen hundred quid. It was quite a sum to raise then, and so I said, "Well, why do I have to give you £1,500?" He said because if I haven't produced it by twelve o'clock they're going to cut my tongue out," and that this was irrefutable. You couldn't say, "No, I'm sorry." They [gangsters] excited him and perhaps he relished the idea that he'd got the better of them, but I doubt whether he did really.'[121] This was Lucian as ever travelling vertically between social extremes, borrowing money from a duke to try to stave off threats from the most depraved gangsters in London. He always somehow managed to square this bizarre circle.

Sitting in Clarke's in his eighties nursing a cup of tea and chiselling pieces of nougat to nibble, he was then far removed from the risk, remorse and exhilaration of blowing money recklessly on mere chance. He never regretted losing, and neither did he regret giving up gambling. 'I only look forward, never back,' he said.

CHAPTER THIRTEEN # Offspring

There was a thirty-six-year gap between the birth of Lucian's eldest child, Annie, born in 1948 towards the end of George VI's reign, and his youngest, Frank Paul, born in 1984, the thirty-second year of Queen Elizabeth II's reign.

Frank is a quietly spoken modest young man with a West Country accent. He has his father's narrow face and inquisitive, darting eyes. He was essentially brought up by his maternal grandmother in Cambridge, seeing his father intermittently. He saw more of his mother, Celia, who also painted obsessively in her London studio. At Cambridge he read languages, and speaks Russian and German.

'When I was little I very much admired Dad, but found it hard to relate to him because he and I lived in such different ways. Our tastes were very different, one extravagant, the other plain. He liked very posh restaurants and to eat oysters and mussels. I liked plain food like burgers and chips or pasta. I liked videos and computer games and became really obsessed by them.

'I found it hard to relate to the fact that he lived in a very sparsely decorated flat and never seemed to watch television or play computer games, or do any of the things that I was into, and felt were pre-requisites for fun.

'But he seemed very true to himself and never altered his behaviour in any way to please the person he was talking to, which I admired greatly. I remember coming to his flat when he had just finished *Benefits Supervisor Sleeping* which stood on an easel on the

paint-splattered floor, and he asked me what I thought of it. My mum tells me that I said I thought it was disgusting but very good. He liked that.'

The longest time Lucian spent with Frank was during a series of sittings. 'There were a lot of silences between us when we were alone and I found that quite awkward, but he was entirely comfortable with that. I remember pointing out what I perceived as an awkward silence and he said he didn't find it awkward at all. I felt quite small at that point; I wanted to be someone who was equally comfortable with silence. I think I am more so now.

'I remember admiring him more as he never seemed to care what other people thought. I remember telling a friend of mine when I was about seventeen and at school how my dad had heard that "*porca Madonna*" was an incredibly offensive thing to say in Italy and he had decided to test this by shouting it out in a restaurant and was thrown out. My friend replied, "Wow, I wish my dad was like that." I remember feeling immensely proud.'

One singular childhood memory of him is being tickled by Lucian, 'which I didn't particularly enjoy, but I was quite helpless to stop. I felt too awkward to tell him. I remember looking pleadingly at my mother and hoping she wouldn't leave the room, but being a bit too scared to announce that I wanted her to stay. She just smiled and she did leave the room and he did tickle me.'

Frank had his father's telephone number for a short while, but rarely rang him. 'I don't think I ever called him for a chat. I felt it was a very different relationship from what other people had with their fathers, but I never felt particularly upset about that,' he said.

He always used Paul as his surname. 'I assumed it was my mum's decision. She said she wanted me to be able to choose if I wanted to associate myself publicly with the Freud family. She thought it would be nice to have the choice to be more discreet about it if I wanted, which I think was a good decision,' he said.

Frank was twenty-six when his father died. There were thirteen other children who Lucian acknowledged as his, and to whom he left an equal portion of his fortune. He may have fathered as many as thirty children according to estimates by his friends (some journalists have put the figure nearer forty), with many of

these children presumably discreetly folded into the existing families of some of the women with whom he had affairs. 'My reckoning at one time was that we could count twenty-four children who were his,' said Lucinda Lambton, Bindy's daughter (who did not have children with him).

Despite threatening newspapers with libel writs to dampen speculation, rumours about his priapic propensity and fabled fecundity were always circulating. As we sat in Clarke's, over breakfast, he shared his thoughts on fatherhood.

GG: 'Did you aim to have lots of children?'

LF: 'No, I never thought about it.'

GG: 'Did you want children?'

LF: 'No. I don't mean, "Oh God, children!" but it seemed quite exciting when women were pregnant. I don't like babies. I think partly because they're so vulnerable. But I'm very good with older children.'

GG: 'Was it impossible for you to have a family life and be a painter?'

LF: 'For me, yes. I've always liked being on my own part of the time or feeling on my own. When I was sort of married I always said, "Delamere is a place of my own where I work and occasionally have people staying there." Communal life's never had much appeal.'

At times, Lucian was an adorable father, the clown who did headstands, the entertainer who swirled toddlers round the room. He had a real playfulness that lit up their lives when they did see him, but of course as none of them lived with him this was intermittent.

When any child of Lucian's was born, the complication for the mother was immense as he never made any secret of the fact that he did not do conventional family life. In 1961, for example, he became a father to three children (Bella, Isobel and Lucy) by three different women (Bernardine Coverley, Suzy Boyt and Katherine McAdam). Lucian had met Katherine when she was studying fashion at Central St Martins and he would drop by to sit in on life-drawing classes. In the interconnected life he led, it was no coincidence that she had also been a babysitter for Annie and Annabel, his children by Kitty.[122]

Some of his children took his surname, others mixed it with that of their mother, or never used it at all.

Most of Lucian's children loved him unreservedly, despite all his obvious failures and complications as a father. There was anger and resentment at his absences and neglect but his life force and charm made them wish they could see more of him. He managed to make them forgive him almost anything. The four McAdam Freuds, who he barely saw for a gaping twenty years after their mother Kathleen left him in 1966, were the most angry. When Lucy got married, aged twenty-two, 'to have a family, be a proper family', he never responded to the invitation to her wedding and did not attend.[123] He never met her two sons, Peter and James, his grandsons.

John Richardson saw Lucian's casual attitude to producing so many children almost as if he was deliberately putting down roots in his adopted country by having them. Lucian's former assistant Rebecca Wallersteiner, with whom he had a brief affair, believes it was psychologically connected (even if unconsciously) to his survival after escaping the horror of the Holocaust. Although some of his relatives were murdered, it was not something upon which he dwelt; the more obvious truth is that he simply slept with a lot of women and never took any precaution to avoid having children. The other obvious truth is that neither did they.

Lucian's aversion to living with any of the mothers of his children, was also possibly linked to his love-hatred of his own mother. He needed room. Lucian's friend Cyril Connolly famously wrote that the pram in the hallway is an enemy to art, but it was more than this – Lucian could not bear a pram anywhere in the house. His daughter Jane believed he saw womankind as very separate: 'They were another species for him. This is connected with his mother and her suffocation of him. I asked him about her in the 1990s and he grimaced and said she had been too intrusive. I said I loved her although she did ask a lot of questions. He said she was easier to deal with when she "didn't care" any more towards the end of her life.'[124]

Lucian's second daughter, Annie's sister Annabel, suffered much anguish in her childhood. His portrait of her in his studio sleeping, lying on her side wearing a blue dressing gown, shows her

in a state of deep sleep, almost as if sedated. It is tender and loving, her face hidden from view. It is extraordinary how he can make a girl whose face is not visible seem vulnerable and moving. There is a sense that this may be the best that he can do: her resting, him observing, finding a way to make their worlds come together.

Painting his children was very important for him — and for them. Annie, Bella, Esther, Rose and Freddy all sat for him naked. Jane McAdam Freud was never herself asked to sit, but thought hard about what it meant to have a father who painted his children naked. 'We understood that he lived by his own rules. Sometimes this appeared defiant, childlike or childish even. His feelings were his philosophy. He was allowed to be rather childish in relation to responsibility. However, as he appeared both frightened and frightening, interrogating this would have been rather like questioning the Wizard of Oz because his frightening demeanour masked his fear.'[125]

Another important woman in Lucian's life, Bernardine Coverley, was just sixteen when she met him in a bar in Soho in 1959. Born to Irish Catholic parents who ran a pub in Brixton, she had been evacuated during the Second World War and sent to a boarding school from the age of four. When she was fifteen her parents moved back to Ireland to buy a farm, but she headed to London, where she met the man who would become the father of her two daughters, Bella (who she had when she was eighteen) followed by Esther two years later. When they met, Bernardine had a menial job for a national newspaper but told her parents she was in journalism. Lucian first painted her aged seventeen when she was pregnant. He was thirty-seven and had been married twice. They never lived together but were close to each other.

By the time Esther was born, Bernardine had moved to Camden and the relationship was unravelling. 'She was very independent and didn't want to play the game she felt she'd have to play to stay involved with him, accepting he had other women, pretending not to mind,' said Esther.[126] When Esther was four Bernardine showed her independence by taking both her daughters to live in Morocco. It was a momentous eighteen months, and Esther based her novel *Hideous Kinky* on the bohemian escape to a souk in Marrakech. It was

the ultimate way for Bernardine to distance herself from Lucian, and also a fierce reminder of her not wanting to rely upon him or dance to his faithless tune. Kate Winslet played Bernardine in the film version.

Bella remembers seeing very little of her father until she was about eleven. She and Esther lived with their mother in East Sussex, and Lucian would turn up randomly without warning. 'I'm sure he didn't tell my mother and my sort of stepfather, who I didn't like — and nor did he. I just remember that he arrived in a dark blue Bentley with his girlfriend Jacquetta and her eldest son Jago. Dad showing up unexpectedly was a revolutionary gesture and his unapologetic manner was so exciting. It made us feel like he was breaking us out of prison. He looked around a bit and then drove off. He felt like an unshakeable ally, and that was how I felt towards him from then on.'

When Bella was sixteen she left home and Lucian organised for her to share a flat belonging to one of his friends with her half-sister Rose. Almost straight away she began sitting for a portrait, and she was given a code when calling him — 'ring twice and then ring back'. 'I couldn't wait to get started and spend time with him. He was such good company and so irreverent. I felt terribly proud going out to dinner with him at Wheeler's in Soho. He dressed almost like a tramp in blue-checked cook's trousers covered in paint (taxis often wouldn't stop for him) but the waiters gave him the best table as he left such enormous tips.'[127]

Lucian was very close to Bella and Esther, painting both of them clothed as well as naked, and seeing as much of them as he did any of his children. He painted Bella as an infant and then more than a dozen times. According to Esther, her father and mother remained on good terms: 'Dad always spoke admiringly of her. And they'd often see each other at Bella's [fashion] shows or my first nights when I was an actress. They were both always interested in hearing about each other, and talked very little about the past and what their relationship was like. But that's how they were,' she said.[128] In her own way Bernardine was as imaginative and sprite-like as Lorna Wishart. A skilled gardener, she played the Irish drum, and travelled widely; aged sixty, she went to live in Mexico to work in an orchid nursery in the mountains. It turned into a book about

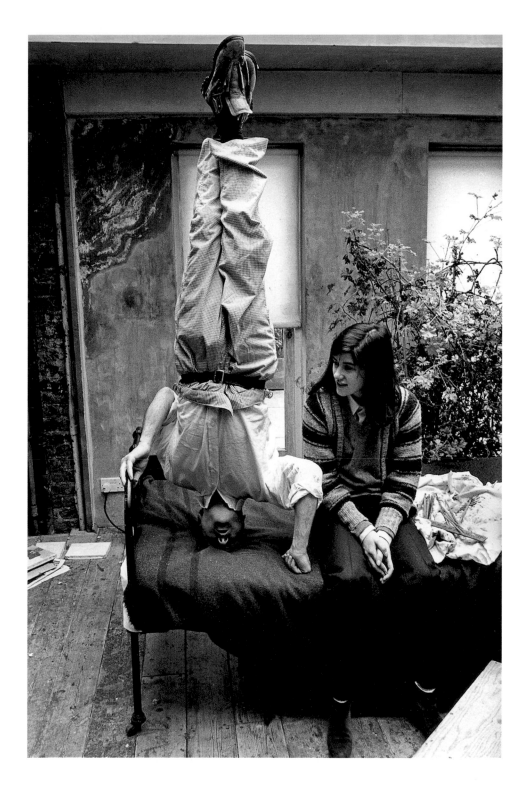

her wanderings, *Garden of the Jaguar: Travel, Plants and People in Chiapas, Mexico*. She passed away in Suffolk aged sixty-eight, just four days after Lucian died.

* * *

Lucian had met Suzy Boyt when he was a part-time teacher at the Slade, where she was a student. Born in 1935 to an army officer, she had been educated at home by a governess before going to boarding school in Wiltshire. Her childhood was mostly spent at Walcott Hall in Shropshire. At the Slade she won several prizes and three of her pictures are now in the art collection of University College London. Lucian's best-known painting of her is as one of the models in *Large Interior, W11 (After Watteau)*. Lucian painted all of his and Suzy's children.

One of his strongest and most successful portraits is *Rose* (1978–9), as exposing as any nude painting can be, both physically and psychologically. She lies back on a sofa, her legs spread, her right hand draped across her forehead, naked save for a sheet covering her left calf and the toes of her right foot. 'I can remember getting undressed, lying down on the sofa and shielding my eyes from the very bright bulb that was hanging from the ceiling above me,' said Rose, who was nineteen when the painting was begun. 'I did not realise that from where my father was standing by the easel the pose I had assumed would look quite so indecorous! I imagined that he would be looking down at me, rather than at me from all angles. I learnt then that his eyes gathered information not in the way the camera sees, in straight lines, but round corners. I think he had a moment before starting work of wondering whether he should save me from myself, but thought better of it.'[129]

They only had night sittings. 'Each lasted from when I arrived at dusk until he could not go on any more or when it got light, whichever happened sooner. Sometimes I would go home after the sitting, often at four in the morning, taking a taxi to my flat by Warwick Avenue via the all-night supermarket in Westbourne Grove, not feeling tired as I stocked up on cigarettes but treasuring the sense that some of my father's power had rubbed off on me.

Other times he would just chuck a blanket over me where I lay and let me sleep until breakfast.'

It was educative as well as intimate: 'He was very interested in Nietzsche, particularly *Thus Spoke Zarathustra*, which chimed in with my adolescent craving for absolutes and did not seem absurd at the time; I was much less critical than I am now.'

Rose went through her own transformation from rebellious schoolgirl to drug experimenter, voyeur of both the punk and club scenes, to writer. Sitting for her father was a catalyst for change. 'I sat more or less every night for about a year, during which I made the decision to go to university; my father had inspired me to read voraciously. It was my idea to wrap the piece of sheet round my leg when it became clear my foot was going to be amputated by the edge of the canvas.'

Her views on the painting changed over time. 'Crew cut, open legs, naked. It's a great painting, now in Japan, thank God. No, I was not at all embarrassed, though, looking back, I don't know why. Perhaps I've become a bit of a prude in my old age.'[130]

Rose's elder brother Ali, born in 1957, went through various stages of anger towards his father as a result of his erratic parenting, but ultimately forgave and never stopped loving him. His view was both rose-tinted and realistic about the absences in his formative years. 'Though it troubled me for a while, the degree to which he was absent seems largely irrelevant now. His sense of family, which by his own admission was limited for much of his time, grew into a thing of substance in later life. I apologised to him for any worry I caused him during my wilder years. He replied: "That's nice of you to say, but it doesn't work like that. There is no such thing as free will – people just have to do what they have to do."'

Lucian's words and presence were extraordinarily potent to his children. To feel his warmth was life-enhancing and to be absent from him coldly hurtful. He was closer to some rather than others and that too was not easy. Bella at his memorial service spoke of his great capacity to show love and give her time, describing both of them writing a poem together, as she shared happy memories of a father who relied upon her increasingly in his final years.

Sometimes their time with him took on a magical narrative,

and Ali remembers many otherworldly stories Lucian told, such as 'his friendship with the opium-addicted, illegitimate son of the king of Egypt, who was so rich and handsome that he would look at Hollywood magazines and if he saw someone he liked, he would go and get them, once simultaneously having an affair with both Marlene Dietrich and Johnny Weissmuller. I believed every single word.

'He also gave me advice when I owed money to villains: "Don't bow to their threats." We shared stories about women; he told me about the whores in Shepherd Market [in Mayfair] during the war who gave a "twopenny upright". He told me once that what he knew about love was that he would "rather have a miserable time with someone he loved than a nice time with someone he didn't care about".

'My memories of childhood with him were of handfuls of sixpences for the one-arm bandit in the Colony Club, playing spoof with the bar staff, Dad saying "This is my boy" to gangsters and artists, real blind black piano players performing in the smoky haze. Someone once told him that I was addicted to obsessive love, and he answered with conviction, "But, surely, obsessive love returned is the finest thing a man can experience."'

In his last decade he saw more of his children and in the immediate aftermath of Lucian's death, the children talked to each other and met more than they had ever done during his lifetime. It led to a dramatic gathering at his burial, and seven months later at his memorial service in February 2012 in the National Portrait Gallery, to coincide with the retrospective exhibition of portraits.

There was no predictable pattern with Lucian. Lucinda Lambton, for instance, remembers Lucian being a loving, attentive father to his two oldest daughters, Annie and Annabel, when they spent time with her family. Yet despite this bonding with his own children, she felt that Lucian, who was almost a stepfather to her, loathed her. 'He told me I needed a dog handler to look after me rather than a human handler. He was malign and magical. I adored him but he was also very cruel,' she said.[131]

When Lucinda was living in Bath Road, Chiswick in her late twenties she had an encounter that was macabre and unsettling.

'Lucian asked me to perjure myself over a driving offence. He had some girlfriend who had been in a car and wanted me to take the rap. I cannot remember the precise details but I refused. I knew it was not right. He was furious,' she recalled. The next thing she knew her doorbell was rung late at night and a letter posted through the door. It was a piece of paper with letters cut out from newspapers to form the words 'I am going to kill you'. Lucinda then opened the door to see who had delivered this psychotic note. She saw a car with its engine running and a man inside holding a torch beneath his chin deliberately and sinisterly to light up his face. The car drove slowly by and she saw that it was Lucian. 'It was so frightening but there was a side to Lucian which was indelibly cruel.'

In the next breath Lucinda explained how she would have walked across coals for him. 'He was magical and extraordinary, but that was the point; there was a dark side to his magic which was partly why he was so attractive to everyone. The fact that he disliked me intensely and would give me long, disdainful looks was no deterrent for my wanting to be near him and to please him,' she said.[132]

Victor Chandler once boldly questioned Lucian about his role as a parent. 'I asked if he ever felt any guilt about his behaviour towards his children, hardly seeing them. He said, "None at all." We talked about guilt and conscience and he said he felt no guilt about what he had done, even though he must have done a lot of damage to many of them. God knows how many there were.'

Lucian simply never examined his conscience. He also genuinely believed he gave a lot by painting them, giving them his most intense, precious time, doing what he did best – with them.

Lucian in his bedroom in Notting Hill, May 2011

CHAPTER FOURTEEN **Finale**

In his last years Lucian went out more often. The different people whom he had kept so separate started to converge. He saw more of his children and grandchildren. His obsession with privacy diminished.

He still loathed being snapped by the paparazzi, especially when flash was used. At Buckingham Palace he inadvertently spoiled an official photograph of the Queen and other recipients of the Order of Merit by stepping forward and shielding his face when the flash went off. In the picture he looks as if he is trying to do a runner, or deliberately ruin the picture. The truth was he was simply fearful that the flash would hurt his eyes and so affect his painting.

But while he mellowed, his appetite for work never diminished. Testimony to that is his final portrait of David and his whippet Eli, the two most constant companions in Lucian's life. This was a picture he seemed not to want to finish. *Portrait of the Hound* took up every morning, after he and David had met someone for breakfast in Clarke's, or had sat and read the papers there together. It was never completed, yet somehow it seems as complete as it was ever intended to be.

Any talk of retirement was quickly dismissed. 'What does that mean? Not doing what you have always done so that you have to find something to do. That is what so-called hobbies are for. If I am asked about them [i.e. hobbies] I say, "Wanking," just to stop talk of a boring topic,' he told me.

At the beginning of the twenty-first century he could remember

his friendship with the poets Stephen Spender, W. H. Auden and also Cyril Connolly, who published his first self-portrait in the April 1940 issue of *Horizon* magazine when he was only seventeen years old. It was essentially his first exhibition, albeit within a magazine, and, typically of Lucian, it was in grand company and made an immediate impact among the cognoscenti. This launched him into the world of those with cultural power or money. It would remain thus. Another contributor named on the cover of the same issue was Laurie Lee, who two years later would become a bitter rival in love over Lorna Wishart. Inside was a review by George Orwell of *Finland's War of Independence* by Lt. Col. J. O. Hannula, but strangely there was no mention of Orwell on the cover. Lucian later had an affair with his wife Sonia, following on from her previous lover William Coldstream, the leader of the Euston Road school of painters, who had invited Lucian to teach at the Slade and also painted his portrait.[133] Lucian's world was always populated by many of the most interesting people of his time.

In June 2011 the picture of David stopped progressing. And he stopped going out. It was the winding down of a life that had once seemed inextinguishable. It was a farewell that I had never wanted to make.

One evening on a blistering hot Sunday my son Jasper and I rang the doorbell at Kensington Church Street. One of the brass numbers nailed to the side of the matt-grey front door had come loose, and Jasper tried to press the figure eight back into position on the wall. It dangled helplessly, oddly symbolic, the faltering of Lucian's lucky number. David opened the door looking flushed, pink shirt roughly tucked in. We knew we were there for the last time, even though this was unsaid.

We remembered how Lucian had handed a small silver gavel given to him by Henry Wyndham, the chairman of Sotheby's, to Jasper one day after breakfast when we were sitting around chatting in his house. He had pretended to hammer Jasper's head with it, playfully darting round him at speed. In the hall the three of us stood and chatted about a fading water stain on the ceiling caused some years back by Lucian overflowing his bath. Lucian liked the rusty stain on the ceiling, and so it had stayed above the paintings

by Frank Auerbach. It was like an abstract pattern in its own right, a variation of the high–low mix in his life, priceless paintings hanging on soiled walls, chipped plaster next to eighteenth-century furniture by John Channon.

The drama of his studio was palpable as soon as you entered the house, with the imposing Auerbach landscapes dimly lit on the walls, past other paintings into the lino-floored kitchen where the bellied bronze Rodin statue, *Naked Balzac with Folded Arms*, stood on a table, lit by the light pouring in from the French windows into his rear garden.

There was a heightened sense of quietude as he lay upstairs in bed. Beautiful fresh flowers had been sent, as usual, by Jane Willoughby, but were just beginning to wilt on the table by the front door. For weeks Lucian had been getting weaker as the cancer and old age took their toll. 'He's OK, we're in Clarke's. Won't stay long,' had been a text six days earlier from David. This time it was definitely a visit at home, as his days at Clarke's were over, the sickness slowly closing in. There was no feeling of a dramatic end, more an ebbing away.

David locked the front door because Lucian sometimes became restless and confused at night, pulling on his overcoat, but not sure where he was going or what he was doing. He was looked after with extraordinarily tender patience by his friend, who was in constant touch with his doctor. He had been given a morphine patch by Dr Michael Gormley, his private doctor, who was the brother of the sculptor Antony Gormley (whose work Lucian could not stand, as he was never afraid to tell anyone, even Michael Gormley). The pain was being managed and he was allowed a small, regulated dose per hour, the final stand against the ruination of cancer. Some, like his sitter Mark Fisch, felt the cancer had to some extent been caused by his use of the famous lead-filled Cremnitz white paint, which gave the particular tone to all his paintings. If so, he would have wanted it no other way. Painting came first.

We went up to where he was lying in bed, very perky to see us, offering his usual saluting wave and warm smile. His bare leg stretched out from under the sheets, long and thin and with a bruise on his ankle. He kept it out of the covers to adjust his own body temperature. 'Exercise,' he said, commenting on the protruding limb.

'Like a ballerina,' I joked and he laughed, exaggerating a faux-elegant movement of his leg.

On the bed lay a brochure showing Lucian's drawing of a dead rabbit on a chair, to be sold at auction the following week by the collector Kay Saatchi. Jasper flopped on the bed and with a thirteen-year-old's natural excitement started telling Lucian about a rabbit he had shot at his grandparents' farm in Hampshire the day before, which we gutted, skinned, cooked and ate. Also for sale at the auction was the portrait of Suzy Boyt. 'Who is she?' asked Jasper.

'She is the mother of some of my children,' he said. 'That is right, isn't it?' he said to David.

Its estimate is £4 million. David and I tell him we hope it will go for six or seven million.

Lucian lay pale and wan in his bed, his eyes still bright and darting. Jasper, naturally affectionate, lay close as Lucian playfully stroked his hair. 'Why am I feeling so ill?' he asked. 'My left ball aches and I feel so awful. Have I got an illness?'

David said, 'Yes, sort of.' Lucian was clearly not sure, partly forgetful, sweetly unaware. He was in a mauve shirt, his trousers on the radiator, a tray with a glass and bottle of mineral water beside him. He was very unshaven but not as bearded as he sometimes was. His humour and sharpness were still evident. He listened as we chatted about Jasper's rabbit and then he congratulated Jasper on passing his exam into Eton. I showed him a photo on my iPhone of Jasper at his school. He asked for his glasses, which David found.

Jasper asked if the picture hanging opposite the bed ('The Buggers') was a Francis Bacon. 'I have never been so close to one,' Jasper said. Lucian explained he bought it cheap because it showed something rather rude. Jasper asked if all the other pictures in the room were by Auerbach. Yes, Lucian said, apart from the Jack B. Yeats on the right wall beside the bed. Two Rodins, *Meditation* and *Iris*, were subtly enhanced by the sunlight. The double doors into the sitting room were open and Lucian pointed to the Corot, *L'Italienne, ou La Femme à la Manche Jaune* above the mantelpiece. Lucian quietly stated that he was not feeling well. Jasper reached out his hand, which Lucian gently took. It was moving to see them giving and receiving comfort.

The sun was gently streaming in through the wide-open window. 'It is a beautiful room,' said Jasper.

'Very, very nice,' said Lucian. He was mostly at peace, gently joining in, the odd joke, an aside, an aperçu but all refracted through a veil of affliction. David was seated by the window, Jasper and I on the bed. As we left him to have a nap, Jasper kissed his hand. '*Au revoir,* see you soon, *auf wiedersehen,*' Lucian waved and lay back. It was the final goodbye. As we walked downstairs, we knew we would never see him again.

Two weeks later, Lucian died.

* * *

On the night of his death, the builder and the brigadier were having dinner with David Dawson at Clarke's. As they sat and reminisced, Lucian was breathing his last a few doors away, some of his children with him. Pat Doherty remembered how Lucian had thrown bread rolls in Clarke's to get attention. 'He was a mischief-maker.' At 10.30 p.m. Lucian died as his friends sat there together for the last time. A telephone call confirmed his life was over. David did not return to the house that night. It was all too painful. He briefly went to the front door but did not go in. He wanted to grieve alone.

There had been a steady stream of farewells as the family and friends gathered for his end. Much was forgiven and forgotten. A rota had been organised by Rose Boyt, who had taken the lead. David was always there, an essential presence. 'He was certainly one of the great loves of Lucian's life,' said John Richardson, who had seen and known most of them. David was there from early morning and sometimes through the night, staying in the spare room as Lucian's final days saw him grow weaker. Towards the end it was David who sat through the night, gently turning Lucian every two hours. It was always evident how much they cared about each other, both being so un-beholden but modestly, quietly, irrevocably linked.

Their ease and closeness was evident when I photographed Lucian painting him in his studio. They had agreed that I could watch them do together what they did for so many hundreds of hours. David discarded his clothes and sat with the whippet Eli

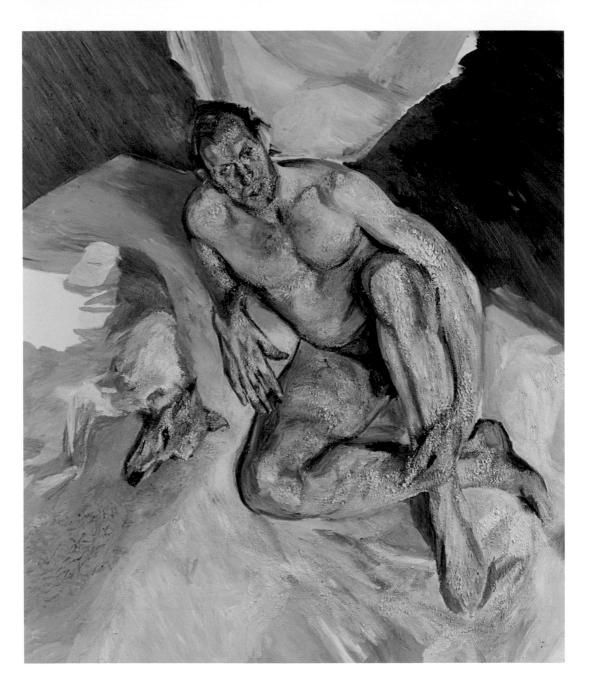

Portrait of the Hound, 2011

on a mattress, Lucian standing by the easel. A silent drama unfolded, the crucial link between them, united by paint. There was an ease, a familiarity and a sense of comfort. The painting was about an uncovering, a deciphering of love and friendship, of patience, of

sitting quietly there, sharing space and time. It was a mutual giving and receiving, an understanding of and by two men connected to each other, and also an appreciation of the slow but extraordinary change that all paintings went through.

David's soft-white skin took on a subtle warm tone as light from the garden window shone through the trees outside. It was as much a portrait of Lucian in some ways, his feelings and affection so tangible. I was a silent witness to a magical moment of intimacy and trust, and the connection between the two men was understated but overwhelmingly obvious. Lucian looked, sensed and reacted intuitively, adding a brushstroke, an extra dab of colour. It is in essence a love painting. 'Lucian couldn't stop himself. You have these very powerful and sometimes loveless nudes and then you end with this gentle bathing in light of the body by someone who clearly loves him. What a sense of affection. He couldn't stop himself showing the love in that final painting,' remarked David Hockney when he went round the National Portrait Gallery exhibition, which ended with three portraits of Dawson. There is indeed a tenderness that is missing from so many of the other raw pictures of naked bodies.

David had lived through Lucian's highs and lows for twenty years. Possibly the most alarming moment for David had been when Lucian, aged eighty-six, was photographed with a wild zebra in a film studio in Acton, West London, echoing the zebra motif in his paintings. A film-maker called Tim Meara was making a film about Lucian and as an imaginative gimmick had hired a zebra for the day. It took fright after Lucian tapped it on the nose, and bolted. Lucian clung on to the reins, which he was holding as he was dragged crashing to the floor. 'He instinctively never let go and so was pulled along,' recalled Dawson. There was a huge panic, as Lucian was rushed to the Cromwell Hospital for a scan. He suffered only a groin strain, but it was a moment that David had thought might have prematurely ended his life. Kate Moss came round to comfort him and was memorably photographed by David giving Lucian a cuddle in bed.

The term 'assistant' fails to do justice to the intimate and fundamental nature of David Dawson's role as curator, keeper of the door and guardian of the flame. In the final years David had fixed

everything for him, and Lucian saw more of him than any other person. Quiet, intelligent and funny, David also had a steely core which he used to protect Lucian. He was essential to the artist's life. He was the only named beneficiary in Lucian's will, and was left the house in Notting Hill and £2.5 million.

The bulk of Lucian's wealth – a staggering £96 million – was left to his daughter Rose Boyt and his lawyer Diana Rawstron to act as trustees to carry out his wishes, which were not published but were expected to be of benefit equally to his children through a trust whose contents will remain secret. Just as he had preserved the privacy of most sitters by not naming them, it was typical of him to maintain an anonymity for his children in his last testament.

There were many farewells. John Richardson flew in from New York and chatted animatedly, showing him a collage of his painting of the Queen cut in half and joined to a photograph of her, both appearing almost identical. Lucian laughed. Jeremy King, his host at the Wolseley for dozens of dinners, told him, 'Lucian, you do know we love you,' only to get the reply, 'Oh I say, don't go overboard.' King added: 'I know it is uncomfortable for you to hear that but you need to know that we love you, that I love you.' Lucian quietly said thank you. Such sentimentality was not his thing, but it was appreciated. Sally Clarke stood quietly by his bed, and even though she knew Lucian would not completely approve, she said a prayer.

When Lord Rothschild, friend, sitter and patron, dropped by a few days earlier, Lucian got up, started to get dressed and said to David that they had a meeting and must get ready to go to it. 'Yes, we have to go to the National Gallery,' said David. Lucian clearly did not want his bed-bound vulnerability to be exposed. He had always needed to be in control.

Nicholas Serota had come by some weeks before, partly to help David and Lucian sort out which pictures still in the studio should be culled. They looked through unfinished works, and some, which Lucian felt he did not want left in the studio, were destroyed. These were the works he had abandoned or was no longer working on. It was Lucian's final act of control over his legacy.

Celia Paul came, as did Sophie de Stempel, his muse for so

many years, and a constant stream of children and grandchildren. The McAdam Freuds, who had rarely seen him over the last twenty years, all turned up. Lucian faced the parade with sweetness and patience.

The two most important women in his life were there for the last days. Jane Willoughby lay beside him in his quiet, cool bedroom. Theirs had been a love affair that had lasted more than half a century. She had been the most loyal patron, supporter, friend, lover, muse and soul mate.

David had the delicate task of making sure that Jane did not bump into Susanna Chancellor, who came for her goodbye. David called through from downstairs to Jane who said to Lucian that she had better go as Susanna was coming. 'Who is Susanna?' he mischievously asked, the great juggler of hearts right to the end, making all feel that they were the only one. Susanna lay beside the man who had been such a force in her life. Then she flew to her home in Italy to await the final news. He was slipping away fast.

There were always people opening and closing doors around him; he was at the centre of every entrance and exit. The circus surrounding his life was almost over. Now the children, who had never before been in charge, had control. They would make the decisions about his funeral and memorial service. The man who had avoided a family in any conventional sense had them all around him at the end. Some took umbrage as they were given strict times for visiting, but it was necessary as there were so many, and to avoid a bottleneck of visitors. They all were moved and moving about their father, from the eldest girls, Annie and Annabel, down to Frank, the youngest, who had been walking from Land's End to John O'Groats when he got a call in Yorkshire and immediately returned.

'My mum had already been to see him about ten days earlier and asked me if I wanted her to come along. I asked Rose if it would be OK and she said fine. It was difficult for Mum because she had had a certain finality and felt a great sense of warmth and wasn't sure if it was appropriate to go again. A couple of my half-sisters were there and also a nurse.

'We stood around and there was a lot of silence. My sister Rose was very open about the certainty of him being about to die

and didn't mince her words. Not that she was crass, but she didn't resort to euphemism or the language of false hope. She said the last of the senses to go is your hearing, so we could still say a final goodbye to Dad and he'd be able to hear. She said I should hold his hand and say something to him and she left me alone with him to do that. I did hold his hand, which didn't respond, but I couldn't think of anything to say so I was just silent.

'I had never particularly seen him as a father figure, even though he was my father. The adjective that comes to mind when I think of him is "playful", and that he was very uninhibited about the impression that people would get of him, no matter what the company.'

His life was always a tangled web, which did not end with his burial. Jacquetta Eliot, the mother of his son Freddy, was told she was not welcome. Yet Freddy did turn up. It was a curtailed affair, with the children restricting it to themselves and his grandchildren. Lucian's niece, Dorothy (the daughter of Stephen Freud, Lucian's older and surviving brother) was told it was just for the immediate family. It was the children's time and theirs alone, after years of playing second fiddle to the women and the work in his life.

The night after Lucian died, restaurateur Jeremy King ordered a black tablecloth to cover his corner table in the Wolseley, with a single candle burning in his memory. David Gilmour, the guitarist from Pink Floyd, and his wife, the writer Polly Samson, dined there that evening. 'There was an ecclesiastical hush, tangible sadness around the black tablecloth with a single flickering flame. As when Lucian was living, everyone tried not to stare,' said Samson. Sophie de Stempel was also there, as were Lady Antonia Fraser, the biographer and widow of Harold Pinter, and Victoria Rothschild, widow of the playwright Simon Gray, and they shared a moment of respectful silence.

Lucian had been born into an era when fields were ploughed by horses, and died during an age when images of his work are stored on microchips. His life was governed by obsessions, selfishly pursued, whether women or his art, never restrained or diverted by what others thought. He broke every rule which did not suit him, and perhaps had no rules at all. 'How can it be selfish when he only

says what he is going to do? There was no narcissism,' said Jeremy King.

In trying to understand the complexity that is Lucian Freud, it is necessary to stay focused on his art. The pictures tell who he slept with and spent time with. He mostly kept the names hidden but the paintings don't lie. Look for the pictures of Anne Dunn peeping through a curtain of brambles, Caroline anguished in bed in Paris, the gay coterie of Peter Watson, Stephen Spender and Cyril Connolly, or even the young boy Charlie Lumley, who Lucian claimed broke into his flat in Delaware Terrace.

It ended surprisingly with a Christian funeral (although Lucian had told David he just wanted his body thrown in the local canal in a bag – the pull of Paddington always remained strong). Instead, the grandson of the most prominent Jew in Europe had a service in a Christian church overseen by Rowan Williams, the former Archbishop of Canterbury (who is married to Celia Paul's sister Jane, and is thus an uncle to Lucian's son Frank). The last time I had seen Lucian in a remotely Christian context was in another Jewish household, the home of Sir Evelyn and Lynn de Rothschild, who had an annual Christmas dinner in Buckinghamshire where carols were sung. Lucian and my wife Kathryn shared a hymn sheet as we belted out 'Good King Wenceslas'. He knew every word and sang heartily. Wine spilt down the dress of producer and actress Trudie Styler, Sting's wife. 'Did you do that on purpose' I asked Lucian, as he helped her wipe her lap. He laughed. Mischief was always part of his repertoire.

Outside the immediate family, only Jane Willoughby and David Dawson were at the service in Highgate Cemetery (although Sister Mary-Joy brought her skewbald mare, Sioux, to the graveside). Lucian's best friend Frank Auerbach, totally dedicated to painting, did exactly what Lucian would have done: he stayed in his studio. Susanna Chancellor stayed at home. Some of the children gave readings. They were united by their father's death.

In Trafalgar Square, plans had already been drawn up for the enormous retrospective exhibition of his portraits at the National Portrait Gallery. The world would soon see so much of the intimacy of his life in the public displays. He had been excited by the

prospect. It was to be the most successful portrait exhibition ever held in Britain.

Across London, the table at the back of Sally Clarke's restaurant remained unoccupied that morning, an empty stage through the window. The white cloth was bare, his chair unfilled. Breakfast with Lucian was over.

Acknowledgements

This book would not have been possible without the trust of Lucian Freud and the many people who fell under his spell who also trusted me with their experiences of being with him. Especially, I thank David Dawson, my fellow breakfast companion, whose aim is and was simply to achieve the best for Lucian.

As always, nothing would ever have happened without my agent Ed Victor, who made the embryonic notion of this book become a reality and has been extraordinary in his support and friendship. I am grateful for wise editing from Dan Franklin and David Milner at Jonathan Cape. Also pivotal in keeping the book in focus was Mark Holborn. I am grateful for advice after reading early drafts from James Adams and Kate Chapple.

Crucial encouragers and wise heads along the way have been Justin Byam Shaw and Andrew Solomon. My PA Rosalyn Jeffery was key, bringing calm, clever organisation and resourceful research.

A special thanks to my brother Louis who generously let me and my family stay in his flat in Lucian's building in Holland Park.

During the last two years as I have typed away at this book, mostly by BlackBerry, I thank my wonderful wife Kathryn and my children, Jasper, Monica and Octavia and their nanny Marie Reyes for giving me the space and time to be able to write before, after and sometimes during breakfast.

I owe Michael Meredith a special debt not only for introducing me to the works of Lucian Freud but also for being the person who most changed my life.

Many others have helped along the way, including some who do not wish to be named. I owe thanks to:

William Acquavella; Diana Aitchison; Clarissa, Countess of Avon; Andrew Barrow; Lucy Baruch; Emily Bearn; Tim Behrens; Antony Beevor; Felicity Bellfield; the late Caroline Blackwood; Sandra Boselli; Ali Boyt; Rose Boyt; Ivor Braka; Craig Brown; Verity Brown; John Byrne; Alexander Chancellor; Susanna Chancellor; Victor Chandler; Perienne Christian; Evgenia Citkowitz; Sally Clarke; Cressida Connolly; Rachel Coulson; Caroline Cuthbert; Anthony d'Offay; Sir Evelyn and Lynn de Rothschild; Sophie de Stempel; the Duke of Devonshire; Anne Dunn; Jacquetta Eliot; Clare Ellen; Mandy Estall; Lord Fellowes, Mark Fisch; John Fitzherbert; Dame Antonia Fraser; Ann Freud; Annie Freud; Bella Freud; Esther Freud; Matthew Freud; Stephen Freud; Jonathan Gathorne-Hardy; A. A. Gill; Lady Glenconner; Lord Gowrie; Lady Greig; Nicky Haslam; David Hockney; Sir Howard Hodgkin; Robin Hurlstone; Raymond Jones; Jay Jopling; David Ker; Jeremy King; James Kirkman; Lady Lucinda Lambton; Sister Mary-Joy Langdon; Evgeny Lebedev; Janey Longman; Ivana Lowell; Billy Lumley; Neil MacGregor; Jane McAdam Freud; Barbara McCullen; Tim Meara; Elizabeth Meyer; Ffyon Morgan; Mary Morgan; Charlotte Mosley; Danny Moynihan; Sandy Nairne; Lord O'Neil; Pilar Ordovas; Andrew Parker Bowles; Janetta Parlade; Celia Paul; Frank Paul; Terence Pepper; Diana Rawston; Freddy Rendall; Sir John Richardson; Grace Riley-Adams; Viscount and Viscountess Rothermere; Lord Rothschild; Hannah Rothschild; Michael Saunders; Sir Nicholas Serota; Bettina Shaw-Lawrence; Julia Shaw-Lawrence; Matthew Spender; Sting and Trudie Styler; James Stourton; Vassilakis Takis; Sue Tilley; Lady Sophie Topley; Harriet Vyner; Rebecca Wallersteiner; Peter Ward; Lord Weidenfeld; Volker Welker; Alex Williams Wynne; Harriet Wilson; Sir Peregrine Worsthorne; Randall Wright

I'm extremely grateful to the Lucian Freud Archive for permission to use images of his paintings, all kindly provided by The Bridgeman Art Library.

Excerpts from Laurie Lee's diaries reproduced by permission of Curtis Brown Group Ltd, London on behalf of the Estate of Laurie Lee. Copyright © Laurie Lee 2013.

The quatrain "Don't Ian, if Annie should cook you" is an extract from *Don'ts for my darlings* by Noël Coward © NC Aventales AG reproduced by permission of Alan Brodie Representation Ltd www.alanbrodie.com

The extract from 'The Gyres' reproduced by permission of Scribner, a division of Simon & Schuster, Inc., from *The Collected Works of W. B. Yeats, Volume 1: The Poems*, revised by W. B. Yeats, edited by J. Finnereran. Copyright © 1940 by Georgie Yeats, renewed 1968 by Bertha Georgie Yeats, Michel Butler Yeats. All Rights Reserved.

Lucian's

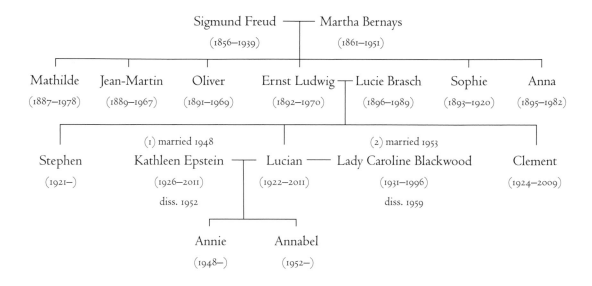

Sigmund Freud ——— Martha Bernays
(1856–1939)　　　　(1861–1951)

Mathilde　　Jean-Martin　　Oliver　　Ernst Ludwig ⊤ Lucie Brasch　　Sophie　　Anna
(1887–1978)　(1889–1967)　(1891–1969)　(1892–1970)　　(1896–1989)　(1893–1920)　(1895–1982)

(1) married 1948　　　　　　　　　　(2) married 1953

Stephen　　Kathleen Epstein ⊤ Lucian ——— Lady Caroline Blackwood　　Clement
(1921–)　　(1926–2011)　　(1922–2011)　　(1931–1996)　　(1924–2009)

diss. 1952　　　　　　　　　diss. 1959

Annie　　Annabel
(1948–)　(1952–)

Family

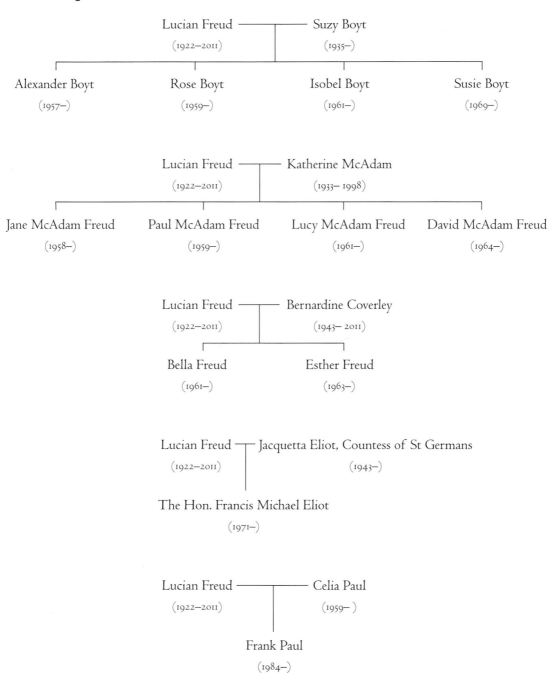

Lucian Freud ———— Suzy Boyt
(1922–2011) (1935–)

Alexander Boyt Rose Boyt Isobel Boyt Susie Boyt
(1957–) (1959–) (1961–) (1969–)

Lucian Freud ———— Katherine McAdam
(1922–2011) (1933–1998)

Jane McAdam Freud Paul McAdam Freud Lucy McAdam Freud David McAdam Freud
(1958–) (1959–) (1961–) (1964–)

Lucian Freud ———— Bernardine Coverley
(1922–2011) (1943–2011)

Bella Freud Esther Freud
(1961–) (1963–)

Lucian Freud ——— Jacquetta Eliot, Countess of St Germans
(1922–2011) (1943–)

The Hon. Francis Michael Eliot
(1971–)

Lucian Freud ———— Celia Paul
(1922–2011) (1959–)

Frank Paul
(1984–)

Notes

CHAPTER ONE

1 Author's interview with Jacquetta Eliot, 1 May 2012
2 *Lucian Freud: Portraits*, JA Films/BBC 2004
3 Annie and Annabel by Kitty Garman; Bella and Esther by
 Bernardine Coverley; Susie, Ali, Rose and Isobel by Suzy
 Boyt; Paul, Lucy, David and Jane by Katherine McAdam;
 Frank by Celia Paul; Freddy by Jacquetta Eliot
4 Author's interview with Anthony d'Offay, January 2012
5 Author's interview with Jeremy King, November 2011
6 Author's interview with Victor Chandler, November 2011
7 *Man with a Blue Scarf*, Martin Gayford, Thames & Hudson
 (2010), quoted by Nicholas Serota at Lucian Freud's
 memorial service at the National Portrait Gallery
8 *Mail on Sunday*, 20 May 2012
9 Robert Hughes, *Guardian*, 6 April 2004

CHAPTER TWO

10 Author's interview with Tim Behrens, 20 January 2013
11 Augustus Egg (1816–63) was best known for his triptych *Past
 and Present*
12 Author's interview with Frank Auerbach, *Evening Standard*,
 10 September 2009
13 Ibid.
14 Francis Wyndham, *Tatler*, June 2002

15 Author's interview with Jacquetta Eliot, May 2012

16 Author's interview with Lucian Freud, 2009

17 Author's interview with Sophie de Stempel, November 2011

18 Lucie Freud's will from the family papers of Matthew Freud

19 Author's interview with Lucian Freud, 2009

20 'Lucian Freud Paintings', Robert Hughes, Southbank Centre catalogue (1998), p. 9

21 Author's interview with Ann Freud, October 2011

22 Ibid.

23 Interview with Dora Mosse in 1950s, Leo Baeck Institute, New York, LBI/AR99 Mosse Family

24 *Lucian Freud: Painted Life*, Randall Wright, BBC/Blakeway Production, 16 February 2012

25 Author's interview with John Richardson, December 2011

26 Author's interview with Lucian Freud, 2009

27 Author's interview with Mark Fisch, December 2011

28 Dartington school report, from Matthew Freud family papers

29 Francis Wyndham, *Tatler*, June 2002

30 *Ernst L. Freud, Architect: The Case of the Modern Bourgeois Home*, Volker M. Welter, Berghahn Books (2012), p. 145

31 Ibid., p. 140

32 'Lucian Freud Portraits', Sarah Howgate (curator), Michael Auping and John Richardson (interview by Michael Auping), NPG catalogue (2012), p. 41

33 'Lucian Freud Paintings', Robert Hughes, Southbank Centre catalogue (1998), p. 14

34 Ibid, p. 15

35 Author's interview Mark Fisch, December 2011

36 Author's interview with Lucian Freud, 2009

37 William Feaver interview with Lucian Freud, *Guardian*, 18 May 2002

38 Ibid.

39 *Lucian Freud*, Bruce Bernard (ed.), Jonathan Cape (1996), p. 11

40 Author's interview with Neil MacGregor, March 2012

41 *Lucian Freud: Painted Life*, Randall Wright, BBC/Blakeway Production , 16 February 2012

42 Author's interview with Annie Freud, August 2011

43 *Lucian Freud*, Lawrence Gowing, Thames & Hudson (1992), p. 8

CHAPTER FOUR

44 *Lucian Freud: Painted Life*, Randall Wright, BBC/Blakeway Production, 16 February 2012

45 Author's interview with Bettina Shaw-Lawrence, December 2011

46 'Lucian Freud: In the Silo Tower', Sandra Boselli, *The British Art Journal*, Volume XIV no. 3, Summer 2013

47 *Stephen Spender, The Authorised Biography*, John Sutherland, Penguin (2005), p. 263

48 *The Girl from the Fiction Department: A Portrait of Sonia Orwell*, Hilary Spurling, Counterpoint Press (2003), p. 57

49 Author's interview with Matthew Spender, November 2011

50 Diary, 7 February 1940, quoted in *Stephen Spender: A Life in Modernism*, David Leeming, Henry Holt (1999) p. 133

51 Email from John Sutherland to author, August 2012

52 'Lucian Freud: A Scottish Interlude', Sandra Boselli, *The British Art Journal* Volume XI no. 3, June 2011

CHAPTER FIVE

53 *Laurie Lee: The Well-loved Stranger*, Valerie Grove, Viking (1999), p. 83

54 Author's interview with Lucian Freud, 2009

55 *The Rare and the Beautiful: The Lives of the Garmans*, Cressida Connolly, Harper Perennial (2010), p. 174

56 Ibid., p. 151

57 Ibid., p. 242

58 Ibid., p. 153

59 *Lucian Freud*, Lawrence Gowing, Thames & Hudson (1992), p. 8

60 *The Rare and the Beautiful: The Lives of the Garmans*, Cressida Connolly, Harper Perennial (2010), p. 174

61 Author's interview with Lucian Freud, 2009

62 *Laurie Lee: The Well-loved Stranger*, Valerie Grove, Viking (1999), p. 428

63 Ibid., p. 190

64 Author's interview with Valerie Grove, September 2011

65 *Laurie Lee: The Well-loved Stranger*, Valerie Grove, Viking (1999), p. 191

66 Ibid., p. 185

67 *The Rare and the Beautiful: The Lives of the Garmans*, Cressida Connolly, Harper Perennial (2010), p. 181

CHAPTER SIX

68 *Guardian*, 19 January 2011

69 Obituary, Kitty Godley, *Daily Telegraph*, 14 February 2011

70 *Lucian Freud*, William Feaver, Rizzoli (2011), p. 19

71 Author's interview with Anne Dunn, November 2011

72 Ibid.

73 *In Tearing Haste: Letters between Deborah Devonshire and Patrick Leigh Fermor*, Charlotte Mosley (ed.), John Murray (2008), p. 35

74 Author's interview with Nicky Haslam, September 2011 & January 2013

75 *Lucian Freud*, Bruce Bernard (ed.), Jonathan Cape (1996), p. 10

76 Author's interview with Jacquetta Eliot, 1 May 2012

CHAPTER SEVEN

77 *Mr Wu and Mrs Stitch: The Letters of Evelyn Waugh and Diana Cooper, 1932–66*, Artemis Cooper (ed.), Hodder & Stoughton (1991), p. 123

78 Extract from *Don'ts for my darlings* by Noël Coward © NC Aventales AG By permission of Alan Brodie Representation Ltd

79 *The Letters of Nancy Mitford and Evelyn Waugh*, Charlotte Mosley (ed.), Hodder & Stoughton (1996), p. 243

80 Ibid., p. 245

81 *Knowing When to Stop*, Ned Rorem, Simon and Schuster (1995), p. 521

82 Author's interview with Evgenia Citkowitz, August 2012

83 Author's interview with Charlie Lumley, 6 September 2011

84 Author's interview with Lady Anne Glenconner, 10 October 2011

85 Author's interview with Vassilakis Takis, in Athens, Greece, May 2012

86 Ibid.

87 *New York Review of Books*, 16 December 1993

CHAPTER EIGHT

88 Lucian Freud, *Encounter*, 1954

89 *Man with a Blue Scarf*, Martin Gayford, Thames & Hudson (2010), p. 54

90 Author's interview with Neil MacGregor, March 2012

91 Author's interview with Victor Chandler, November 2011

92 Freud's obituary, Catherine Lampert, *Guardian*, 22 July 2011

93 Author's interview with Mark Fisch, December 2011

94 Author's interview with Jacquetta Eliot, January 2011

95 Author's interview with John Richardson, December 2011

96 Ibid.

97 *Lucian Freud: Painted Life*, Randall Wright, BBC/Blakeway Production, 16 February 2012

98 Author's interview with Robert Fellowes, February 2012

99 Author's interview with Verity Brown, November 2011

100 Ali Boyt email to author, 6 December 2011

101 William Feaver interview with Lucian Freud, *Observer*, 17 May 1998

102 Author's interview with Sister Mary-Joy Langdon, November 2011

103 Author's conversation with Robin Hurlstone, December 2011

CHAPTER NINE

104 Author's interview with Tim Behrens, in A Caruna, Spain,
 20 January 2013
105 Author's interview with Ffion Morgan, December 2011
106 Author's interview with Harriet Vyner, February 2012
107 Email to author from Celia Paul, November 2011
108 Author's interview with Sophie de Stempel, November 2011
109 Sir Nicholas Serota quoting Lucian Freud, memorial address,
 National Portrait Gallery, 6 February 2012
110 *Lucian Freud: Painted Life*, Randall Wright, BBC/Blakeway
 Production, 16 February 2012
111 Author's interview with Alexi Williams-Wynn, December 2011

CHAPTER TEN

112 Author's interview with Annie Freud, August 2011
113 William Feaver interview with Lucian Freud, *Guardian*, 18 May
 2002
114 Author's interview with Annie Freud, August 2011

CHAPTER TWELVE

115 Author's interview with Damian Aspinall, March 2012
116 Craig Brown, *Daily Telegraph*, 9 April 2005
117 'The Master and The Gallerist' by Tom Vanderbilt, *Wall Street
 Journal Magazine*, 24 March 2011
118 Author's interview with Anthony d'Offay, November 2011
119 Author's interview with James Kirkman, December 2011
120 Author's interview with Lord Rothschild, September 2011
121 *Lucian Freud: Painted Life*, Randall Wright, BBC/Blakeway
 Production, 16 February 2012

CHAPTER THIRTEEN

122 Roya Nikkhah interview with Lucy Freud, *Daily Telegraph*, 20
 June 2011

123 Ibid.

124 Jane McAdam Freud, email to author, 31 October 2011

125 Ibid.

126 Esther Freud, email to author, 18 May 2012

127 Bella Freud, email to author, 26 October 2012

128 Esther Freud, email to author, 18 May 2012

129 Rose Boyt, email to author, 1 July 2012

130 Interview with Rose Boyt, *London Evening Standard*, 29 April 1991

131 Author's interview with Lady Lucinda Lambton, March 2012

132 Ibid.

CHAPTER FOURTEEN

133 *The Girl from the Fiction Department: A Portrait of Sonia Orwell*, Hilary Spurling, Hamish Hamilton (2002), p. 59

Picture Credits

Index

Page numbers in *italic* refer to illustrations.

Man on a Chair 102; Rose 222–3; Self-Portrait with a Black Eye 130; Skewbald Mare 147; Sleeping Head 159; Standing by the Rags 166; Sunny Morning – Eight Legs 144; Three-legged Horse (sculpture) 43; Two Plants 161; Waste Ground with Houses, Paddington 57; Woman with a Daffodil 77–9, 78; Woman in a Fur Coat 152, 154; Woman with a Tulip 77–9, 80, 82

Writings: 'Some Thoughts on Painting' (1954) 127, 128–9; Tatler article (2004) 127, 129

Freud, Lucie (née Brasch; Lucian's mother): family background 41, 59; marriage and child-rearing 41, 43, 59; relations with Lucian 41, 42, 43, 55–8, 59–60, 61, 88, 218; life in Nazi Germany 44, 46; flees Germany for England 10, 46, 61; life in England 52, 58; and Lucian's schooling 53, 54; widowhood 23, 55; depression and attempted suicide 23, 55–7; death 42; will 42; Lucian's portraits of 21–2, 23, 55–8, 56, 145–6, 146

Freud, May (Lucian's granddaughter) 186, 187

Freud, Sigmund (Lucian's grandfather) 2, 27, 41, 59–60; Lucian's recollections of 8, 46; legacy and royalties 9, 197; friendship with Lou Andreas-Salomé 42; life in England 46; Lucian's relations with 46–8; friendship with Marie Bonaparte 47; as zoologist 47

Freud, Stephen (Lucian's brother): childhood and schooling 42, 43, 43, 45, 46, 49, 52, 53; marriages and children 43, 236; relations with Lucian 48–51; Lucian's portrait of 50

Galway 94
Garbo, Greta 6, 67
Gargoyle Club 86, 93, 96
Garman family 79–82
Garman, Douglas 79, 81
Garman, Helen 79, 81, 92
Garman, Kathleen (later Lady Epstein) 79, 89
Garman, Kathleen 'Kitty' (Lucian's first wife): family background and early life 89–90; marriage to Lucian 89, 92, 96, 147, 181; appearance and character 90, 179; Lucian's portraits of 90–91, 91, 93, 109, 145, 147; affair with Laurie Lee 92; children 92, 176–7, 178, 179, 181, 182, 185; affair

with Henry Green 96; at Anne Dunn's wedding to Michael Wishart 97; and Lucian's nude portrait of daughter 176–7; marriage to Wynne Godley 178–9, 181

Garman, Lorna see Wishart, Lorna
Garman, Marjorie 82
Garman, Mary 79
Garman, Ruth 90
Garman, Sebastian 81
Garman, Sylvia 79
Garman, Walter 81–2
Gascoigne, Caroline 32
Gayford, Martin 16, 129
George, Prince of Greece 47
Gilbert and George 19, 211
Gilmour, David 236
Glenconner, Lady Anne 116, 118
Glenconner, Colin Tennant, 3rd Baron 118, 204–5
Glendinning, Victoria 122
Godley, Eve 179
Godley, Wynne 178–9, 181
Goethe, Johann Wolfgang von 6
Goldeneye, Jamaica 105
Goldsmith, Sir James 12
Gollancz, Diane 64
Goodman, Arnold, Baron 150, 208
Goodman, Francis, photographs 76, 85
Gormley, Antony 229
Gormley, Michael 229
Gourmont, Remy de, The Natural Philosophy of Love 172
Gowrie, Grey Ruthven, 2nd Earl of 121, 125
Grange, Peter 201
Gray, Simon 236
Green, Henry 96
Greig, Sir Henry Louis Carron v
Greig, Jasper 4, 6, 6, 7, 228, 230–31
Greig, Kathryn 237
Greig, Louis 32
Greig, Monica 4, 7
Greig, Octavia 4, 7
Grove, Valerie 84
Guinness, Desmond 139
Gunwalloe, Cornwall 81
Gurland, Marilyn 150

Hall, Jerry 12, 34, 203–4
Hampstead, Sigmund Freud's house 46, 73
Hanbury, Marina 102
Hanover Gallery, London 209
Hardy, Thomas, 'The Turnip-Hoer' 40
Harrison, Tony 38
Harrod, Tanya 101

Haslam, Nicky 97
Hastings, Dorothy 197
Hastings, Jane 197
Hayward Gallery, London 31
Hellaby, Felicity 64–7, 66, 69; Lucian's portraits of 64–5, 65, 66
Hellaby, Richard 65
Hellaby, Ruth 65
Hicks, Zoe 100
Hiddensee 46
Hideous Kinky (film) 220
Hill, Derek 202
Hirshhorn Museum, Washington 210
Hirst, Damien 211
Hitler, Adolf 44
Hitler Youth 44
Hockney, David 28, 30–31, 157, 192, 233; Lucian paints 188, 189–92
Hokusai 42
Holland Park, Lucian's flat/studio 4, 9, 11, 25, 34, 35, 132
Holocaust 10, 88, 218
Horizon (magazine) 71, 73, 228
Hornby, Sir Simon 108
horses and horse-racing 43, 53, 147, 197–201
Hughes, Helena 94–5
Hughes, Robert 19, 30
Hughes, Ted 23
Hurlstone, Robin 148, 150
Hyndman, Tony 71, 73

illegitimacy, accusation of Lucian's 48–9
Ingres, Jean-Auguste-Dominique 77, 131, 190
Iraq 86–7
Islington: Liverpool Road 135, 136; Job Centre 210–211

Jackson, Derek 95
Jackson, Rose 95, 101
Jagger, Gabriel 203
Jagger, Sir Mick 203–4
Jamaica 105
James, Henry 39, 161
John, Augustus 100
Jones, Raymond 23–7, 28
Jopling, Jay 211–12
Joshua (whippet) 156

Kasmin, John 191, 192
Kensington Church Street: Lucian's house/studio 3, 9, 17, 35, 126, 131–3, 190, 200, 228–9, 230; Kitty and Wynne Godley's house 179
Kent, Prince George, Duke of 47
Kentish, David 69–70, 74